1976

THE APPRECIATION OF THE ARTS 5 Painting

General Editor Harold Osborne

the appreciation of the arts/5

London · *Oxford University Press* · New York · Toronto · 1970

PAINTING / *Peter Owen*

Oxford University Press, Ely House, London W. 1

GLASGOW NEW YORK TORONTO MELBOURNE WELLINGTON
CAPE TOWN SALISBURY IBADAN NAIROBI DAR ES SALAAM LUSAKA ADDIS ABABA
BOMBAY CALCUTTA MADRAS KARACHI LAHORE DACCA
KUALA LUMPUR SINGAPORE HONG KONG TOKYO

Paperback edition SBN 19 211912 5
Hardback edition SBN 19 211911 7

Made and printed by offset in Great Britain
by William Clowes and Sons, Limited,
London and Beccles

To Valerie

Contents

Illustrations

The author's drawings and diagrams are not listed here.

Numbers in the right hand margin of the text give page numbers of the illustrations referred to.

The Language of Painting[1]

Painting is a visual language. If we cannot understand its vocabulary and syntax it can communicate very little to us. Although this language is rooted in our common visual experience and primeval heritage many of us with maturity lose the ability to see things fully and completely. Unless we can recover this capacity for full visual experience much of the language of painting will be hidden from us.

That we have lost the art of spontaneous vision is not surprising, for from adolescence we tend to use our eyes generally for *intellectual* perception, to qualify what we see with reservations formed by acquired knowledge and to restrict our view of the outside world to things of practical interest and immediate necessity. From this store of knowledge gained by precept and experience we identify the people and the places, the objects and objectives of our own environment by the slightest of visual clues, our almost blinkered vision seeking only some remembered detail to serve as a recognition signal. If a train or a motor-coach draws up each day before us it probably no longer provides, as once it must have done, a vivid sensation of shape, xiv colour, size, weight, and power. Instead we may record only an instant, snapshot detail—a mere route number or destination-board—since that is all that we are interested in and looking for.

So the notice, the label, the number, the tag—the nose for a person, the door for a house—may supply all that we demand for a rudimentary visual code by which the part is briefly noted as a token to record the whole. Perfunctory glances, anticipated images, irrelevant associations, and inherited prejudices may easily produce an aesthetic myopia that is, perhaps, the price we pay for speed, comfort, scholarship, and sophistication. We may find, in fact, that we do not *need* to look for more—certainly not for any aesthetic or expressive qualities—in order to survive with reasonable safety and efficiency in the twentieth century. Because of such self-imposed perceptual withdrawal we are rarely startled by visual discoveries and may find that we have lost the capacity to be surprised, enchanted, or impressed by the visual phenomena of the outside world—the objects and events of daily life having become only too familiar, ordinary, and explicable.

An artist employs shape, line, texture, tone, and colour as the basic elements of his painting. With these he can create the pictorial qualities of form, space, movement, and design. If in everyday life we are not

[1] Numbers in the right-hand margin of the text give page numbers of the illustrations referred to.

FOUR-YEAR-OLD CHILD:
Bus

fully alert to these perceptual elements in our environment, we are likely to be less responsive to their possibilities for aesthetic experience in our appreciation of paintings.

Accustomed to using our eyes only in order to gather everyday practical information, some of us may therefore seek, when we look at a painting, qualities and objectives with which the artist is not mainly concerned. Many people unconsciously tend to assume that the painter's purpose is like that of the journalist or the photographer— understandably so, for since we are educated to use our eyes primarily for literary comprehension we may find ourselves attempting to make only literary sense of the painter's visual symbols and to expect them to provide only factual information. And because a painter, if he chooses, can represent the shapes and colours of familiar things with reasonable accuracy, and is able to create a convincing illusion of the textures, volumes, and spatial depth of the real world, his technical skill may lure us into attempting to read his pictures as if they were enigmatic mimes, or cunning scenic reconstructions. These attitudes of approach inhibit and may altogether break the aesthetic contacts which form true artistic appreciation.

I do not want to suggest that subject-matter and theme are un-important to our full appreciation. We must be aware of the so-called abstract and formal qualities of a painting and of their expressive

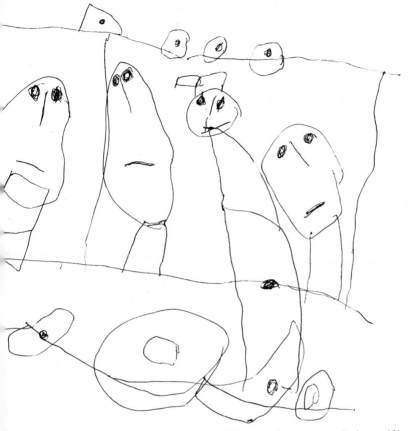

function. It is no less false to look at every painting as if it were just an abstract than to concentrate solely on subject and story as if it were a catalogue-illustration. When a shape or a form represents something in nature this has a psychological influence on its prominence and impact in the picture: to some degree it alters its character as form. In historical, mythological, and religious painting, the scene depicted carries implications for a 'story' which goes beyond itself; a fact germane to the total message of the picture. Even still lifes, and other non-anecdotal genres of painting communicate to us the artist's individual vision of the world around and this too is part of the picture's message. By and large the subject or theme is that which many pictures may have in common; the form, is what gives to each picture its individual character. But in great works of art, whose impact upon us is both profound and lasting, a unity so intimate is achieved between expressive form and content that it often seems artificial to speak of a distinction between form and content. In appreciation they are fused.

In our approach to a great painting it is essential, therefore, that our primary interest should be in its capacity as a visual language to communicate ideas that only paintings can express. If when we stand in front of a picture nothing *happens*, if all that reaches us could as well have been expressed and communicated in words, or waxworks, we are probably blind to the painter's language, our everyday perceptual habits having been blurred by the influence of the partially seen instant messages of mass media and distorted by the pressure of the literary and technological age in which we live. To rouse our perceptiveness and to enable ourselves to read the painter's language with understanding and pleasure, we should set ourselves deliberately to see and enjoy the formal and sensuous qualities of our everyday surroundings. At the same time we should develop the ability to look carefully and intently at the various aspects of painting.

This book aims to help the reader towards a deeper understanding and enjoyment of those paintings generally known as 'easel' or 'studio' pictures, that is towards an appreciation of the paintings he will see in public museums and in private commercial galleries rather than mural and ceiling decorations in churches, tombs, palaces, and temples, which should really be studied in their own architectural environment.

The full appreciation of every visual art is an experience that reaches us simultaneously from many levels. The various component elements of painting—shape, line, tone, colour, texture, and so on—are interrelated and interdependent and if he is to experience a painting completely the viewer when he is looking at a picture cannot examine each of its qualities in isolation. But appreciation can be reached through the development of latent faculties, and this is a skill that may be cultivated. As in the cultivation of any skill this can only be achieved through the study and practice of each of its aspects in turn. In my first chapter I propose, therefore, to talk about the aspect of shape.

TITIAN (active before
1511, d. 1576): *Portrait of
a Man*. National Gallery,
London

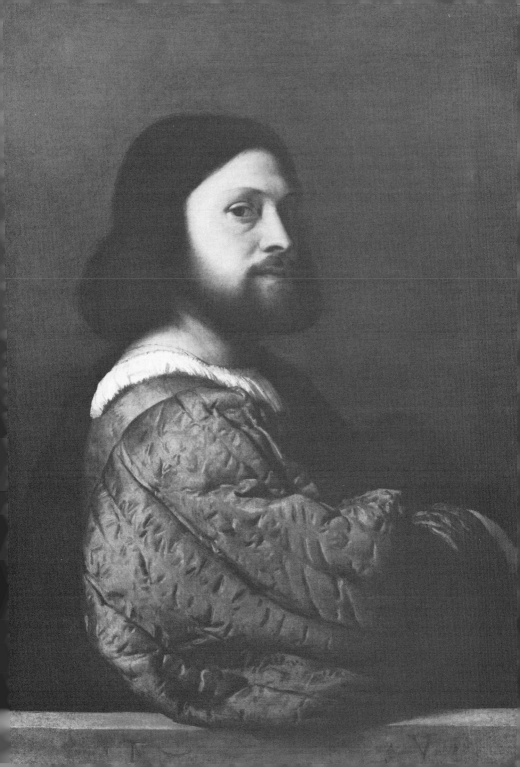

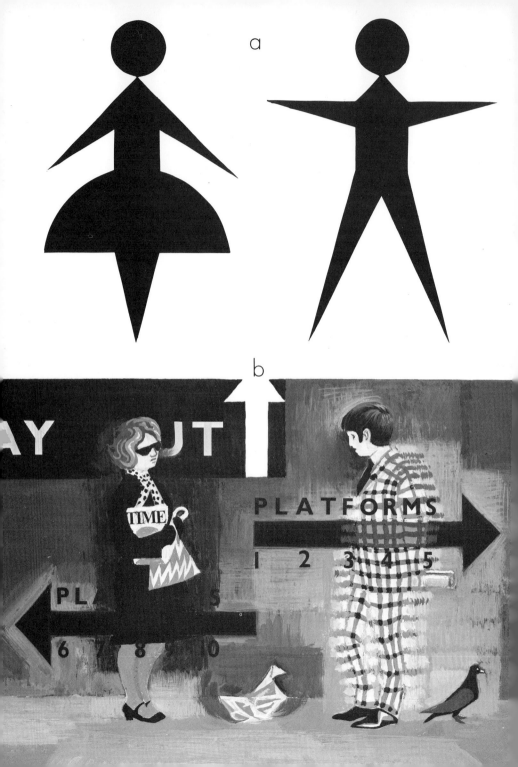

a

b

I use the word 'shape' here in a specialized sense to mean any area on a flat, two-dimensional surface. Most paintings, whatever their style and subject, and however many other aspects they may offer us, can be appreciated as patterns of shapes defined on the picture surface. Therefore every area described on the surface of a painting may well be seen (among other things) as a shape.

Shapes are made in a number of ways. They may be defined in a painting as the boundaries of apparently weighty objects that seem to exist in a three-dimensional picture space, or they may be composed from parts of different adjacent objects or exist as the gaps, or negative shapes, *between* objects. It is important for us to be able to see shapes by whatever means they are described, since painting is a two-dimensional medium of communication and its flat shapes provide an expressive vocabulary for every style and for the interpretation of any subject.

In the outside world, most people make use of this visual language whenever it seems to be the most direct means of communication—from the passionate images drawn in childhood and the symbols xiv–xv scratched to establish school-desk tenancy, to the plans, directional maps, and instructional diagrams scribbled spontaneously by adults when words confuse and time is short. Most of us are also frequent shape-*readers*, since from time to time we have to translate visual symbols into the information we need. As easily as we can interpret the alphabetic shapes of our own written or printed language into words, we can generally recognize and understand the sparest of pictorial codes when these are in the familiar form of charts and currency, of badges and trademarks, commercial and industrial hieroglyphics, and all the warning signals of highway iconography.

These symbols are successful as expressive images because the simplicity and directness of their design enables us to read them easily as *complete* shapes. Such shapes will usually be found to have been based on *geometrical* units since most people can immediately perceive the total area of a circle, a square, a triangle, an oval, or a rhombus without difficulty. It is, therefore, easy to grasp the *complete* shapes of the geometrical symbols on the opposite page (a) and to read them at once as representations of a man and a woman. But because real people, buildings, trees, furniture, and vehicles are not perceived as neat geometrical shapes and since we can use our other senses as

1

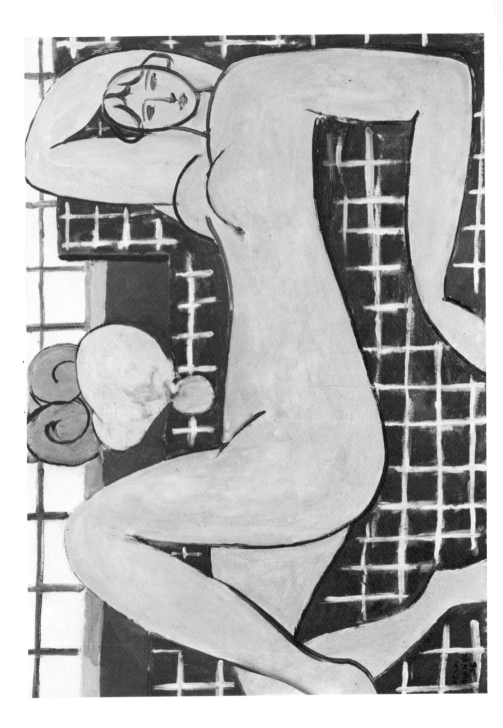

means of knowing and understanding them, our visual impression on meeting a real man or woman would need to be no more complete than the foggy images below (b) where only unrelated details of xviii momentary personal interest are recorded with clarity.

The painter of course can communicate his ideas to us only through the medium of a silent, immobile, two-dimensional picture surface. Therefore it is essential that we should exercise the latent ability to see his pictorial shapes completely if we are to grasp their expressive and formal meanings.

Matisse said that he attempted to make his paintings 'reach that state of condensation of sensations which constitutes a picture'.[1] Proof of his struggle to reach that state in the painting reproduced on the facing page has been shown by a photographic record made over a period of six months, of each stage in its progress towards completion. Those photographs revealed the repeated cycles of definition, obliteration, and restatement of the picture's shapes and proportions of colour and texture before the final version we see was reached. Matisse was attempting to create shapes which would give us immediate sensations of visual excitement through their stimulating orchestration across the picture surface.

But because this painting is reproduced here on its side our first reaction may have been to turn it round merely in order to find details which would identify the representational functions of its images—whereas its very position on the page should make it natural for us to be immediately aware of these images as vibrant whole shapes.

If we found that we did not respond to the living, sensuous qualities of Matisse's shapes, we should develop a technique for seeing shapes as shapes and in their entirety. Rather as we might attempt to intensify our aural concentration and sharpen our sensitivity to the quality of sound in music by occasionally making ourselves listen intently and unselectively to *all* the noises of the outside world around us at a particular time, so we may overcome a temporary condition of shape-blindness by practising a technique of visual perception on the things in our immediate surroundings.

We should be able to see the similarity of any three-dimensional form to that of a flat quasi-geometrical shape if we focus our eyes first upon its outside edges and then consider the area within these boundaries in terms of its most distinctive quality. That is, whether the area is best described by its relative lightness or darkness compared

[1] 'Notes d'un peintre' in *La Grande Revue*, 1908.

to its surrounding field or by its particular colour, or by some special texture or pattern. If, for example, we are sitting in a room we might look towards each wall in turn and staring intently only at the edges of every object that falls within our field of vision, *fixate* it as a shape of tone, colour, or texture until we begin to see its likeness to a particular geometrical figure.

In such a way we might see, on the wall facing us, for example, a door as a dark *rectangle* and a bookcase or a window as a patterned *square*; a mat and the top of a coffee table as *oval*, a hanging coat as *triangular*, and a mirror as *circular* in character. [5a]

If we stare intently enough, we find very soon that these things in our room will have lost their conventional visual identity as practical objects, and that we are seeing them *only* as light or dark, coloured or textured rectangles, squares, circles, triangles, and ovals. We should also have become aware that we are now making none of the usual instinctive allowances for perspective shape distortion. If, for instance, we are staring at a door or a window opened towards or away from us, or at a carpet or chair placed obliquely to our line of vision, we should now be aware of these as the asymmetrical shapes our retina is, in fact, recording at the time, rather than allowing our intelligence to adjust these visual images to match the square and rectangular plan and elevation aspects by which we know them from memory. [5b]

We should then have reached that state of heightened shape-awareness which enables us to see even subtle and complex forms as complete areas—a bowl of flowers, for instance, seen simplified as an overall mass of coloured and textured oval, triangular, and rhombic shapes. We should find that as a temporary optical condition this state is as irresistible as that familiar sensation of 'colour everywhere' which often dazzles us when we leave a cinema after having watched an imaginatively photographed colour movie. We should now look at the Matisse reproduction again, when its whole picture surface will appear to vibrate and the shapes across the surface to be animated.

MAP-READING In paintings designed as patterns of flat shapes—the Indian and Per- [25, 164, 257; 123] sian miniatures and the Chagall for example—objects and their setting are often presented from both plan and elevation viewpoints, the solid forms and three-dimensional space of the outside world being transcribed into a two-dimensional map of flat shapes.

In the design of flags and escutcheons and the plans of streets and ground-plans of buildings, the identity and visual character of different areas are defined by linear shapes which are then filled in with distinguishing tones, colours, or textures. In using this elementary

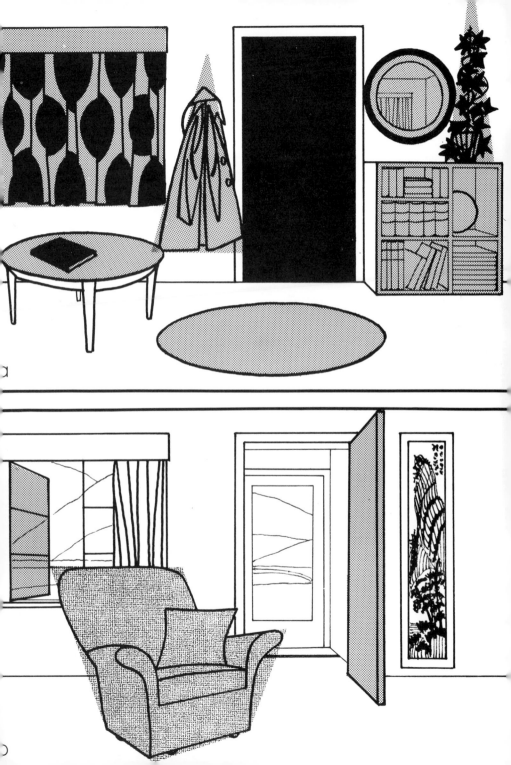

visual language Matisse has been able, therefore, to emblazon his shapes on the flat picture surface as boldly as the heraldic devices on a medieval banner. In his *Pink Nude* the figure, the flowers, and the window are described in front elevation, whilst the couch and the window-sill are shown in plan. By flattening the picture space in this way Matisse has presented the most characteristic view of each object. This allows him to extract the fullest contrast between the feline stretching grace of the figure and the angular, static severity of the couch. He can further enhance their individual shape-personalities by expressive contrasts in tone, colour and texture—the figure is, therefore, painted in a warm, pale, plain colour and the couch painted as its cool, dark, grid-patterned field. Since these forms are represented in the manner in which continents and oceans are displayed on a map we can see them as two-dimensional shapes immediately. But we should also be able to see and experience the special qualities of shape in those paintings in which objects have been expressed as solid forms, and appear to be placed in a three-dimensional spatial relationship to one another.

FORMS INTO SHAPES The means by which we are able to see and appreciate an image in a painting, not only for its illusion of weight and volume but also for its qualities as a flat shape, are those by which we achieved this double reading of the things around us in the perception experiment. That is, by concentrating upon the edges of the forms described in a 'depth composition', and perceiving the areas of paint that lie within them as distinctive shapes of tone, colour, or texture, we are able to appreciate the two-dimensional quality of the most convincingly expressed solid forms of a picture.

The painter sometimes makes this double reading easier by tying down the edges of his forms to the flat picture surface with emphatically drawn contour lines. This quality is particularly prominent in many Expressionist paintings by Munch, Beckmann, Nolde, and Rouault.

Again, just as a massive building may appear as flat as a cardboard screen when seen silhouetted against an evening sky or when exposed so harshly by floodlighting that it resembles a false façade propped up on a film set, so by expressing his 'solid' forms in a uniform light or dark tone the painter can in the same way define these as flat shapes. So the sense of volume created in the foreground battle-debris of Uccello's *Battle of San Romano* is at the same time almost denied by the mask of dark tone that silhouettes these pieces of armour against a light ground. This emphasis on flat tonal pattern enables us

2

151

a

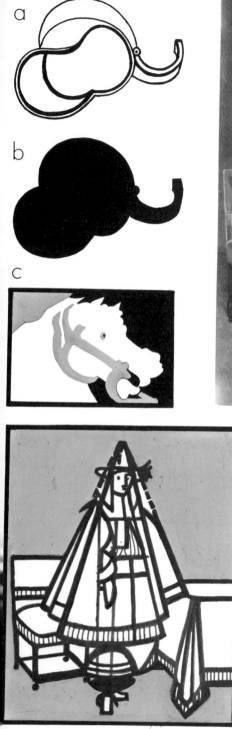

b

c

d

e

f

also to read Uccello's soldiers and horses simultaneously both as solid forms in space and as two-dimensional shapes decorating a flat surface. 6, 8a, b, c

These flattening, superimposed masks of tone will often reveal an underlying flat geometry of pattern in even the most spatially composed painting. A Velazquez and a Manet, for instance, may be seen 8e; 93b, c both as three-dimensional compositions and as carefully considered maps of light and dark shapes, Ter Borch's substantial young man 8d becomes a simple, lozenge-shaped silhouette, and the weighty sculptured forms in the Bruegel can be read as shapes of local tone and 8f colour pressed out into ovals, squares, rhombi, circles, and segments flat as biscuits.

A three-dimensional form can also be read as a flat shape when a sharply defined area of colour is spread across it. By the use of these films of local colour even the solid, substantial images created by such conjurors of spatial illusionism as Mantegna, Raphael, Poussin, Caravaggio, Ingres, and David can be seen as flattened silhouettes also. Therefore as well as appreciating their pictorial forms for their qualities of volume and planar relationships in depth, we should also be able to see them as flat areas of colour which combine to create overall arabesque patterns—as in the El Greco and the Poussin, for 110b, c example.

COLLECTIVE AND
CONTRAPUNTAL
SHAPES The flat area of local tone or of local colour which enables us to read a three-dimensional representation of a pictorial image as a two-dimensional shape will often be extended across the picture surface to embrace or mass together many individual forms and so create a collective shape-pattern. In real life we see these massed shapes whenever various objects share a common tone, colour, or texture— a clump of trees gathered within a single dark silhouette, a squad of soldiers seen as a single line of khaki, the things observed normally as separate forms being combined into a broad expanse of texture when snow-flakes begin to spot them uniformly.

When Manet in his *Olympia* and Botticelli in his *Mars and Venus* 93b, c; 258 flattened their pictorial forms into light and dark silhouettes, they also fused them into tonal masses spread in bold patterns from edge to edge of the picture surface with the dramatic economy of a Japanese print or a Toulouse-Lautrec poster.

Other painters unify a variety of diverse forms within a common colour. In this way Gauguin in many of his Tahitian landscapes and figure groups massed independent forms into broad units of a decorative colour pattern. And in Poussin's *Bacchanalian Revel* uniform local 96

9

flesh-colour enables us to see an intricate frieze of dancing figures as a broad, undulating shape carried across the picture surface.

The transitory effects of shadow and sunlight also provide the painter with a vocabulary of shape groups. In the Daumier, for 62 example, since the boundaries of forms are dissolved in light and all detailed features obscured in shadow, the lunatic energy of Don Quixote, the monumental despair of Sancho Panza, and the mocking bleakness of the rocky plain have been expressed mainly by means of massed shapes of light and dark. Light and shadow masses are also the units of the chiaroscuro patterns of Rembrandt and Caravaggio. It is important that we should be aware of the function of these tonal areas as *shapes* since, as we shall see in a later chapter, many painters superimpose them across the forms in their compositions to create a dynamic contrapuntal pattern against a linear design.

SHAPES
WITHIN
SHAPES

Even the smallest parts of things in nature seem to possess shape characteristics similar to those of their parent forms: the lobe-edged leaves of an oak tree echo the linear rhythms of its twisting branches, the floppy leaves of the soft chrysanthemum curl like its petals, and the barbed leaves and pointed petals of a rose could belong only to its thorny stem, as cones belong to the shape of a fir, and fins and scales belong to the elliptical form of a fish. In a great painting the components of every shape—the shapes within shapes, as it were—will be seen to have this same organic harmony: the limbs growing naturally from the torso of Matisse's *Pink Nude*, the cusp-shaped coat which 2 seems almost to grow from the outstretched body of the Bruegel 17 glutton, as inevitably as the splayed wings and tail of a plump pigeon and the interlocked triangles which bring a family likeness to every item of the dress worn by Ter Borch's *Young Man*. 8

Less easily perceived but equally important shapes within shapes are those which are spread throughout the picture surface but not as the parts of one separate and complete form. Some paintings, for example, seem to invite us to discover the innumerable shape permutations which the artist has developed with lines that run like rhythmic veins across all the forms in his design. This linear network creates a complex cellular tissue of small shapes developed across the picture surface. The principle of its optical behaviour is similar to that of the familiar puzzle drawing which teases us into counting the number of shapes of a particular kind that we can find inside it. If we stare at the simple puzzle drawn here for the short time it would take us to unravel 13a its many small squares, triangles and lozenges and all the larger units that the sum of two or more of the single shapes will make, we should

INGRES: *Madame Moitessier Seated* (1856). National Gallery, London

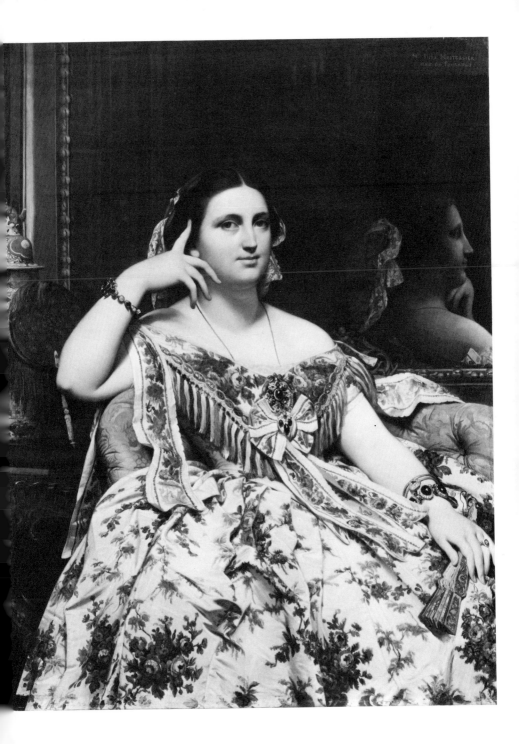

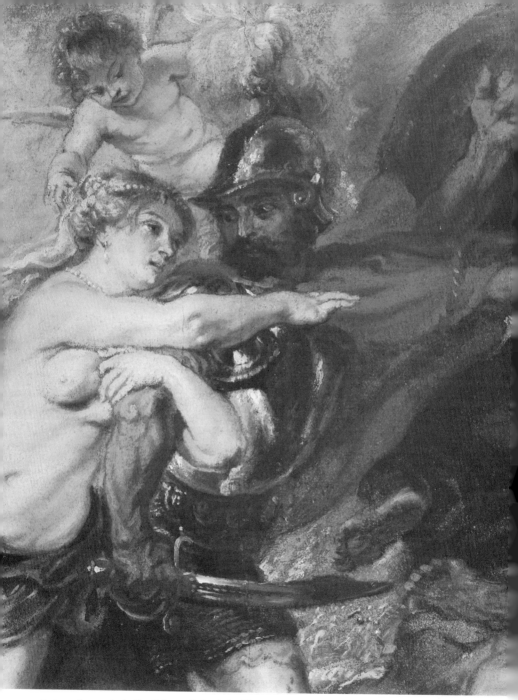

RUBENS (1577–1640): Detail from oil sketch for *The Horrors of War*. National Gallery, London

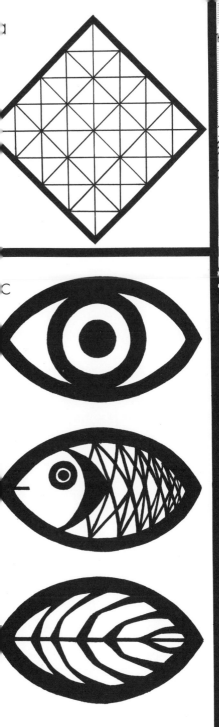

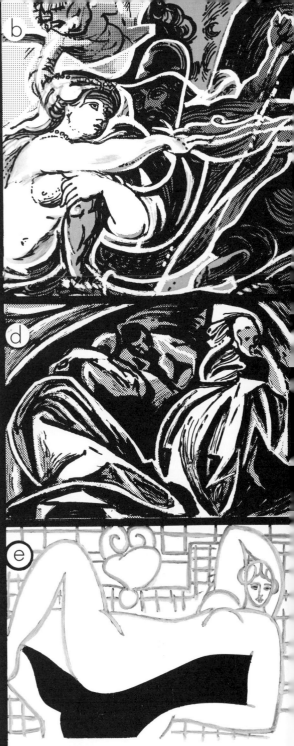

find that our perception has been sufficiently sharpened by this visual exercise in shape-building for us to be able to see the more complex but fascinating sequences of shapes which grow, one from the other, in sections of the El Greco and the Rubens. These interwoven shape patterns may be tracked more easily if the details reproduced from these two paintings are held upside-down so that the reader is not distracted by any pictorial narrative interest.

These multiplying shapes are formed by lines *implied* by the edges of tonal, colour, and textural areas as well as by lines drawn in paint by the artist as visible threads through the picture surface. The discovery of these extra shape relationships makes us aware not only of the organic unity of a pattern to which the smallest sections of a painting should contribute, but also of the intriguing pictures within pictures which these design components create among themselves. The glacial drapery folds in the El Greco detail, for example, are so tightly co-ordinated as interrelated units that when they are scrutinized in close-up they surrender their identity as mere factual representations of drapery folds and exude such a sense of monumentality that they could as well be read as the ridges and ravines of a vast Arctic landscape.

NEGATIVE SHAPES Among those that are drawn into these tapestries of interwoven shapes are the empty spaces or intervals between the edges of pictorial forms. These are referred to as *negative* shapes, since they are the areas that separate one positive image from another on the picture surface.

In ordinary life we see the shapes of things but do not notice the gaps and intervals *between* things as definite shapes at all. But in painting the shapes of these empty spaces are as important to the composition as the shapes of positive images. Far from being regarded by the artist as areas of neutral territory, or arbitrary left-over gaps in the pattern, as it were a pictorial no-man's-land, these negative shapes are used as vital components in the overall design and within each section of the picture they are used to enhance the action and character of the very images whose contours have defined them.

That a negative shape can exist as an expressive area in its own right may be appreciated if we look at the couch area at the base of the Matisse painting. By itself it is a stirring, exuberant shape, its steeply rising contours and descending concave curves making a satisfying contrast to the horizontal edge of the picture frame. By its organic vitality it cradles and elevates the massive figure that rests upon it. The importance of this negative area to the dominating presence of the figure is apparent as soon as we mask it with our hand—when the figure's buoyant vitality is immediately deflated. The contribution

made by negative shapes to the expressive action of the main forms in the Daumier and the Botticelli compositions becomes as obvious 62; 258 the moment that these spaces, too, are concealed.

THE EXPRESSIVE CHARACTER OF SHAPE I have said that it is necessary for us to be able to read all the shapes in a painting by whatever means the artist has defined them since they form an essential part of the language by which the painter communicates his ideas. Shapes and all the other component elements of painting (line, tone, colour, texture, and solid form) have their own expressive meaning and emotional character. These qualities of shape are as important as their representational and symbolic significance to our appreciation of a great painting.

This does not mean that we should withhold our admiration for a painter's skilful description of a particular object's unique character, nor should we deny the fascination of some pictures as contemporary, social, and topographical records. We can also admit and enjoy the romantic and historical associations which may accompany our meeting with the commoners, kings, and concubines of past periods through the medium of portraiture. These are among the extraneous pleasures of aesthetic appreciation and require no special visual training to enjoy.

We might feel, however, that the *meaning* of the shapes in some pictures from alien cultures or distant periods of time have esoteric interest only, obscure to all but the scholar or the art historian. For although the use of symbolic imagery has played an extensive role throughout history, the range of most symbolic systems is limited and few pictorial symbols are intuitively and universally understood. The crescent moon used to represent Night, the sun-burst image for Day and the skull sign for Death are perhaps among the few pictorial symbols which are common to the vocabularies of many traditions of representational painting. Most people also understand, and often make use of, the elementary linear sign-language by which familiar objects have always been identified: two eye-dots, a nose-dash, and a mouth-line enclosed by a rough circle as an acceptable statement of xiv a face; the instant transformation of an ellipse by the rearrangement of the marks inside it from the recognizable image of an eye into a convincing pictograph of a fish or a leaf; the shortened notation of 13c skeletal pin-men which enables everyone to chart and explain a variety of human movements on paper.

But the fact that in many paintings in the past some representational images had, in addition, specific religious, philosophical, mythological, social, political, literary, anecdotal, or satirical meaning and

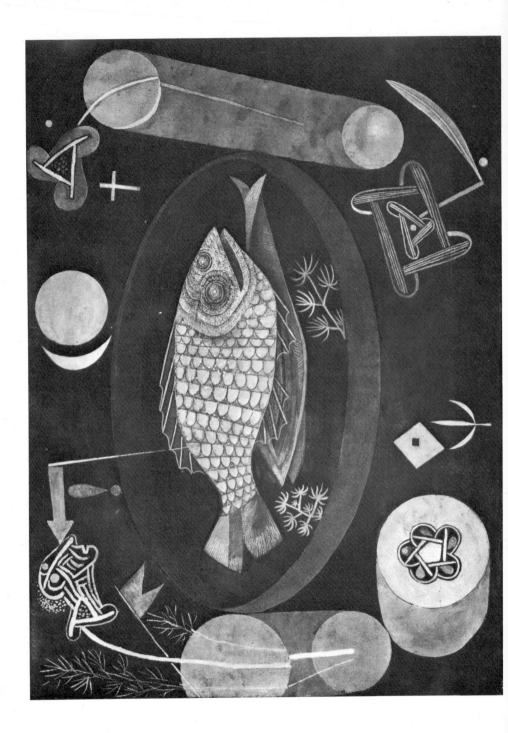

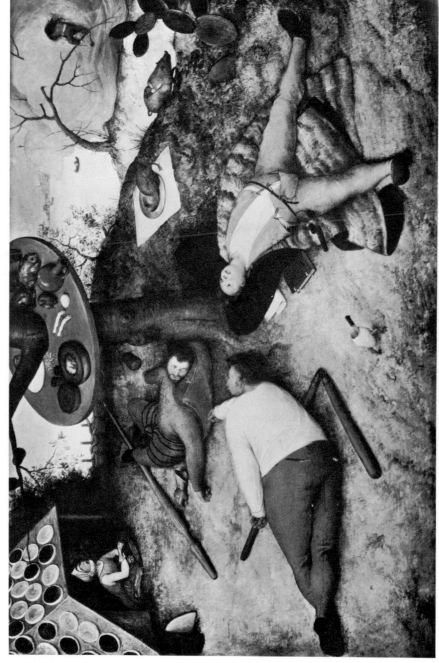

KLEE: *Around the Fish* (1926). The Museum of Modern Art, New York (Abby Aldrich Rockefeller Fund); © SPADEM, Paris

below

BRUEGEL: *Land of Cockaigne* (1567). Alte Pinakothek, Munich

that the connotations and symbolic significance of many of these will be understood only by the initiated does not make it impossible for us to appreciate splendid works of pictorial art in which this symbolism may now be silent. Our capacity to appreciate an Indian miniature or a Chinese scroll painting, for example, does not depend upon a knowledge of Hindu love-imagery, or Zen Buddhist philosophy, any more than the enjoyment and aesthetic understanding of a Renaissance painting depends on a scholar's knowledge of its pictorial symbols, whether Christian or pagan, allegorical or political.

Some painters may seem even to confuse us with a private and personal symbology. For instance, it is easy to identify, among the incongruous company that swims as a shoal of shapes 'around the fish' in the Klee painting, a sun and a moon, a flag, an exclamation mark, a cross, an arrow, some weed and mistletoe, and two drinking straws seen refracted in their glasses. Into their bizarre relationships the viewer may, if he so wishes, see a visual conundrum and may read into it any message or poetic imagery that he chooses, since Klee himself offered no decoded interpretation to accompany his picture.

Of course the total experience afforded us by a great painting may be enhanced by a knowledge of the symbolic systems used in some cultures and by some individual painters. Fortunately, however, we do not need to familiarize ourselves with the time symbolism of scythes and hour-glasses, with the floral sign-poetry of roses and lotus blossoms, lilies and plantain leaves, nor with the extensive mythological menagerie of monkeys, bulls, dragons, bees, fishes, doves, serpents, cockerels, or winged horses in order to understand and experience the expressive vocabulary of a language of shape.

Since we can enjoy looking at a starred night sky without the need for astrological or astronomical scholarship, so by using our sensory rather than our intellectual perception of shape we can appreciate any great painting without recourse to a dictionary of symbolic codes. Iconographical knowledge may enrich our experience of certain paintings, but unless we also have the power to see and respond to the *expressive* character of shapes this information is an isolated feature of intellectual curiosity only. For the shapes in a painting should be read as independent entities. We can enjoy them in themselves as shapes with an expressive character of their own. Knowledge of symbolism can be obtained from books and book-learning; the appreciation of expressive shape is a skill which must be cultivated.

THE EMOTIONAL CHARACTER OF SHAPES We often speak of the 'emotional characters' of familiar things. By this we mean the mood that their shape seems to express. Just as one

piece of music seems sad and another gay, so we see one building as depressing and another as majestic, one tree as drooping and another as agitated, one person as dejected in pose and another as energetic and self-assured. When we react in this way to the things we see in the outside world we are judging the character of shapes by the visual standards which psychologists refer to as the physiognomic qualities of things. Whilst we recognize these expressive changes of shape in everyday life we may have to train ourselves to be alert to them in painting where they constitute a very important aspect of the formal elements of pictorial communication.

Whenever we have time to watch the tidal movement of breaking and withdrawing waves, the slow disintegration and re-formation of clouds, the swell and sway of sails and foliage, we are as soothed and reassured by their rhythmic certainty as we may be apprehensive of the sudden frantic dispersal of a calm smoke column, of an agitated tree, a wildly leaping flame, or a hugely gathering wave. These different emotive movements and formations, like the vacuum shapes described in air by the chopping, embracing, waving, and caressing gestures of a demonstrative speaker, create images of particular character and mood which we all intuitively understand.

After all, most of us at times instinctively draw or 'doodle' rhythmic lines on some available surface as an unconscious aid to concentration or because in idle moments it gives us pleasure. We may even scribble fiercely in an almost therapeutic release of tension in times of stress. The examples shown here are typical of the two types of mood 20a, b drawings most frequently discovered decorating blotting pads, newspapers, directory covers and agenda sheets. If the areas made by the lines in these particular examples were to be filled in with different textures two sets of expressive shapes of contrasting character and mood would be defined. The first set seem calm, pacific, assured, 20c sensuously relaxed, and even optimistic in relation to the aggressive, thrusting, urgent, anxious, and even agonized character of the spiky 20d shapes of those below.

The painter exploits such emotional qualities of shapes by giving his pictorial images a particular character which suits his overall purpose, whatever may be the accepted form of the objects he has represented. So the figures and landscape features in the El Greco, and the 23 Giovanni di Paolo are interpreted, through shapes which by their 22 pointed, sharp and jagged edges suggest anguish, danger, and antagonism—by association perhaps with fire, splinters, thorns, twisted metal, cracked ice, or drought fissures. By contrast those in the Botticelli and the Bruegel are flowing, full, and expansive shapes, 258; 17

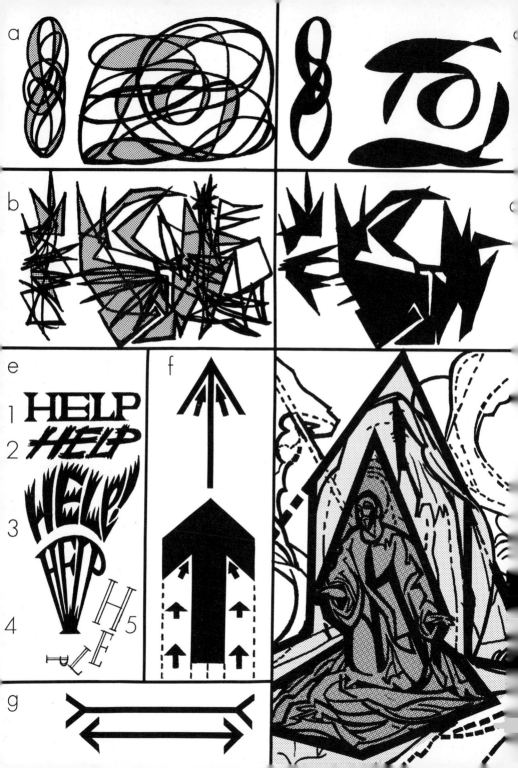

having characteristics that could as well express the mood of an opulent still life or of a peaceful and luxuriant harvest landscape.

As an example of the great visual force and direct impact of shape in the expression of a mood we see also in the Bruegel that the delicious 17 yawn in paint that is his subject is communicated primarily through his use of swollen, cusp-shaped figures that, spread like plumped-up pillows round the 'spindle' tree-trunk, seem to spin lazily on the tipsy turntable of the curving mound in surfeited surrender to a drifting afternoon. It is only later that we find that Bruegel has thrust home his pictorial sermon on gluttony and indolence by having his sleepers stretch in such blissful neglect across the symbols of their trades: the scholar on his book and papers, the peasant on his flail, the soldier on his lance. Just as the characters and emotional associations of familiar things may seem to change with a change in their shape—the bleakness of a skeletal chestnut in winter and the confidence and vigour evoked by its filled-out form in summer—so the same things represented by any two painters may, through the different characters of their shapes, assume a very different emotional meaning. The drapery in the Botticelli, for instance, falls in graceful corrugations like the 35 ripples on a brook but in the El Greco these creases resemble the 23 splinters of shattered glass.

The expressive force of shape is often especially prominent in commercial design and graphic illustration. For example, according to the shape character given to the letters making up the word 'help' we can read the message (1) as a confident offer of comfort and 20e assurance, or (2) as a sudden shout for aid and rescue, or (3) as a lighthearted screech of protest, or (4) as a despairing yell, or (5) even as a dying cry.

There is evidence that there is a good deal of unanimity in our apprehension of the expressive character of shapes. Reproduced together here are details from pictures by a twentieth-century American 23 top (Lichtenstein), a sixteenth-century Italian (Giovanni di Paolo), and 22 a seventeenth-century Greek working in Spain (El Greco). The 23 below subject-matter of these pictures is very different. Nevertheless any experienced observer will recognize the common expressive character of these jagged and explosive shapes. The radiating starburst shapes are animated not only by their primeval association with the dynamic, physical action of growth (like the striving tributaries of roots and branching nerves) and of released energy (like forked lightning, splashes, spreading stains, and cracks), but seem to share an almost onomatopoeic quality. In the Lichtenstein, for example, the word 'WHAAM!' not only expresses its meaning by its sound as

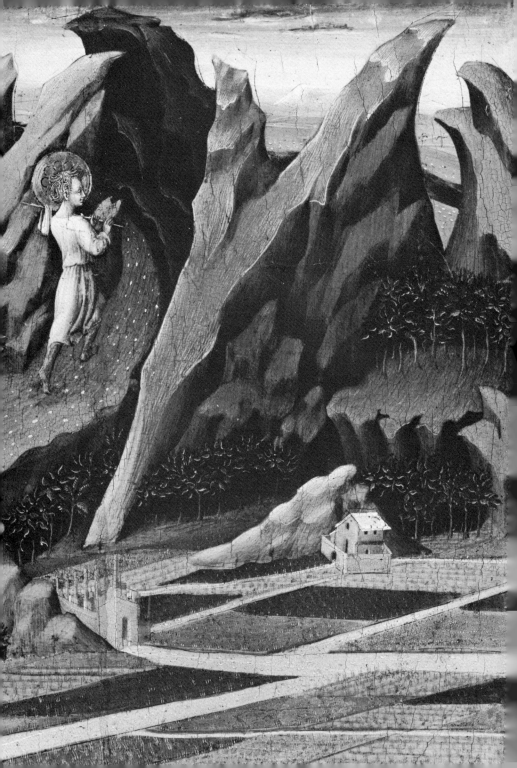

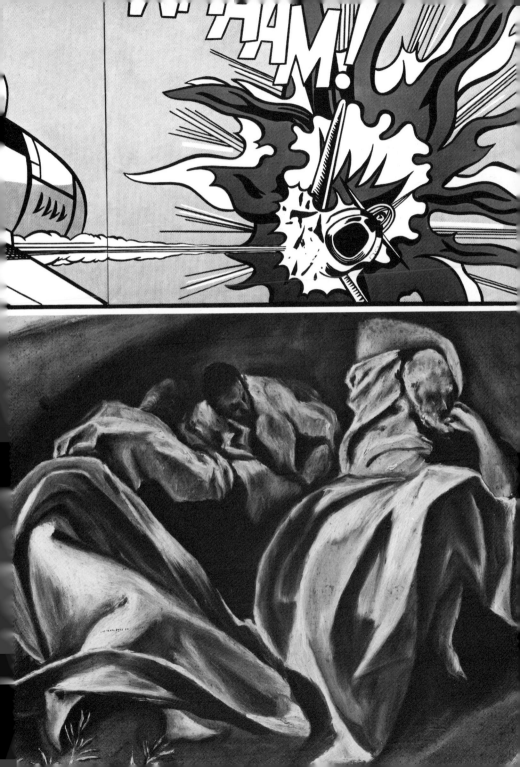

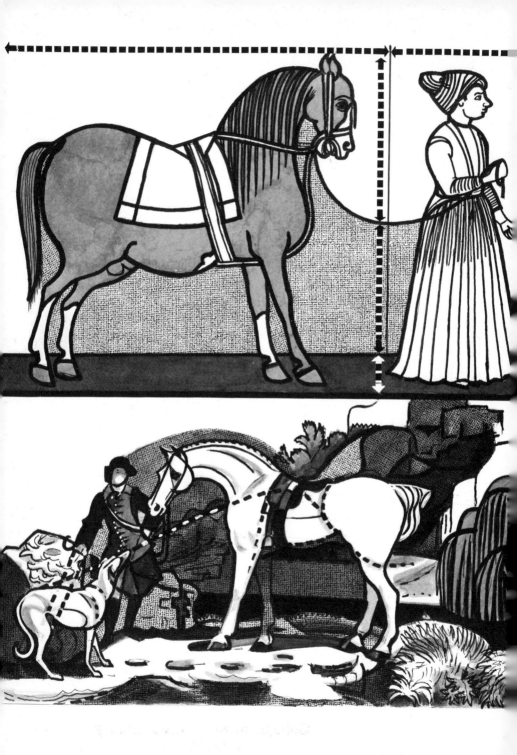

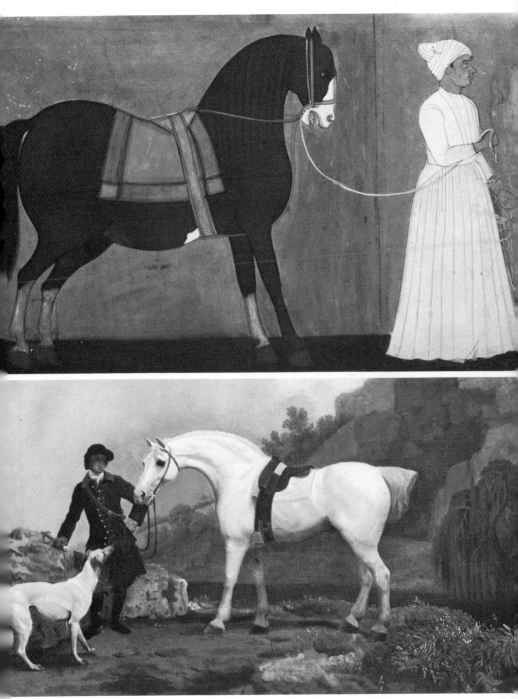

College of St. Francis Library
Joliet, Illinois

a spoken word but the jostling order and metallic character of its five block-capital letters and its exclamation mark suggest that 'whaam' is the sound these shapes would whine if they really were expelled into space.

In the sucked clouds and dart-shaped waves in the Turners there is a 217 visual interpretation of the indrawn hiss and cataclysmic roar of a storm at sea, whilst in the gently running sequence of undulating shapes of Botticelli's sleeping Mars there is echoed the rhythmic 36 murmur of slow breathing. There is a remarkable contemporary use of these sounding shapes in Arthur Dove's *Fog Horns*, where smoky images seem to throb like muffled siren hoots across a river. In the repetitions and contrasts of Klee's and Kandinsky's shape sequences 16; 5 there are uncanny analogies with the vibrating sounds of strings, woodwind, and tympani. Our sensibility to these physiognomic qualities of visual form is a faculty to be cultivated by experience and practice.

Our ability to read and to respond to shapes is an essential condition of the capacity to appreciate visual art as a full, living language. For the vocabulary of shape is universal to painting, transcending all differences of style, technique, and subject-matter.

It may take time for some of us to be able to appreciate new move-ments and unfamiliar periods in painting because, often unconsciously, everyone acquires aesthetic prejudices in some degree. But we should find that with experience and confidence we are able to enjoy and understand a Persian painting in terms of a Matisse, for instance, a 205; Mondrian in relation to a Poussin, and to respond to the expressive 271; language of shape used both by El Greco and Gottlieb, by Bruegel and 23; 1 Klee, by Uccello and Kandinsky, or by Bonington and Alfred Wallis. 16; 6 We should be able to see a pattern of light and dark shapes clearly 171; in the George Stubbs painting of a horse and groom as well as in the 25 version by an eighteenth-century Indian artist, with which it is re- 24 produced here, to see the qualities in each of exquisite proportions, echoed textures, rhythmically binding contours, and an exciting variety of positive and negative masses.

The geometrical basis of shapes provides painters with an elemen-tary vocabulary of shape meanings with which to express actions, ideas, and emotions. Some people have a sufficiently developed gift of empathy to be able to identify their personality with the moods and movements of the shapes they contemplate—they can feel that they are growing with a tree, soaring with a bird, swimming with a stream (a state of mind and spirit which Chinese painters were instructed to attain)—and such people will probably respond intuitively to the

messages inherent in the basic shapes of a picture. Since the painter, consciously or instinctively, makes use of these basic shapes it is our capacity to respond to them that will enable us to experience the movement, structure, and mood of the picture at a deeper and more enduring level than is provided by an understanding only of his narrative symbolism or an admiration for his technical skill.

Our response to these fundamental shapes will probably be conditioned by all manner of primordial and compulsive optical reasons. The arrow-shape, probably the oldest directional sign, is an obvious example—for, apart from its association with the movement of birds and fish, and with the irrevocable flight of a primitive weapon towards a target, it also compels us to look in a particular direction by the magnetic attraction produced by the intersections of the arrow-head 20f with its shaft. The arrow also has obvious directional functions in the overall patterns of the Klee and the Kandinsky. Less obvious is its 16; 54 presence as the basis of the silhouette shape of El Greco's Christ, 20h where it expresses the figure's spirit of aspiration—an optical movement echoed by the triangular rock behind.

Thus we find that the closer a pictorial image is to a symmetrical geometrical figure, the more permanent, self-contained, and dominant it will seem—whether the painted shape represents a tree, a building, a warrior, or a loaf of bread. Shapes based on the square seem to express impregnability, those based on the circle will arrest the eye and usually suggest suspension and perpetual motion, those on the triangle suggest strength and aspiration, on the inverted triangle tenseness and delicate, uneasy balance, and on the oval security, peace, and reassurance.

If we can read this basic vocabulary, we should be able to experience the feeling of sublime exhaustion and calm expressed by the shapes of the Bruegel sleepers, the expanding grace of Matisse's nude, which 17; 2 stretches like an espaliered vine across a trellised wall and in the Kandinsky the exciting tensions of attraction between the curved 54 'amoeba', bent arrow, and cuspidate 'snake' and the forces of repulsion between these and the angular grille and comb structures. 49d

In this way we are able to appreciate the full orchestration of shapes in a great painting—a fascinating principle of pictorial design which we shall examine in a later chapter.

Line

'There are no lines in Nature.' (Goya)

The use of line as a means of defining shapes is a natural convention. Children's drawings, prehistoric magic signs, and modern city-wall xiv *graffiti* suggest that it is a primeval instinct to make shapes by drawing in paint and chalk and by engraving and scratching outlines on any available surface. As a direct, economical, and spontaneous technique this convention is sometimes also used by painters. The painter's brush line is an abstraction from nature since no visible bands outline the shape of things in the outside world.

We do, however, see linear textures. Brick-bonding is a surface pattern in lines, for instance, as are the narrow gaps between paving-stones, the channels in the bark of a tree, the cracks in dried mud, the thin light and dark streaks of water ripples, and the creases and folds of fabrics. We also see linear patterns composed of units that, strictly, are lean shapes—twigs, stems, poles, posts, struts, wires, scaffolding, cobwebs, and so on. These patterns are transcribed by many painters into a textural shorthand with which ten thousand human hairs, or a million blades of grass are represented by a few symbolic brush marks.

In some styles of painting these linear conventions are used with such expressive economy that line becomes the primary means of communicating ideas.

CALLIGRAPHY An obvious example of the communication of ideas in line is, of course, by handwritten messages. But the passage of Arabic script and the 29 t ornamental English copperplate, with its flamboyant flourishes and 31 k extravagant curls, reproduced here, were also intended to appeal to us as vibrant decorations. The emotive, descriptive, and sensuous possibilities of such calligraphic lines have been explored as much in great paintings as in drawings.

Chinese and Japanese artists, for instance, used a language of line 208 in their ink-paintings closely related to their art of handwriting. bot The calligraphic technique with which they created the form of their word-characters also provided the skill and discipline on which they based a vocabulary of brush-stroke lines capable not only of describing the texture, movement, and volume of a thing but also of expressing its character and mood, its spatial position in the implied depth of the picture and even the atmospheric conditions surrounding it. The

28

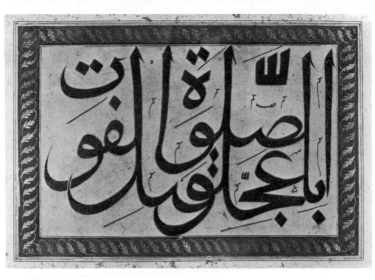

Arabic script in Tughra
style (18th century).
Victoria and Albert
Museum, London:
Crown Copyright

below

NAGANOBU (1775–1829):
Owl in the Moonlight.
Victoria and Albert
Museum, London: Crown
Copyright.

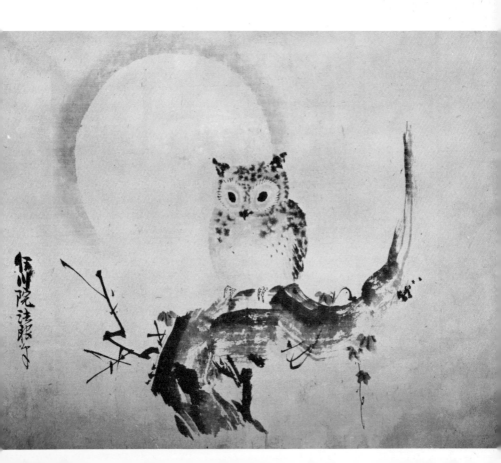

technique and appearance of these brush-drawings were indeed so close to those of their calligraphic scripts that written characters could be incorporated into the overall pattern as easily and naturally as if these were pictorial representations of flying birds or swaying reeds rather than words. It is interesting to compare the artist's seal and the vertical columns of complementary passages of prose and poetry in Chinese painting with the textural patterns of script forms 2 used as design units in the panel at the top of the Persian and Indian 2 miniatures and with the strip-cartoon convention of a 'speech balloon' in the Lichtenstein. 2

The young Chinese painters learned their linear vocabulary by a disciplined spiritual and manual training in interpretation and movement as exacting as the traditional exercises practised by ballet-dancers at the studio *barre*. As Western children have been taught the skill of copperplate penmanship from copy books, so the Oriental student might also be instructed from a book of examples and methods like the standard Chinese seventeenth-century work, *The Mustard-Seed Garden Manual of Painting*. In fact, since such choreographies of brush movement applied equally to the execution of their painting and their calligraphy, the technique employed the same expressive manual pressures used in forming letters by all pen-and-ink manuscript 31 craftsmen. That is, by pressing on the 'stomach' or fat centre of his ri 31 brush hairs, the Japanese and the Chinese artist makes his thick 'flesh' strokes in the same way that the spreading points of a split quill or a pen-knib produce a broad line with the downward stroke of a letter- 31 shaping sequence. But by drawing from the pointed tip of his brush the painter produces an incisive and delicate line (the 'bone') as the upward lifting movement of a pen-nib will also leave a thinner line.

But between manuscript writing and calligraphic painting there is an important difference. For although the form of many Oriental characters seems to express the spirit of the word symbolized, the visual character of linear symbols used in other scripts is not relevant to the meaning the words express. There is, for example, no expressive difference between the visual character of the lines which define the letters of the word 'war' and those making the word 'peace'—as there is no change made in the linear character of 'thunder' to distinguish it from the different message of 'sunshine'. But the character of a calligraphic line in painting is always relevant to the character of the thing it defines. Wide strokes generally express weight, softness, or slackness—thin lines seem to express lighter, harder surfaces and qualities of tautness and tension. The subtleties of linear expressiveness are well nigh infinite.

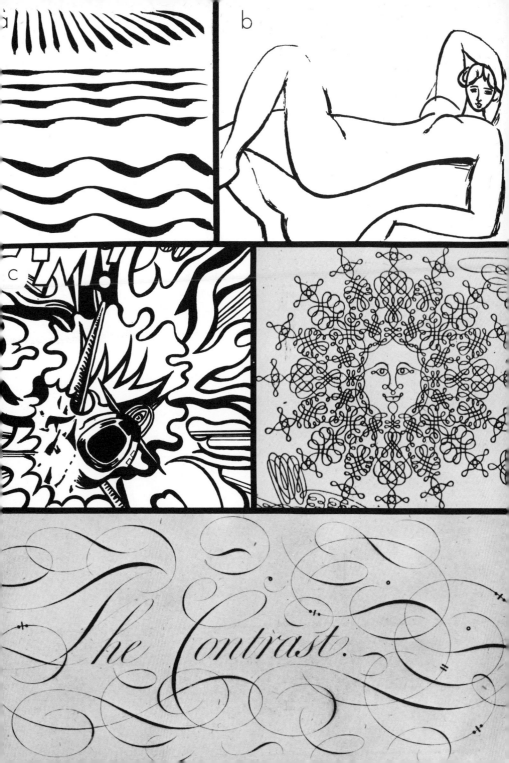

These expressive calligraphic variations are found in some Western pictures as well as in much of Eastern painting. Picasso, for instance, 71 broadens the outline of a woman's arm in order to describe its relaxed weight. In the Matisse the contours not only contribute to a vibrant 2 decorative pattern but can be seen to have been so sensitively and sensuously drawn that even without their supporting, or contributory, features of tone and colour they are able on their own to express the surface changes of the figure. The organic force of calligraphic lines is also a quality of the Lichtenstein, where it may be seen that even if the 31 tones and textures are extracted from this detail, the vibrating lines will continue to flash their message of impact and explosion.

The optical sensation of advance and retreat, of weight and weightlessness, and of flight and fall that variations in the width of a line can induce is demonstrated dramatically in Bridget Riley's *Fall*, where 33 an overall texture of thick/thin black lines undulating in gradually changing sequences creates the remarkable kinetic illusion of a shimmering, corrugated surface collapsing and recovering in endless, wave-breaking rhythms.

LINE AND VOLUME In the Bridget Riley an entire picture area appears to be moving as we look at it. But the interpretation of volume and movement by means of expressive linear textures is generally restricted to particular areas of a picture. We can see that if lines are drawn across a flat shape in a pattern of curves the area appears to have been transformed into an undulating surface. In representational painting the curved lines of drapery folds, tresses of hair, looped jewellery, decorative fabrics and so on are therefore often used to describe rounded surfaces—in the Picasso and the Botticelli, for instance. Another illustration shows 71 one of the ways in which an arrangement of straight lines will produce 34 an effect of angular projections and receding planes. Linear textures of this kind have often been used to describe the three-dimensional character of architectural and landscape settings—particularly in European and Eastern manuscript painting, and in the work of naïve painters, though this technique also appears in the Giovanni di 22 Paolo, where white lines give a razor sharpness to rocks and emphasize the cubic form of a building, and in the Van Gogh, where a bird's-eye 38 view of the rushed seat and the patterns of the tiled floor cause these horizontal planes to tilt dramatically towards the viewer.

Lines that are drawn across a shape in these ways serve the same sort of purpose as the cross-sections indicated on their working drawings by carpenters, industrial designers, and sculptors. They enable us to read the most subtle of surface changes by the manner in

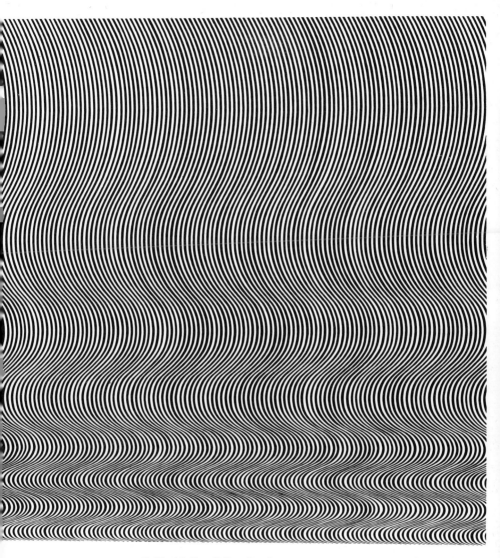

RILEY: *Fall* (1963). Tate Gallery, London

3e 35

TTICELLI (*c.* 1445–
o): Detail from *Mars*
Venus. National
llery, London

which they are made to turn, twist, rise, and fall. In fact, we make cross-sections whenever we tie a parcel with string, for the loops and intersections will then accurately describe the three-dimensional character of the wrapped object. The harness which binds the horse's head in the Uccello performs this function also, since these bands are 6, 8c drawn so as to appear to turn *behind* the visible surface thus allowing

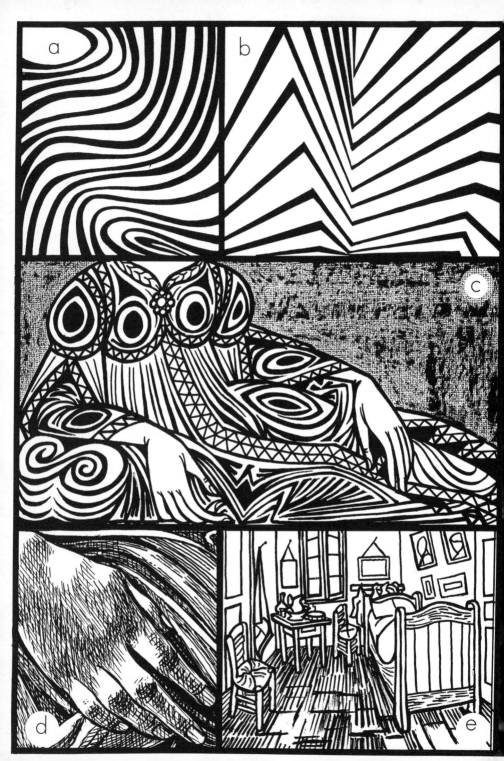

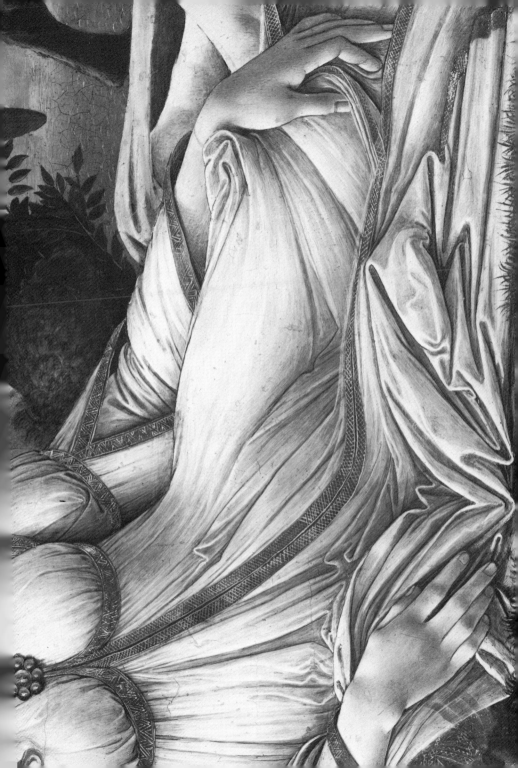

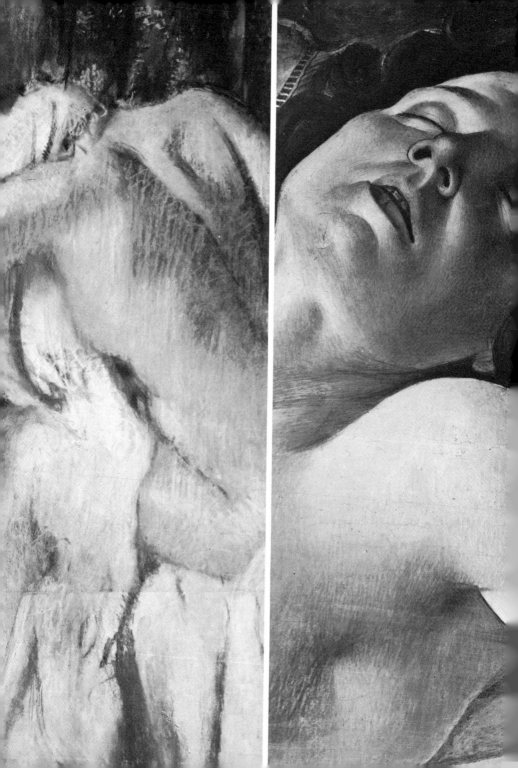

the viewer to experience the white silhouette both as a unit in a flat pattern of shapes and as the representation of a solid object in space.

Traditionally in Persian, Indian, and Byzantine-Gothic painting the faces of men and women were usually portrayed only with the impassive features of masks. Therefore the artist, like a puppet-master, had to interpret their roles in the narrative action of his picture by the outlines of their stylized and exaggerated gestures and through the expressive movements of their flowing draperies. In medieval and Eastern manuscript painting the architectural and landscape features of the background were usually depicted as linear patterns resembling the cardboard settings of a toy theatre. In these intimate pictorial melodramas the figures posture and gesticulate in silhouettes as fiercely expressive as the movements of miming actors. The character and the rhythmic contours of these painted silhouettes are echoed in the lines of the creases, folds, and textile patterns of their costumes. By their character and direction these embracing lines give substance to the figures around which they appear to be wrapped. In many Gothic paintings the drapery lines are arranged in more complex patterns to express subtle changes of form by a system of inset linear shapes—like the technique used to indicate altitude levels on a contour map. At the same time they create textures like watered silk or wood graining. In order to explain this technique I have shown how a 34c painter using this linear code might have rendered the surfaces of the Botticelli draperies.

The development of oil glazing enabled later painters to express volume with imperceptibly graduated shadows of almost photo-graphic realism in the Ingres portrait, for example. But those working 11, 215 in a dry medium such as pastel or a quick-drying paint like tempera often used a technique of *linear* shading and modelled their shapes into an illusion of relief by means of multiple parallel and cross-hatched lines which produced tonal areas like those made in etchings or in some pen and ink drawings. This method is used in the Botticelli 34d, 36 and the Giovanni di Paolo although in reproduction *modelling* lines 22 may be more clearly seen in the coarser, gritty strokes of the Degas 36 pastel.

Lines can also create an illusion of spatial depth in a painting. A familiar device for suggesting distances is the use of aerial perspective. This method is based on the observation that in nature intervening layers of atmosphere lower the intensity of distant areas of colour. In order, therefore, to suggest the depth of a room or the recession of hills and valleys without thus sacrificing the purity of their colours by using aerial perspective, painters like Gauguin, Van Gogh, Munch,

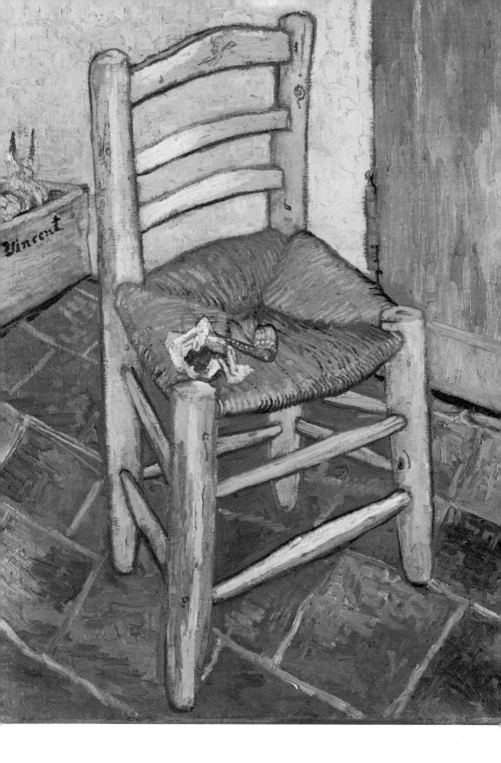

Matisse, and Bonnard made use of the linear perspective with which 260
the Renaissance artists had been preoccupied. That is, by accentuating
the converging lines of walls, floors, roads, fields, and furrows, they
made it possible for us to read the areas in their pictures both as glowing
shapes in a mosaic of brilliant colours, and as planes that at the same
time appear to retreat away from us. The diagram shows the lines with 34e
which Van Gogh represents the cubic space of his *Bedroom at Arles*
and the structure of the furniture within it.

Although the lines in a Cézanne may seem to stammer uncertainly,
they are in fact as precise and considered as other kinds of brush-stroke
in his paintings. But, like his tone and colour statements, his lines have
many purposes. In a diagram based on the section of his composition 41a
reproduced on the page facing it I have attempted to demonstrate 40
something of the range and complexity of his linear vocabulary. This
diagram shows those lines which are used to mark the point of contact
between one surface and another (A), and those that indicate a planar
change within a form (B), the multiple vibrating contours expressing
the movement in space of a rounded surface (C), and the linear accents
establishing important spatial positions of forms (D). Each of these
is so placed on the picture surface that it may be carried through the
composition to create an overall scaffolding of design; these paths I
have indicated by broken lines in the diagram.

The Analytical Cubists developed Cézanne's research into form and
structure with the obsessive fervour of pioneer anatomists. A linear
analysis of a section from one of Braque's Cubist paintings shows the 43
kind of scalpel-incisive lines with which he defined the edges and
insertion points of his interleaved, reshuffled surfaces and with which
he summarily identified a fish-head here and a bottle there. We find
that our eye has only to fall on any one of these lines to be carried ir-
resistibly from plane to plane across the picture area. The diagram
also emphasizes some of the tonal contrasts which Braque brought up
to each side of these linear incisions in order to project the planar
edges towards the viewer. From the reproduction of the whole
painting it can be seen that these lines become fainter as they move
towards the picture-frame, thus throwing the central planes into
sharper focus. This device resembles the tradition of relief-carving
of medallions, coins, plaques, and panels where the shallow back-
ground would be lightly engraved in contrast to the higher relief of
foreground forms—rather as a receding tide leaves an anchored
boat high and dry on a shingly beach or as the form of a trapped
vehicle's wheels re-emerges as the embracing snow or mud is cut
back to road level. Duchamp used this Cubist linear technique to 233

39

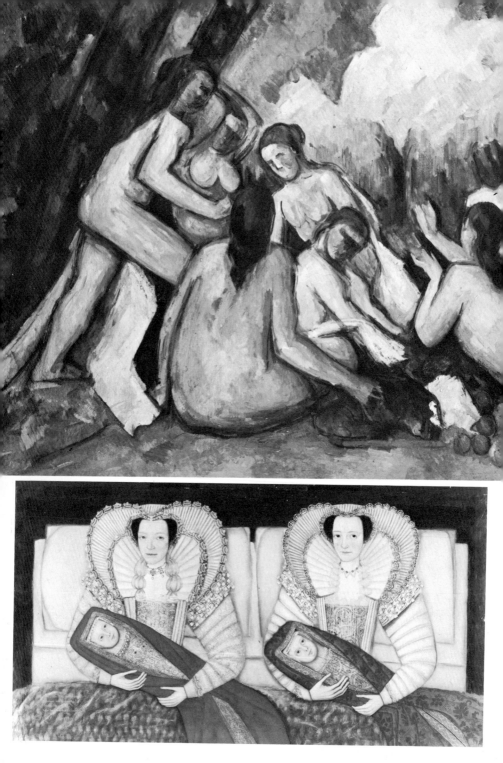

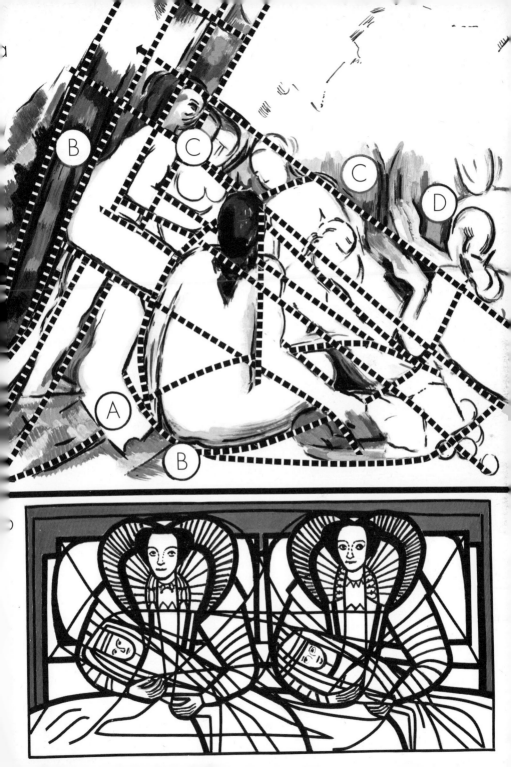

explain the rhythmically articulated mechanism of a figure descending a staircase, his knife-edge lines creating thin planes like armour-plating or falling leaves of paper.

The lines which provide a scaffolding for Braque's still-life structure 43 are threaded *beneath* many of the planes crossing their paths, to re-appear further along the picture surface like roads emerging from under a bridge or tree branches driving through foliage. In much the same way a taut cat's-cradle network of lines knits together the repeated images of the Elizabethan double portrait into a unified 40 pattern. 41

Although this fascinating skill may not be demonstrated in every great work so clearly as in this example, it is an element of design we can find in all styles of painting.

For example, if we follow the black contours with which Matisse 31 created his monumental nude, we find that they serve as routes across the picture surface, like the sinews or the nerve communication system drawn on a medical chart. If we follow the fat cable outlines which define Léger's robot women, we find that they act as winding 13 counterpoint rhythms to the geometrical patterns of transparent colour rectangles. And as I have described in the previous chapter, there is in the Rubens detail a rhythmic system of brush-drawn lines 12 and silhouette edges which evolves exuberantly to contain a rich patchwork of various shapes and textures by encircling and lassooing them in a perpetual hoop-la.

The linear network is a vital element integral to the overall structure or design of any picture. It may even be the main expressive element in the design: as it is of the black and coloured bands of Mondrian's 27 series of grid-patterns; or in the early English Psalter, where contours 16: as emphatic as those in Byzantine mosaics and weaving or of the lead strips in Gothic stained glass create what is virtually a colour-embellished line-drawing. Often, as we shall examine later, this design may be expressed by the direction, balance, and tension of the *edges* of tone and colour silhouettes in a painting, as it is by the hard boundaries of an Ellsworth Kelly colour shapes and by the black and white 22 silhouettes of Rembrandt's *Interior*, whose edges perform a dynamic 81 function in the whole tonal pattern. 26:

To discover these linear arteries in the design of a painting is to experience something of the same thrill of surprise that comes to us when the power cable network beneath a road surface or behind a blank wall panel is unexpectedly exposed to announce the secret

BRAQUE: *Still Life with Fish* (1925). Tate Gallery, London; © ADAGP, Paris

42

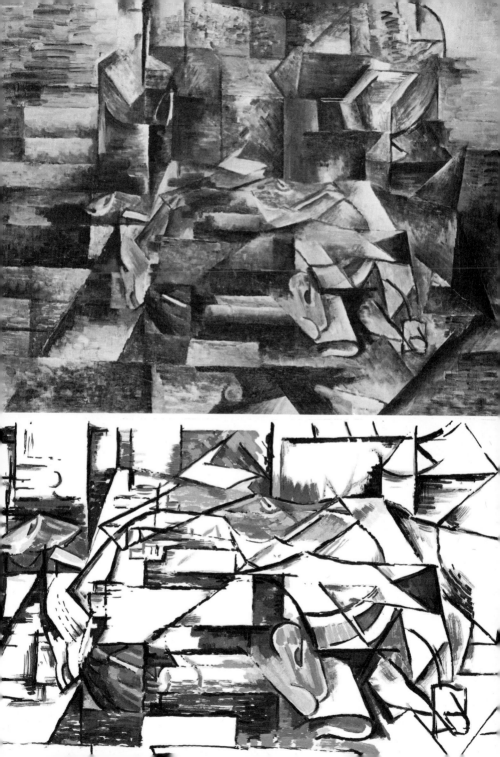

anatomy that lies beneath the outward covers of our everyday environment.

The physical character of lines in a painting will obviously be affected by the nature of the tools and painting surface used by the artist. If he draws with a fluid, responsive medium like oil paint, ink, or water-colour, his brush-strokes may have the spontaneous character of rapid handwriting, and be capable of producing marks as dramatic as those made by skis and skidding tyres, as rhythmic as the arching grace of an aircraft's vapour trail or the wash that curls in fanning lines behind a speedboat. Such calligraphic quality is demonstrated in the Chinese and the Picasso paintings, where the 20 flexibility of direct ink and oil painting has been exploited so success-fully that the artists' brushes have become instruments as sensitive and responsive as fingers. By comparison the tempera line of the Botticelli, like the linear quality of the Lorenzo Monaco and the 35 Bihzād miniatures, has the hard, uncompromising precision of a 20 glass or metal engraving.

One aspect of our full appreciation of a painting should be the visual pleasure afforded by the sensuous nature of its surface. Sometimes the physical appearance of lines drawn in certain materials and with a special skill will be so delectable and stimulating that such lines may be enjoyed for their own sake whatever may have been the primary pictorial function that the artist had intended them to express. In fact, it has been the aim of many contemporary artists that our attention should be directed to this very surface quality in order to remind us that it is only the material out of which a painting is made that has phys-ical reality and that the rest, as a representation of reality, is make-believe. Therefore, whilst the black contours drawn by twentieth-century artists like Beckmann, Rouault, Nolde, Marin, or Hartley function primarily as a means of expressing ideas and emotions or representing natural phenomena, their sensuous quality is a secondary though still an important aspect. But the lines in many works by later Abstract Expressionist painters such as Kline, Mathieu, Soulages, and Pollock are, as visually exciting streaks of paint on can-vas, themselves the subject-matter of the picture. Such paint marks are not therefore made as lines intended to communicate observations about and personal reactions to the behaviour and appearance of things from the outside world. They are, instead, the linear records of the gestures made by these artists (also sometimes known as Action Painters) when they turn their picture areas into arenas for pyro-technic displays of shooting and exploding lines—demonstrating the

above
BURRI: Detail from
Saccoe Rosso (1954). Tate
Gallery, London
below
MILLARES: Detail from
Cuadro 150 (1961). Tate
Gallery, London

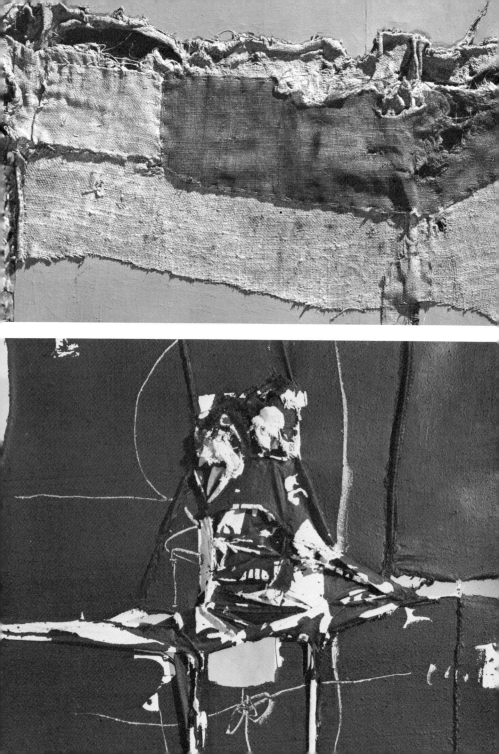

capacity of paint itself to behave like a natural force by changing the appearance of a surface (the canvas) by actions as dynamic as those forces of fire, wind, or rain whose transformations, trails, and patterns earlier artists had invented painting techniques in linear textures to represent.

If lines could now express their own events and patterns rather than simply imitate those of external nature, it was logical that the conventional means of making lines with paint and brushes on the picture surface should be challenged also. The repertory of line was therefore extended. And rather than impersonate in paint the scratches and tears and the cracks and rents of real things seen in the outside world the artist could now re-enact on the picture surface itself the destructive processes and physical happenings which would have produced these dramatic linear textures in real life.

So whilst a grand master of heroic illusionism like Delacroix interpreted the political symbolism of torn clothing and tattered tricolours (for example, in *Liberty on the Barricades*) through the medium of oil-paint brush-strokes, Fontana a hundred years later cuts slits like the lines of deep wounds into the stretched surface of the picture itself and Burri creates lines from the split and raised grain of real wood veneer and from the ripped and re-stitched fabrics he sticks on to his canvasses. Where Botticelli transcribed the thin highlights and shadowed creases of drapery into delicate brush lines, Burri has also made gleaming lines from the taut folds of plastic sheeting and real shadows are cast by the reliefs in string and shredded materials that Millares ties and sews to his paintings. Whilst a Giovanni di Paolo or a Pre-Raphaelite painter would suggest the cracks in masonry and rock by illusory indentations created by brush strokes, Hartung and Tapies use cutting tools to scratch, scrape, gouge, and emboss their painting surfaces. As a development of Cubist and Dada *collage* techniques—by which pieces of newsprint, wallpaper, labels, commercial illustrations, and stencilled letters are used as ready-made pattern units—painters like Rauschenberg and Dine have extended their pictorial vocabulary with the lines and edges of real hose-pipes, chains, wires, workshop tools, and fragments of city junk which they fix to the surface of their paintings.

In conscious reaction to the exclamatory paint gestures of Abstract Expressionists are the impersonal statements of those American artists who are now generally known as Post-painterly Abstractionists —as in the work of Frank Stella, where metallic lines are inscribed on polygonal-shaped grounds with machine-like anonymity. Although in this style of abstract painting the use of ruling pens, masking tape,

46

and spray-guns obliterates all evidence of direct manipulation, these 'mechanical' lines have a classical perfection as satisfying as the faultless regularity of nylon threads or gleaming metal tubes.

So far I have talked about the linear element in painting when it is expressed as a visible entity and exists in the form of drawn lines on the picture surface. But equally important in painting are the linear qualities inherent in the edges of an area of tone, colour, or texture, by an alignment of shapes, by rhythmic paths implied across a picture and by the axes of shapes or groups of shapes.

Of the three details reproduced in the previous chapter, for instance, lines are expressed as brush-drawn contours in the Lichtenstein but 23, 31c exist in the El Greco and the Giovanni di Paolo more as the boundaries 23; 22 of colour and tonal areas—that is, as we see the linear aspect of things in everyday life. And contours are often made, both in the outside world and in paintings, by the edges of an area of texture—the irregular fretted edge of a mass of foliage, the vertical and horizontal sides of the paragraphs of type on this page, the stylized figures of Seurat's Pointillism. But because these are the ways in which we 100 generally perceive 'lines' in nature we may not be so alert to them in paintings as we are when they are defined for us as separate statements in brush-drawn contours. We can, however, develop the ability to appreciate the expressive edge of a painted shape.

On looking at the Chardin, for example, our attention is probably 264–5 immediately drawn to the focal point of human interest in the youth's profile. From this silhouette we could now follow a path to the jutting edge of his lapel, down the steep slope of his upper arm to the elegant curve of his sleeve—where the 'line' dips, hops, and then—as if using as a springboard the playing card he holds—bounces across the intervening background space on to the sharp edges of the standing cards, to turn back along the table top, and so on. As my illustration demon- 49a strates, this perimeter journey was planned by Chardin, both to soothe and to stimulate the viewer by its calculated variety of edge quality and by its changing tempo of ascending and descending contours. If this experiment were to be repeated by starting at a focal point on a silhouette edge of the Ter Borch, the Botticelli, or on the Uccello 8; 258, 49c; pennons we should experience a visual sensation of calm/agitated, 49b, 144 convex/concave, smooth/jagged variations, and quick/quick/slow boundary rhythms as invigorating and unexpected as a switchback ride.

When the edges of different shapes are in close proximity—in the 123, 49e; Chagall, for instance, or the El Greco—or are arranged within the 67 top

47

picture pattern as shapes of contrasting character—like the figures in
the Persian miniature or the Bruegel—we can approach them from
their surrounding *negative* areas and allow our eyes to feel their way
like radar instruments or hands groping across surfaces in the dark.
If, therefore, we approach the inner boundaries of the Chagall figures
from the white space between them and those of the El Greco group
from a position in their negative background area, we can look from
edge to edge of these expressive silhouettes—as we would follow
intently the path of a ball as it ricocheted from one surface to another
in a billiards game or on a pin-table.

In the Kandinsky shapes move across a uniform dark ground like
acrobats spot-lit against the ceiling of a Big Top circus-tent. The
optical movement created between these shapes can be experienced
if we first stare at the sponge form in the centre right of this composition
—'A' in the diagram. We should then find it difficult to resist the visual
gymnastics which begin a movement towards the diving amoeba
shape above (B), to rebound, directed by the arrow (C), in a trapeze-
swinging rhythm and find an echoed response in the curling edge of
the S-shape (D). An irresistible force seems to draw these two shapes
together as if their outlines were the edges of temporarily separated
components of a larger mass about to re-form like biological cells
or drops of mercury. An oscillating tension will be felt to exist also
between the contours of these snaky silhouettes and those of the
aggressive, angular structures erected in pin-point precarious
balance like highwire masts to left and right of the picture.

ALIGNMENT I have referred to the rhythmic threads with which Rubens and
Cézanne bound their shapes into harmonious patterns and to the
linear scaffolding on which Braque rebuilt the planes of his dismem-
bered still-life objects. These drawn lines create a sense of 'rightness',
permanence, and inevitability about the relative position of each of the
shapes they enclose on the picture surface.

Great paintings in which the linear element is expressed by the
edges of their shapes, instead of by means of drawn contours, achieve
this quality of timelessness and irrevocability in their design by
adjusting the position of certain pictorial features so that an edge or
an accent will fall into place in line with those of other shapes in the
picture. A simple example of this subtle principle of alignment is seen
on this page where the margin areas and the spaces between each row
of type imply horizontal and vertical lines which bring order and
clarity to a complex typographic pattern. This device is often used
in graphic advertising also, where by placing a word or a slogan so

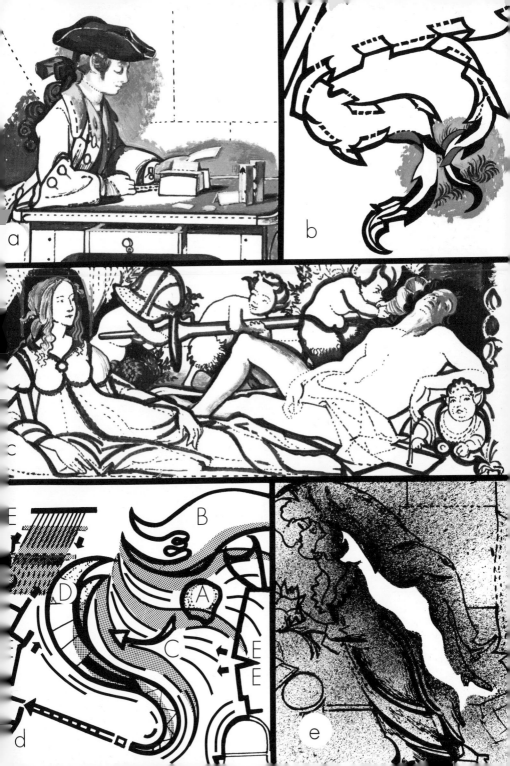

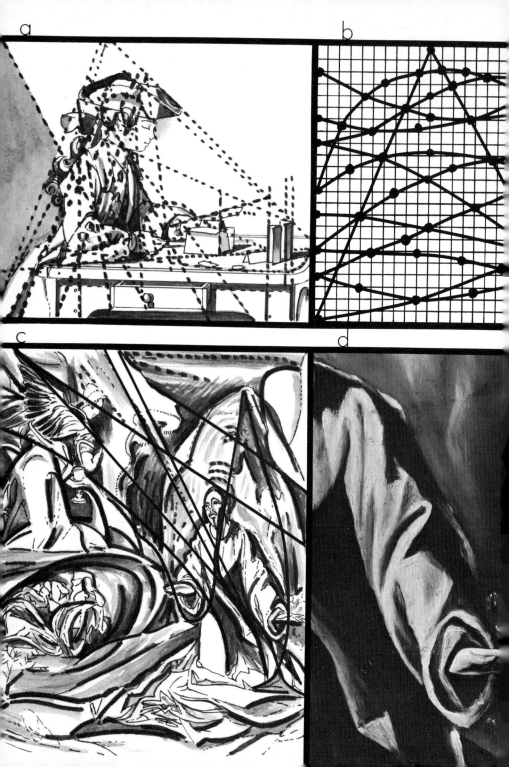

that at least one boundary of the lettering is aligned with an edge of the accompanying illustration, a visual and psychological relationship is established between the two forms of communication.

More complex and subtle than this practical regimentation of different areas by the typographer and the graphic designer is the underlying network which binds together, from point to point, the shapes in such a deceptively naturalistic work as the Chardin. An 264–5 analysis of the lines which are implied from one point to another in 50a this small yet monumental work reveals a pattern so precisely organized that it may be compared to a system of lines drawn on a graph. 50b Thus every crease, button-hole, and shadow's edge has its calculated position on a linear plan. It will be seen that the points on which the straight ghost-lines are laid have been so placed that the interwoven threads of the overall pattern also appear to advance and retreat in space like the rigging of a sailing cutter. We can also enjoy the play between repeated curves: the curling brim of the tricorne hat, for instance, is echoed in the arch beneath the table and there is a pattern of outlined circles and ovals in a coin, a drawer-knob, cuff-links, curls, and buttons carefully scattered across the picture surface. A diagram shows how in the El Greco a similar system of graph- 50c lines, binding rhythms and echoed edges reinforces the tense emotional relationship between the images of Christ and the angel.

E LIVING EDGE The edges of forms in paintings are often defined by means of alternating sequences of tonal contrast which run on each side of the boundary division between an image and its adjacent field. These tonal variations—and in some pictures this quality of counterchange is expressed by colour contrasts or in passages in which impasto, stained, glazed, and smudged paint textures are played against one another—produce vibratory edges as vital and sensuous as those of calligraphic contours. The detail from the El Greco, for 50d example, shows a movement in tonal counterchange which sparkles like an electric charge down the right side of the gown in a light/dark, dark/light progression until the sleeve and background areas merge just before the dramatic accent of the hand. Such alternating tonal contrasts bring a flickering energy even to the enamel monotony of the paint surfaces of a Poussin and an Ingres. 69d; 215

These examples show, however, that localized silhouettes created by boundary contrasts provide more than an arbitrary surface glitter to a picture. They also explain the behaviour of planes at the vanishing edge of a shape, and suggest the spatial relationship of a form to its surrounding areas. For instance, a strong contrast between light and

dark tones, or between warm and cool colours, will sharpen and project an edge; but *blending* tones or colours will produce the effect of a rounded and/or a receding surface. Sharply defined boundaries, like strongly drawn contour lines, also function as focal points in the overall design of a picture (for example, the head and shoulder edges of Christ in El Greco's *Agony in the Garden*), and as a means of directing the viewer's eye by a series of charted flash signals across the picture surface from one accent to another (like the movement from one edge to another described in the El Greco diagram).

LINE AND STYLE A good specimen of calligraphy will generally reflect the personality of its period as well as that of its writer. The Chinese and Japanese artist was traditionally both painter and calligrapher and a close relationship existed also between the linear aspect of an Indian or a Persian illumination and the visual character of its complementary script. Although in Western cultures, with the exceptions of Gothic illuminations, the highly personal paintings of William Blake, and some examples of Pop Art, there is no direct visual link between handwriting and painting, what is expressed through the linear qualities of many paintings since the Renaissance is the essence of a period or of an artist's personal style. In order, therefore, to be able to appreciate the special characteristics and contributions of certain styles of painting we should be alert to the distinctive qualities of their drawn contours and silhouette edges. For linear analyses of these pictures demonstrate that their essential mood and message has been expressed as forcefully in their particular linear characteristics as in statements made in tone and colour. A brushstroke analysis of part of a Gauguin landscape,[1] for example, shows a design in peacock-feather motifs whose serpentine curves are typical of Art Nouveau—that exotic, erotic vocabulary of willowy lines which twist and sway across a picture in decorative patterns to express a striving growth like that of poppy stems and ivy tendrils, of eddying smoke wreaths and drifting seaweed fronds. As vibrantly decorative are the curling, lacy edges which embroider the petticoat foliage and embrace the icing-sugar nymphs and shepherds in a Rococo painting by Fragonard. Characteristically more aggressive, and moving with the force and fury of thunderclouds and ocean breakers, are the silhouette edges and inner spiral rhythms of Rubens's Baroque *Battle of the Amazons*.

In contrast to the exuberance of these restless decorations are the calm rhythms of Poussin's sedate, well-ordered *Bacchanalian Revel*,

[1] *The Alyscamps at Arles* (1888) in the Louvre.

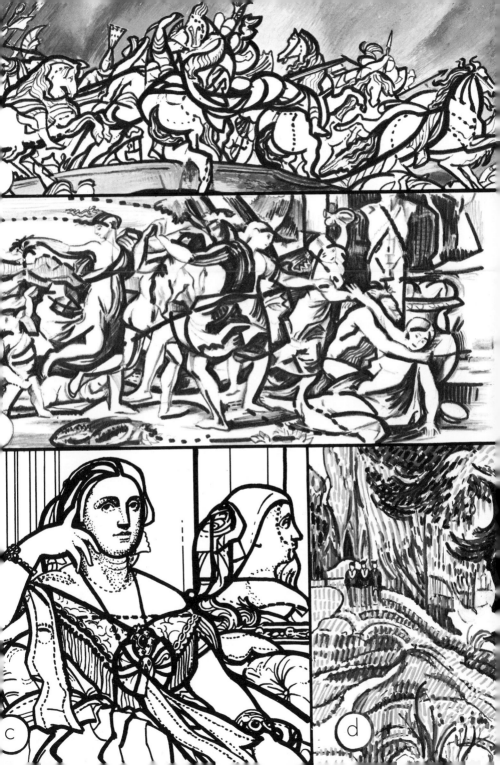

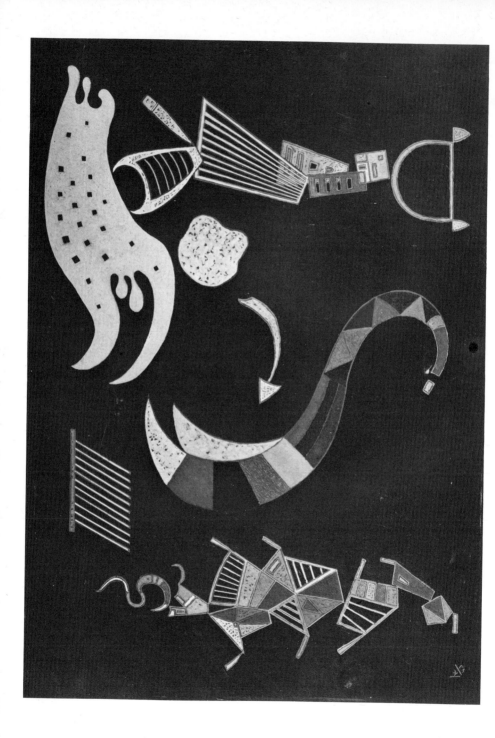

where lines evolve and undulate like slowly crumpling waves. My diagram demonstrates the manner in which Poussin wove his lines 53b through the foreground forms to tie them to contours in the middle distance and background areas of the composition, the drapery folds running into the mounds and mountains and the figure contours carried into the trees and foliage. In this way all the planes of every form in the picture are integrated into an overall pictorial structure. Cézanne acknowledged his debt to Poussin and in his own figure composition he used a similar linear system; he also used Poussin's technique of tonally accented contours which vibrate like Morse code sequences to lead the eye from edge to edge of the picture.

The grace and serenity of Poussin's figure and garland frieze har- 96 monies are qualities also typical of Ingres's Neo-Classical portrait, 11 where linear directions are charted like the flights of gliding birds as the edge of one form carries the viewer coolly and irrevocably to the curve across another. 53c

I have described the various main functions of lines in painting. The reader should find that with experience he will be able to recognize the particular functions lines perform in the painting he is looking at. Although I have chosen examples which illustrate this or that function of line clearly, in very many pictures lines play several of these parts at once, and the observer has to be sensitive to them all if he is to experience the truth of Kandinsky's statement that 'a line is a living wonder'.[1]

[1] Essay by Kandinsky, 'Empty Canvas, etc', included in *The Painter's Object* (London, 1937), ed. Myfanwy Evans.

Tone is the quality of lightness and darkness in a painting. This tonal element is clearly illustrated by the monochrome reproductions in this book, just as our aerial photograph provides a visual record of 57 the different tones of a coastline. The tonal range of a painting or a photograph is expressed in degrees of shading between the extremes of light and dark. A tone-scale defines these degrees of shading in a graduated sequence. A painting composed predominantly of tonal degrees from the lighter end of a scale is referred to as being in a 'high key'—the Monet and the Albers, for instance. One that is painted 59; mainly in darker degrees is said to be in a 'low key'—the Rembrandt *Interior*, for example, and the Goya. 81;

I have divided my tone-scale into seven steps, though in some 57 paintings there may be only two or three of these tonal stages—the Chinese landscape and the Albers are examples of this economy. 208 In others a wide range of middle tones will be used, so that in the tonal modelling of a head by Leonardo da Vinci or Ingres the variations of 74; shading are so fine that their subtle difference from one another can be appreciated only when the *original* work is scrutinized. But however he may restrict or extend the variations of tone in his painting, the artist is always limited by the narrow tonal range of his pigments— for his lightest white paint, and his darkest black cannot match the bright lights and deep shadows of nature. Yet painters overcome this technical handicap with such skill that we are often no more aware of their palette's tonal deficiencies than we are made conscious, during a music recital, for instance, of the limitations of a string trio in comparison to the range of volume possible to a full orchestra or to the range of sounds heard in the outside world.

In an attempt to deal with this problem some artists have viewed the subject of their picture through a smoked glass so that the brilliant lights of nature would appear to them reduced to tones closer to those of their lightest available pigments. Unfortunately this device extinguishes the essential tonal contrasts which produce the glitter and sparkle of lights in the outside world; and the problem of interpreting in paint the tonal brilliance of a sunshine yellow or a fiery red and orange without losing colour intensity remains unsolved since the dark glass merely degrades these brilliant hues into middle-toned green-greys and browns. Many sombre sunset pictures have provided drab testimonies to the handicaps of this artificial aid.

Aerial photograph of coastline at Co. Down, Northern Ireland. Aerofilms Ltd, London

Turner's sunsets, storms, and conflagrations, the electric flashes in a Tintoretto or an El Greco, and the incandescent patterns in a Rembrandt or a Caravaggio are achieved, not by some alchemy of secret pigments, but by the skilful relationships established among all the tones in the picture. Since these tonal relationships are sometimes lost beneath layers of dark varnish and accumulated dirt we should not expect to find such expressive tonality in the golden grime and gravy-brown of the ill-advisedly nurtured patina of the murky Old Masters in some museums. Yet such is the mastery of a great artist that in the El Greco, since this work is in good condition, we find pinks, whites, and yellows with a luminosity and blacks with an 109 impenetrable depth which seem to transcend the range of ordinary pigments.

An elementary example of one way in which painters overcome the tonal limitations of pigments is demonstrated by the optical illusions created by changing contrasts. For example, the white spots on the shaded divisions of my tone-scale appear progressively lighter and 57 brighter as their surrounding tone becomes darker and the black spot, isolated in the surrounding white at the top of the scale, probably seems darker than the blackest degree of shading elsewhere on the page. And in diagrams (a) and (b), a middle-tone star-shape seems to be 59 darker against the white field and to have become lighter against the black one. Thus, as we can see in the El Greco detail, the light shapes 67 seem most brilliant where they are in adjacent contrast to the darkest tone and, as another detail from this painting demonstrates, wher- 67 ever a black or a white is isolated in this predominantly middle-toned painting the contrast it makes with the surrounding area of tone is as startling as the shocking rattle of a dropped pencil or the deafening crash of a cough that splinters the silence of a hushed room.

An isolated accent of black or very dark colour is often so placed that it will intensify the luminosity of all the light tones in a picture. Therefore if we mask the black silhouette of the ship on the horizon of Turner's stormy seascape, the light of the electric sky and the fiery 217 surf will seem to sputter out as if the dark accent had been a black control-button we had pressed. Indeed without the dark accent present *somewhere* in Turner's dawns and sunsets the tonal brilliance of his orange, yellow, and pale blue would vanish, leaving only opaque areas of saccharine paste; his opalescent mists would cloud over and return to paint. We can also hide the velvet-black oval tray at the bottom of the Bonnard and the black cat against the icing-pink dress 260 in the Manet to witness the soft light, which makes these such *glowing* 176 paintings, immediately extinguished.

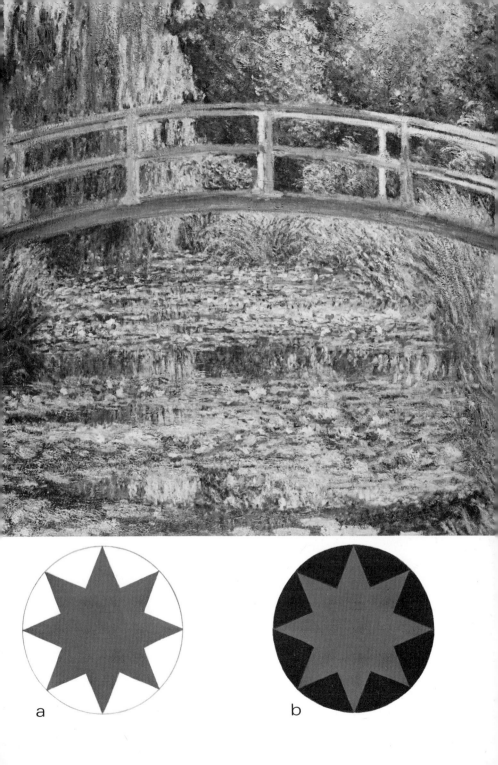

a

b

It is obviously easier to appreciate the expressive interplay of tones in a *monochrome* painting—that is, one that is composed of the tonal degrees of only one colour, or of a few colours in very close harmony like greens and blues or ochre with umber and black. Painters like Rubens, Seurat, and Manet often made preparatory monochrome 61 tone-studies for a major work before beginning the final version in colours. During the great period which extended from the use of traditional tempera techniques to the methods of direct (*alla prima*) painting, colours were usually glazed as transparent films of pigment over a monochrome tempera under-painting (as in the Giovanni di Paolo 22 and the Lorenzo Monaco)—rather as photographs and engravings 149 were sometimes colour-tinted by hand before the days of direct colour photography.

Many important works have, however, remained in monochrome in their finished state. I have referred to Japanese and Chinese ink 30 paintings and among major Western works in near-monochrome or a very restricted colour range are Picasso's *Guernica* and the paintings of his Blue Period, most of the Analytical Cubist pictures, and many American and European abstract paintings since 1945 by artists like Kline, Motherwell, Newman, Reinhardt, Albers (whose 189 *Homage to the Square* is in four tones of yellow) and Pollock (whose 106 *Painting (1952)* is predominantly black and white). The Daumier 181 reproduced here in black and white may be seen, in the original work, to be almost a monochrome painting in browns—like a sepia photograph—being composed in white, grey, and umber, relieved only by small patches of blue and brownish-pink in the sky. The small Rembrandt *Interior* is in *grisaille*, its tone-scale descending in degrees of 81 white, cream-grey, grey, umber, and black. Many paintings by Velazquez, Goya, and Manet are really *grisailles* also, since their colour-range is limited to degrees of slightly tinted greys and blacks relieved 75; only by a few isolated accents of pure colour.

The expressive qualities of a monochrome picture will generally survive reproduction by most black and white photographic printing methods. But many of the illustrations in this book—the Kandinsky, 54 the Chagall, and the Bonnard especially—are reproductions of works 123 in which *colour* is an important expressive element. Black and white photographs of paintings such as these make it easier, of course, for us to appreciate their tonal qualities—just as the published script of a play enables a theatre-goer to discover nuances of meaning and intricacies and ingenuities of plot-construction of which he may not have been aware during the stage performance. Indeed, the intoxicating colour relationships of the *originals* of some paintings may blind us to

RUBENS (1577–1640): *A Study of a Lion Hunt.* National Gallery, London

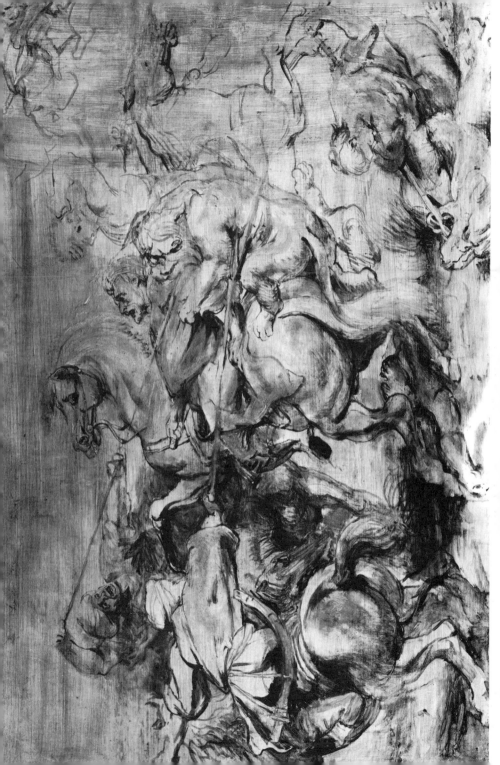

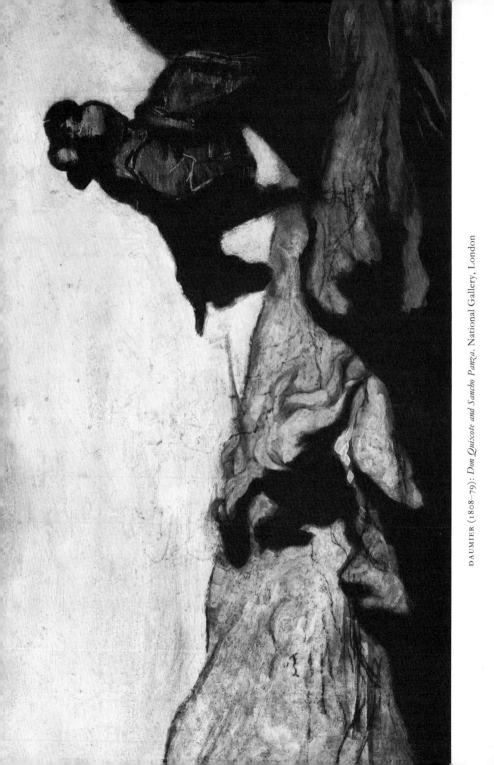

DAUMIER (1808–79): *Don Quixote and Sancho Panza*. National Gallery, London

the expressive functions of their *tonal* qualities. Though these tonal qualities may not easily evoke the immediate emotional response of colour, nor will the tones of all paintings be as readily perceived as their textures, lines, and shapes, tone is a most important and fascinating part of the painter's language and we should be sensitive to the particular functions it performs in different styles of painting.

NAL PERCEPTION The contribution of tone to the language of painting is made through the interplay of its various degrees of shading. In order to understand and experience this expressive interaction of tones we should be able to establish the relative lightness or darkness of the various shapes in a painting, however powerful that painting's colour qualities may be. Most people will find that this sensitivity to tonal variations is in fact easier to cultivate than is, for instance, the ability to recognize, for an appreciation of music, the particular sounds from the doh-ray-me scale when these are rearranged in sequences related to the words and syllables of a song.

There are several ways in which we can develop an ability to see tones more clearly. One useful exercise is to find the lightest tone in a black and white photograph and then to count, in descending order, each area of a darker shade. We could begin with the aerial photograph, since we can then judge its tonal order against the degrees of 57 shading on the accompanying tone-scale. Any press photograph, in fact, will serve to extend this exercise if its tonal areas are outlined to make a patchwork pattern. These shapes can then be numbered as in the inverted Daumier tone diagram. If this kind of tonal analysis is 64a also carried out on *coloured* magazine illustrations it will not be very long before we are sensitive to the tonal element of the most vividly coloured painting. Just as the wearing of sun-glasses lowers the brightness and intensity of the colours of things around us and makes us more aware of their patterns of light and shade, so we may find that at first our perception of tone is made easier if we look at a painting for a moment or two through half-closed eyes since this has much the same effect.

Whilst there are many ways in which a painter can create striking colour contrasts, he can make his most violent contrasts in tone only by placing his lightest light and darkest dark adjacent to one another or by painting a sudden accent of black or white in an area dominated by middle tones. To appreciate the expressive contrasts between tones we should look along the boundary edges dividing them, just as in the previous chapter I suggested this technique of perception as a useful means of experiencing the expressive qualities of a contour.

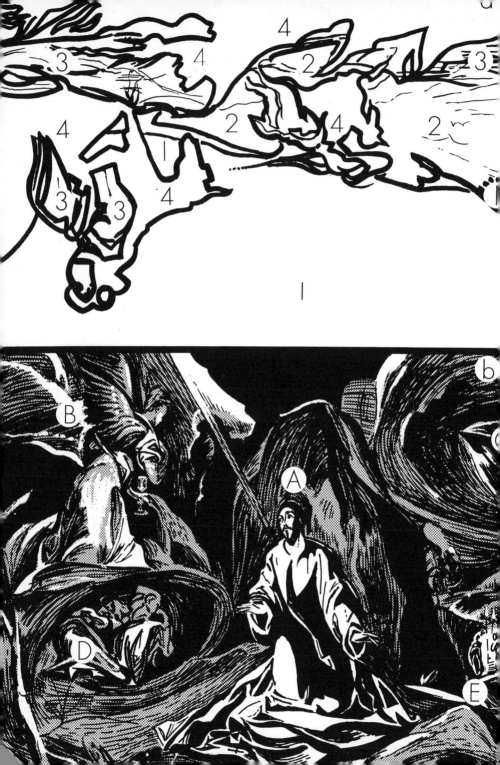

To be alert to the interplay of tones across the whole picture surface we should stare intently at some focal point of strong tonal contrast such as the light/dark contrast of Christ's gown in the El Greco. 67 After a few moments we should become aware of tonal responses from the surrounding areas of light and dark, which will begin to vibrate like flashing signals within our cone of vision—like the areas indicated on the El Greco diagram as accents which vibrate from 64b each side of the focal centre in the original painting—that is, accent 'B' flashing across the picture to 'C' and accent 'D' to 'E' on each side of the centre image, 'A'.

TONE AS AN INDEPENDENT ELEMENT The tonal patterns of the Matisse and the Persian miniature are really 2; 205 the light/dark aspects of their colour patterns. And if we compare the colour of the original Chagall with the reproduction of this picture in monochrome we find that the same areas are defined as differences 123 in tone as are defined as areas of red and green colours. In my first chapter I compared the viewer's approach to this kind of two-dimensional pattern with map-reading, since all the shapes are seen as areas of flat tone and colour. This style of representational painting expresses the intrinsic nature of things by their *local* or inherent colour. Since most colours have a natural tone value (pink is a *lighter* colour than red, for instance, and brown is a darker colour than lemon), we can also refer to the relative lightness or darkness of shapes in this kind of painting as an expression of things by their local, or natural, *tone*. Therefore in a two-dimensional pictorial style an extent of grass, for example, would generally be painted in only one flat tone which would not be varied by transitory effects of sunlight, mist, reflected lights, or cast shadows. We describe things in terms of this visual language in everyday life when we identify the things around us both by their natural tones and by their intrinsic colours: 'blondes and brunettes', 'as light and as white as snow', 'as dark and as black as pitch', and so on. In the outside world we rarely see the natural lightness and darkness of coloured things in this way except under conditions of artificial diffused strip-lighting or beneath a cloudy sky, when forms seem flattened and shadows are negligible (like the pattern in natural tones shown in the aerial photograph). 57

The tonal element in some other styles of painting, however, does not function merely as a quality of colour to identify and describe shapes, but instead becomes an expressive element in its own right, independent of colour, with its own functions to perform and capable of creating its own patterns. So, if we compare the black and white photograph of the El Greco with its reproduction in colour, we find 67, 109

two different kinds of pattern existing in one picture. There is the pattern composed in colour masses and the pattern created from tonal shapes independently of colour. These different patterns interact with each other like contrapuntal melodies played, as I shall explain later, sometimes in opposition to each other and sometimes in harmonious accompaniment. In representational painting the shapes making these contrapuntal tonal patterns are usually those of the lights and shadows which cross and often partly camouflage the outlined or coloured forms.

The phenomena of tone/colour relationships, which apply to all styles of painting, I shall discuss further in the next chapter. The rest of this chapter, however, will deal with the expressive functions of tone in its capacity as an independent element in painting.

I shall therefore attempt to explain the ways in which artists have exploited the various qualities of tone: for emotional expression, to break up the picture surface into exciting patterns of light and dark shapes, and to create illusions of light, form, space, and movement. But for the viewer to be able to recognize the skill with which a painter has arranged his tones to perform these functions is of course only one level of appreciation. It is another, and a deeper and more rewarding, experience for the viewer if these expressive tonal arrangements react on him in such a way that he feels a tonal interpretation of form or space or illumination as a sensuous, tactile, and emotional thing and experiences in a painting these visual phenomena of everyday life as if he had never been fully conscious of them before. Just as it is necessary for us to perceive the unique qualities of shape, line, colour, and texture by looking at parts of a painting in particular ways, so I shall suggest certain visual techniques by which we can respond to the optical messages provided by the painter's organized tonal sequences.

FORMS AND SPACE
IN TONE

A preoccupation of artists in many periods of painting has been to find means of creating an illusion of three dimensions on the flat surface of the picture-ground. In the previous chapter I referred to the various ways in which the element of line may be used to describe the rounded and angular surfaces in the representation of solid objects and to express the advance and recession of these objects in the spatial depth of a picture. And I have shown that in some styles of painting tonal shading has been used to reinforce a linear interpretation of form and space.

EL GRECO: *The Agony in the Garden* (*c.* 1590) with details. National Gallery, London

In the star-shape showing the contrast between the tonal extremes of black and white the dividing edge between them seems almost to be

66

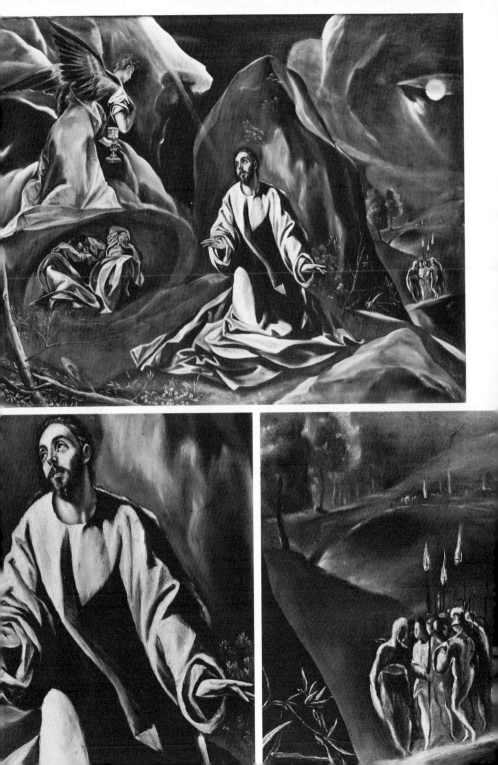

projected *towards* us. This optical sensation may be experienced even between the closely gradated degrees in our tone-scale, which as we stare at it begins to look like a grooved or scalloped strip with each of its dividing edges apparently curling upwards. Planes may therefore appear to be set at projecting angles to one another if this optical illusion is further encouraged by the use of black and white accents painted only along the meeting edges of the planes of a form. This technique gives a harsh metallic character to the rocks and drapery in the El Greco, with sensations of planar projection which seem almost to anticipate the structural researches of Cézanne (who is known to have studied the sixteenth-century painter).

In Cézanne's *Dans le parc du château noir*, for example, we see that the background area is brought forward by tonal accents. By compressing the picture space in this way these more distant surfaces are brought into a closer relationship with the rocks and trees of the middle distance and foreground, compressing all the vertical planes to produce an effect like that of folding sections of a partly closed concertina. With the use also of colour modulations of relative warmth and coolness, purity and greyness, he was able to model subtle surface sequences which lead the viewer's eye easily from the planes of a foreground form to those of a background area—like the flattened spatial representation of things on coins, medallions, and plaques. In order to demonstrate the structural unity created by this method I have transcribed a section of Poussin's *Bacchanalian Revel* in terms of Cézanne's spatial technique.

In the paintings following their Analytical Cubist period Braque and Picasso often made use of the dividing edge between the areas of light and shadow across a form as a precise description or cross-section of an object's protuberances and depressions—the tonal countercharge on the head in Picasso's *Woman Sitting in Red Armchair*, for instance, and even in Rembrandt's portrait, where the light area of the head describes a profile view.

Tonal gradations have often been used to express subtle surface changes for which line alone would be inadequate. In their scientific eagerness to investigate the structural principles and visual effects of nature, Renaissance painters like Bellini, Mantegna, Antonello, Dürer, Leonardo, and Raphael developed a method of tonal modelling by which they represented their pictorial images as free-standing solid forms so convincingly that they seem to have the volume and weight, within the picture space, of sculptures in a courtyard. In this modelling technique a sequence of tones or values was coded so that each degree of shading represented a particular angle at which a sur-

middle left
POUSSIN (*c.* 1594–1665): Detail from *Bacchanalian Revel before a Term of Pan.* National Gallery, London

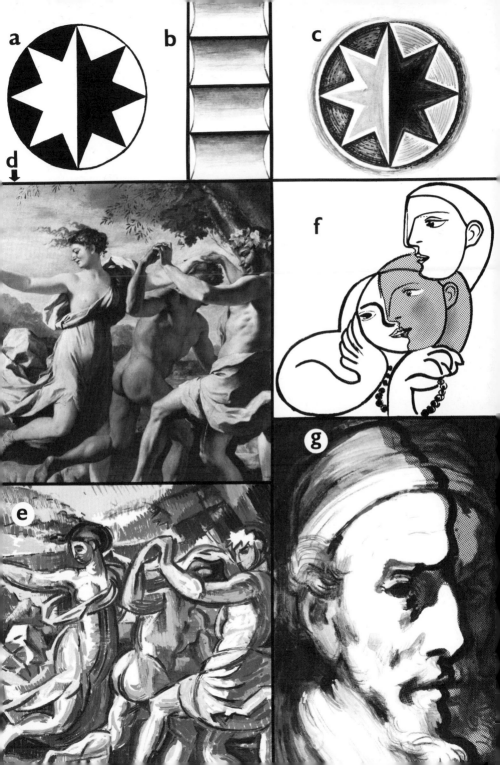

face was turned away from a fixed source of light. The direction of the shadows cast by these sculptural forms on the ground plane of the composition generally implied that this light source was outside the picture-surface and to the left or right of the viewer. The illusion of volume and depth so created was intended to suggest that the spectator was looking at real objects as if through a window-frame and that the ground-level represented in the picture might be an extension of the very floor on which he was himself standing.

In some styles of painting the representation of three-dimensional qualities takes precedence, for one reason or another, over the expression of other visual qualities. When the illusions of volume, weight, and space are created by a system of tonal values the effects are usually more striking if the range of colours used is very limited. It was partly for this reason that Braque, Picasso, and Gris painted their Analytical Cubist pictures in near-monochrome and why Renaissance and Baroque mural painters worked in *grisaille* to create the *trompe l'œil* pilasters and cornices against which their figures were painted, giving the impression that the action of the picture was taking place within a space cut into the stone fabric of the wall. To demonstrate the technical advantages of a full range of tonal values I have represented my star-shape as a three-dimensional *white* form. Therefore I have been able to express its volume and planar changes in tonal values ranging from pure white to deep black.

When the form represented in this tonal modelling system is that of a dark-coloured, matt object, however, its sequence of gradated values will come from the lower register of the tone scale. Thus to represent an inherently *dark* star shape as a solid form I have used 7 degrees of shading in a low key. We find, therefore, that the modelling values of the dark (green) foliage in the original of the Poussin are 9 gradations in a key lower than those of the light (pink) figures and of their draperies in white, yellow, and pale blue.

Although this Renaissance method of rendering form by systematic tonal modelling had been practised in earlier Classical styles of painting —in Roman portrait panels and in the Pompeian murals, for instance —it must have provided a startling experience for the viewers of the period and one to which our own sensibilities may now be blunted, since over the centuries this once expressive language has been reduced to a vocabulary of academic visual clichés. In order, therefore, to be more receptive to the messages communicated through the original form of this style of painting, we should make ourselves more sensitive to the plastic sensations they offer by looking at them in a particular way.

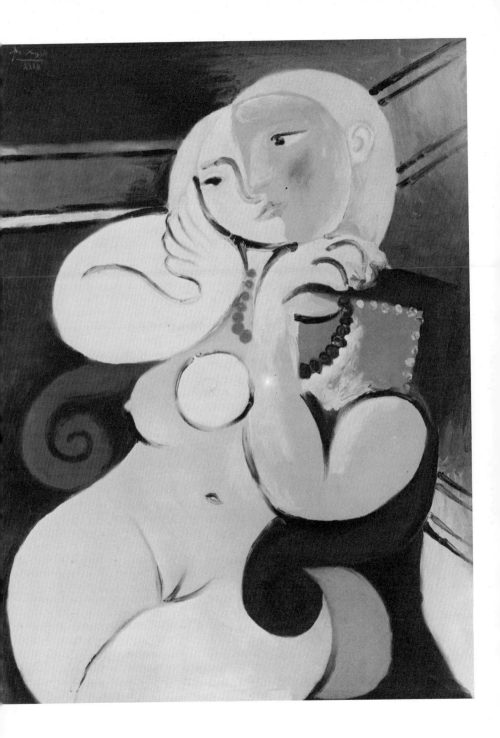

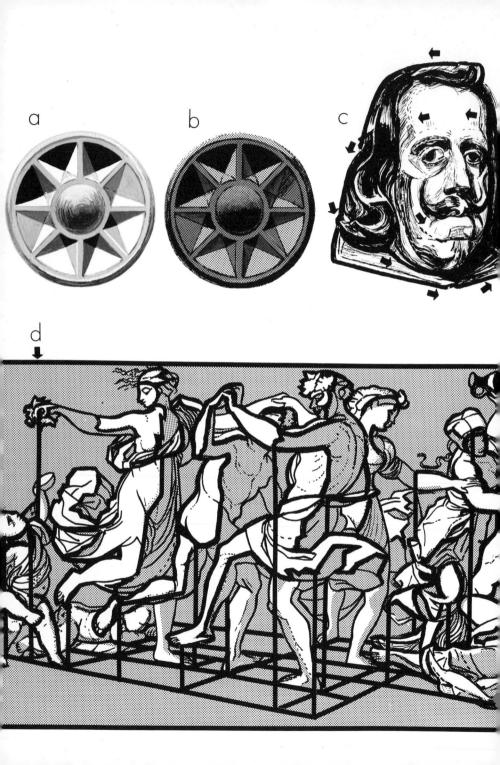

a

b

c

d

I suggest, therefore, that classical compositions of this kind should be scanned slowly from the direction of their light-source. The tonal sequence of the Poussin and the Ingres, for example, would therefore ^{96; 11} be read from the left edge to the right, our eyes moving in and out, up and over their projecting and receding planes, to experience the different plastic sensations of curved and angular, smooth and rippled surfaces, as if gliding closely over the mounds, rocks, and valleys of a landscape. In Poussin's frieze of dancers, whilst the lightest planes on each figure are, logically, those turned towards the source of light, the right-angled division between the side, front, and back surface of each limb, torso, and garment is defined by a dark line like an inside contour mark, the rest of the shaded area being lifted in tone by reflected light. The contrasting planes expressed by this alternating ^{72d} tonal sequence therefore create a three-dimensional structure, whose zig-zag planar design makes a spatial pattern like the panels of a folding screen—but with such intricate variations and subtle transitions that it is as if clouds or waves were disintegrating and re-forming in slow motion before our eyes.

In the Velazquez portrait tonal transitions from one surface to ⁷⁵ another are used to carry the viewer's eye on a tactile exploration of the interlocked structure of the head, shaded planes passing across and returning around the mounds and depressions of the face like wrapped bandages. If the direction of these tonal sequences is fol- ^{72c} lowed the viewer will experience the plastic sensations of this head as keenly as if feeling the bumps and hollows of a plaster portrait bust.

The Renaissance and Neo-Classical technique of precisely modulated tonal modelling depends, of course, upon an idealized situation in which unvarying, neutral light falls upon matt surfaces. But we rarely find this situation in our everyday environment where, for instance, it is with great difficulty that lighting can be suitably arranged for a photographer to be able to make a clear and accurate record of the three-dimensional character and subtle surface changes of a complex piece of sculpture, architecture, or machinery. In real life any systematic notation of tone values would be disturbed by the various ways in which the textures of different surfaces react to illumination—the sudden transitions from highlights to deep shadows on sharp-edged, reflecting materials, the gradual tonal changes on soft surfaces, and the adjustments made to areas of local colour and natural tone by reflected lights, mists, cast shadows, dirt, enveloping gloom, and other temporary and changing conditions of circumstance.

In nature the form of things is often partly obscured in deep shadow

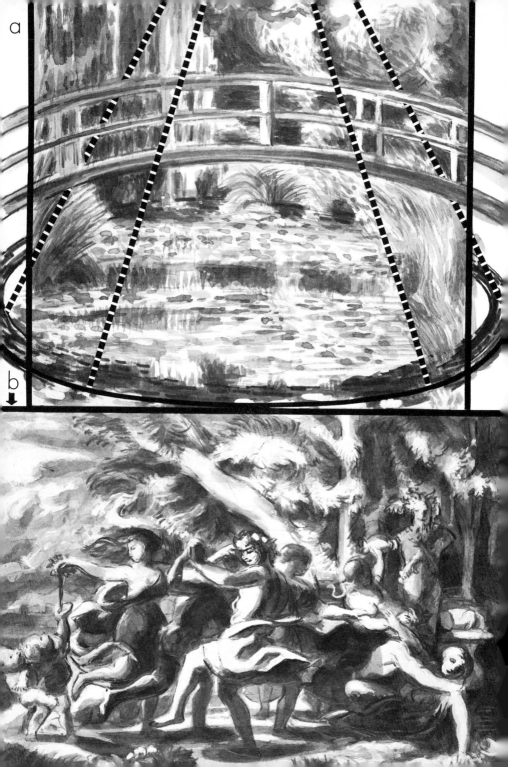

and Leonardo, and later Correggio, used a *sfumato* method of im- 74
perceptibly graded tones to express qualities of volume and struc-
ture, their forms glowing beneath a soft spotlight and the contours
lost in mists and smoky shadows—thus anticipating the aerial
perspectives of Claude, Fragonard, and Turner. Painters such as 78
Caravaggio, Rembrandt, Rubens, and Velazquez created the tonal 84; 85
pattern of their pictures from shapes of light and shade and used these
chiaroscuro effects to create illusions of three dimensions, the project-
ing surfaces of their forms emerging from shadow into light like rocks
breaking the surface of a dark pool.

The breadth and vivacity achieved by chiaroscuro patterns will be
appreciated if we imagine how Titian, Tintoretto, Fragonard, or
Rubens might have interpreted Poussin's *Bacchanalian Revel*—a 96
transcription into light and shadow masses which Rubens did in 76b
fact create in his free versions of some of the classically modelled
compositions of Mantegna and Michelangelo.

In the Caravaggio a concentrated source of light is beamed, as if 85
from a small opening beyond the left-hand corner of the frame, to
fall upon the figures and table and reveal the box-like spatial structure
of the composition. The arrangement of Caravaggio's white shapes
describes the three-dimensional plan of his figure group as lamps and 87a
lighted windows chart the spatial form of a courtyard at night. Picasso
exploited the expressive possibilities of chiaroscuro in a series of
figure studies painted during the early nineteen thirties—his *Woman
Sitting in Red Armchair* is a typical example of these spatial designs in
shapes of lights and cast shadows. 71, 69f

Our experience of paintings in which things are dramatically illum-
inated will be deepened if we follow the passage of light as it stretches
across the 'walls', 'floor', and 'ceiling' of a spatial composition. For
instance, we should be able to feel the overall structure of Turner's
Ulysses Deriding Polyphemus more clearly if, by an effort of empathy, 78
we imagine ourselves able to move back from his setting sun through
the picture space: up and outwards across the ceiling of the sky with 79a
the fanning horizon light beams, along the plane of water and between
the silhouetted rocks to curl over the conical form of the galleon's
sails. Or in the Monet garden-landscape we can project ourselves 59
inside the hazy cone of sunshine which illuminates his lily-pond
like a diffused spotlight falling on to a circus ring. 76a

Illusions of immense distances are created in many Chinese land-
scapes by delicately gradated tonal washes and alternating accents of 208
light and dark. Contrasting areas of tone also suggest spatial dimen-
sions in Cézanne's work and in seventeenth-century Dutch land-

e 78 :
ve
ʀɴᴇʀ : *Ulysses Deriding*
ʏphemus (first exhibited,
ᴇ9). National Gallery,
ɴdon
ɔw
ᴀᴜᴅᴇ: *A Seaport*
44). National Gallery,
ɴdon

77

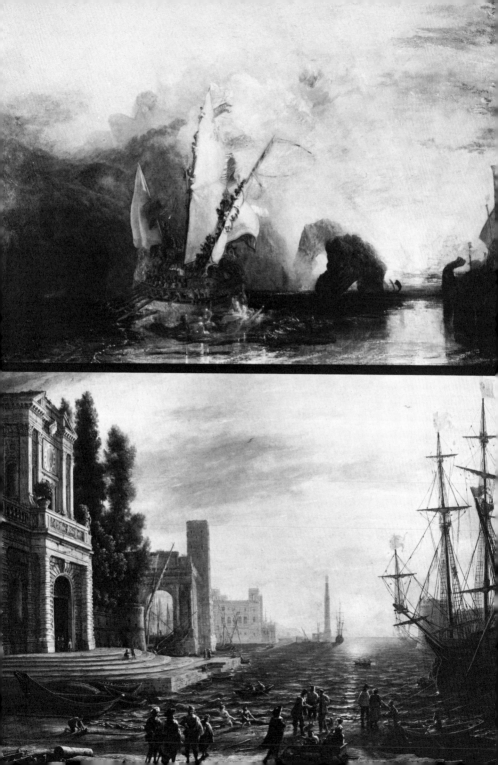

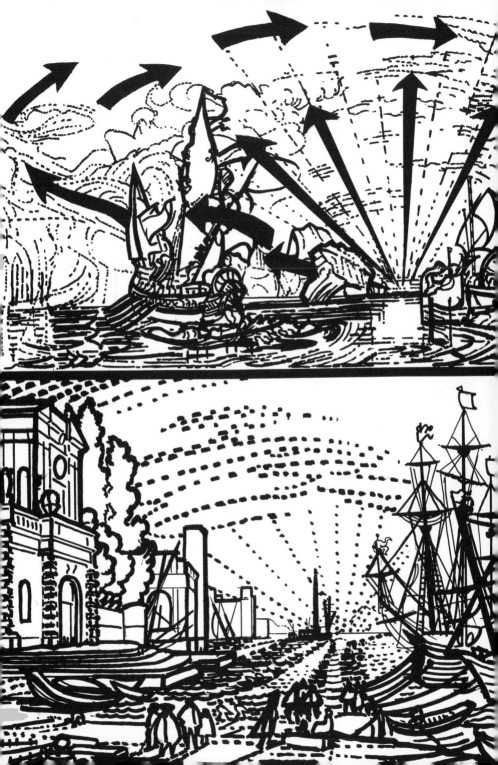

scapes, where alternate bands of light and dark tones often diminish progressively in intensity and become thinner as they move towards the horizon—like a perspective sequence of shadow stripes on the floor of an arcaded cloister. In more dramatic works these light and dark shapes may twist in spiral forms—as they do in the Rubens and the Turner, where they turn like giant fins to a vortex point on the horizon.

In a diagram I have shown the spatial system of a typical seventeenth-century landscape—Claude's *Seaport*—in which the tonal qualities of aerial perspective are expressed by a dark foreground, a middle-toned middle distance, and a light, misty horizon. This convention of landscape-painters and theatrical scenic artists, by which the tones of things are made progressively darker as they move away from a source of light or from the horizon, produces in some works an effect of slow expansion, and throbbing radiation—a quality found in the dreamy, mystical works of Redon, in some of the stirring epics of Delacroix and in the gay decorations of the Rococo painters.

LIGHT The idea of light as solar energy or as an aura of supernatural radiance has been traditionally interpreted by symbols like our star-shapes, suns with faces, and saintly haloes. But when we refer to Rembrandt's chiaroscuro, Caravaggio's 'tenebrism', the pearly glow of a Vermeer, the radiance of a Turner, the snowy dew of a Constable, to a misty Corot, a glimmering Sloan or Sickert, and the qualities in paintings of glitter, sparkle, gleam, or shimmer, we mean by these descriptions the *tonal* expression of certain *visual* effects of light: that is, of shadows, reflections, illumination, and atmospheric change.

Chiaroscuro and tenebrism (low-keyed painting) are terms given to styles in which the observed effects of illumination, shadow, and reflected light form the basis of a particular tonal language. Indeed, the Rembrandt, Daumier, and Caravaggio illustrated here probably impress the reader immediately (in spite of their reduced size in reproduction) by the breadth and boldness of their shadow patterns—compared with the arrangement of light and dark shapes in the Poussin, for instance. But because photography can accurately record such changing patterns in our environment we may, nowadays, be tempted to observe these light and shadow paintings as briefly as we note a press illustration or glance at an outdoor family snapshot. In fact, however, the relationship between the black and white record provided by the camera and a chiaroscuro painting by Goya or Rembrandt is no closer than that between a tape-recording of a splashing fish and Schubert's *Trout Quintet* or Drayton's *Polyolbion*.

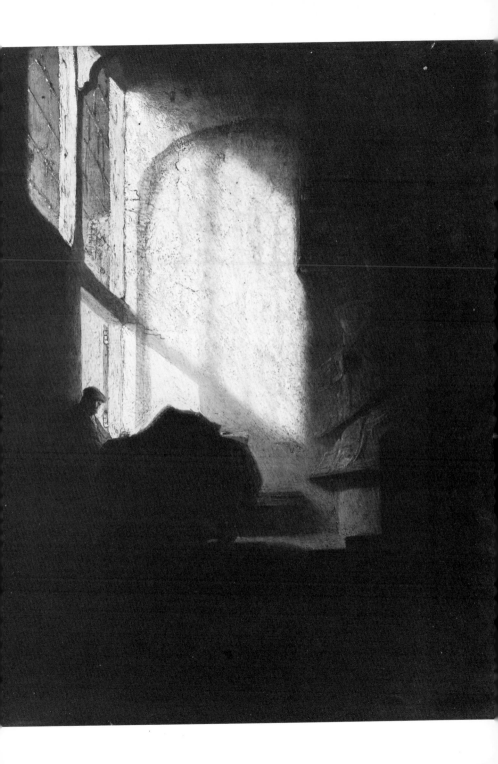

For some painters—Georges de La Tour, the le Nain Brothers, Wright of Derby, and Ruisdael are examples—the visual excitement provided by the dramatic effects of artificial and natural illumination was almost their picture's *raison d'être*. These painters were often attracted by the more melodramatic events of light as manifested in approaching storms, lightning flashes and the glare of braziers and furnaces. Others, like Degas, Daumier, Lautrec, Sickert, and Everitt Shinn were often attracted to the unusual lighting angles of the theatre, showing, for instance, the strange transformations brought by the upward cast of footlights giving the tonal effect of a photographic negative.

For others, like Titian, Rubens, Tintoretto, and Ribera, the emotional intensity of expression and the extension to their pictorial vocabulary offered by the use of fire and candlelight, of soft, looming shadows and vivid silhouettes, provided the means of interpreting their subject-matter. So 'spot-lights' could be used, as in the theatre, to direct the viewer's attention to the principal player or other focal point in the design—the beam of celestial light directed on El Greco's ⁶⁷ Christ, for example—and to subdue beneath a broad veil of shadow those forms which serve as supporting units in the composition. Rembrandt, Daumier, and Goya also used wavering cast shadows as ^{84; 62, 176; 82} on the stage and in the cinema to transform the ordinary into the extraordinary and, as in the Caravaggio, to direct the viewer's eye ⁸⁵ around the picture. Daumier paints black-fingered shadows which ⁶² creep across foreground rocks towards the withdrawing silhouette of the apprehensive Sancho—a melodramatic device anticipating the symbolic shadow shapes which cross the silent streets of Chirico's disturbing metaphysical paintings, and which, in movie classics like *The Cabinet of Dr. Caligari*, *Quai des Brumes*, and *Citizen Kane*, created an atmosphere of disturbing uncertainty and of imminent disaster.

When chiaroscuro effects are used in this way to emphasize the emotional significance of certain features of narrative importance in the overall design, they function very much in the way that music on the sound-track of a film may be used to establish the mood and meaning of a sequence on the screen, so that in a film a simple event like entering a house or climbing a hill may acquire a sense of foreboding or optimism, sadness or gaiety, or even of triumph over adversity, according to the mood suggested by the musical accompaniment.

As we become more familiar with the Rembrandt and the Cara- ^{84; 85} vaggio we realize that even more important than the obsessive interest of these painters in the transformations effected by illumination

83

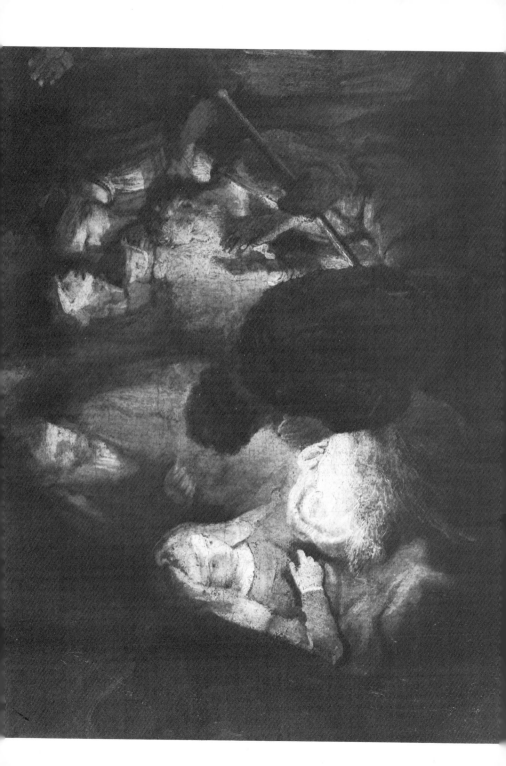

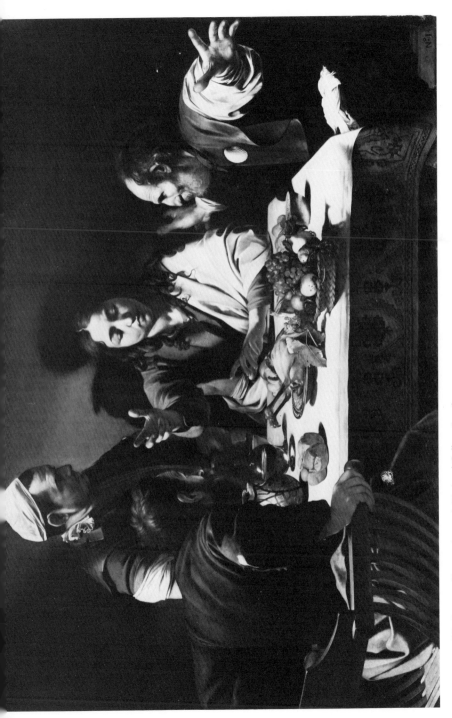

CARAVAGGIO: *The Supper at Emmaus* (*c.* 1595). National Gallery, London

(when these are used in the service of narrative action) is their essential concern with the behaviour of light itself as it spreads across, creeps over, or sometimes is fragmented by the objects in its path. The description of this play of light is more than a pictorial commentary or display of technical ingenuity in surmounting the tonal restrictions of pigment. Both works are, more importantly, interpretations of the manner in which light transforms the commonplace. Since these transitory effects of illumination are organized as tonal patterns the viewer can find in these arrangements an almost melodic sequence of tonal degrees.

In order to discover and to experience these tonal notations the viewer, at some stage of his appreciation of such patterns, should allow his eyes to be directed by the signals flashed by each of the picture's strongest tonal accents in turn. In the Caravaggio these accents 85 are isolated shapes of white and so the tonal journey around the sur- 87 face of this painting may begin at the central focal point of Christ's head, drop to the tablecloth, turn to the right across the picture surface and, via the disciple's napkin (*detail*, bottom left corner), carry the 87 viewer's eye in a spatial, anti-clockwise, peripheral compass of hands, heads, arms, and still-life objects, to return to the centre of the composition and pivotal shape of the movement in the white triangle of Christ's cloak. The viewer should, then, have experienced a rhythmic sequence of various optical signals, a sharp white followed by a blurred stain of black shadow, an even area of light leading to a passage of softly-diffused middle shades, and so on.

The Rembrandt *Interior* seems to be especially concerned with the 81 expression of illumination as an optical experience in itself rather than as a means of interpreting a dramatic human incident—which is the function performed by the tonal patterns of the Caravaggio and the 85 rig Daumier. When the expression of light is the real subject of a painting, 62 such a picture may be appreciated as an almost abstract tonal pattern. The Picasso is an obvious example but the Rembrandt and the Turner 71 should be seen in this way also. Monet's obsession with the movement 26 21 of sunlight virtually made colour abstracts of his later pictures and 10 certain qualities of light—sparkle, flash, glint, gleam, glow, and so on—are important features in many twentieth-century abstract paintings. The calligraphic tonal patterns of Mathieu and Masson, for example, suggest the oscillating linear rhythms recorded by delayed exposure photography of speeding traffic headlights. The black and white Action Paintings of Kline and Soulages evoke the 18 glinting lights which pierce a broken shutter or fence or the tangled roof tracery of a forest; and in the erotic science-fiction fantasies by the

Chilean artist Matta Echaurren, floating structures sparkle and spurt like celestial crystals and outer-space fireworks.

One of the most interesting developments in contemporary painting has been the exploitation by Op artists like Vasarely and Bridget Riley of the optical illusions produced by certain relationships between black and white shapes. Much of the emotional and psychological impact and many of the hypnotic sensations of dazzle produced by black and white Op Art paintings are achieved by an imaginative extension of familiar tricks of optical illusion. Most of us are aware of the effects, for instance, of tonal after-images—the black spot which seems to hover over any surface our eyes rest upon immediately after we have looked up at the sun or inadvertently into a bright lamp. Therefore if we stare at the white spot at the bottom of the tone-scale for a few seconds and then look into the top dark corner of the adjacent aerial photograph, we will see the negative after-image of a black spot on a white rectangle; and if we stare at the black spot on white at the *top* of the scale and then look up into the lighter corner of the photograph, we see a white spot on a dark rectangle. So a Bridget Riley painting composed solely of black spots arranged in sequences on a white canvas has been entitled, logically enough, *White Discs*. If we stare fixedly for a few moments at Vasarely's *Supernovae*, after-image shadows appear at the white linear intersections to create a mesh of dark spots, whilst at the top of the picture, black and white signals flash alternately to left and right with metronomic regularity, balanced by the pulsing white and black 'suns' below.

Our eyes will also record shapes where none, in fact, exist. Thus an arrangement of black bars on a white ground seen at first only as a simple flat pattern becomes, after a moment's study, an optical illusion of ambivalent spatial changes. For each time we are more conscious of the white spaces in this illustration the black shapes appear to recede like shadows beneath a louvred vent or the dark openings between the slats of a sun-blind; but whenever we are more aware of the black shapes these areas seem to advance like the shadowed risers of a steep flight of steps. If we stare intently at the area first seen as a texture composed of black segments it begins to create the white shapes of a square, a circle, an oval and a lozenge— these shapes becoming so clearly defined after a while that they seem to be of more intense white than the white paper of the page surrounding them. As the illusion of this comparative brightness increases, these imaginary geometrical shapes even appear to float upon the page.

VASARELY: *Supernovae* (1959–61). Tate Gallery, London

If we invert a reproduction of a painting in this book we see it primarily as a panel divided into different areas of black, white, and grey, since its narrative interest does not then distract us from considering the light and dark shapes essentially as units of an overall tonal pattern— the Daumier, for example. 62,

I have mentioned the double patterns, that of tone and that of colour, which exist together in the El Greco in counterpoint to one another. 67. Such an arrangement of colour shapes superimposed upon a pattern of lines, tones, and textures, or of a tonal pattern played against and in some passages interacting with a design created in colour, line, and/or texture is a fascinating feature of many styles of painting. Just as we can listen to and follow two or more counterpoint melodies playing together in a musical composition, so we can experience, as a complete visual sensation, an elaborate design comprising inter-woven patterns constructed from several different elements.

This interplay of one kind of pattern against another in a picture is perhaps most easily appreciated in twentieth-century painting. Léger, Gris, Picasso, Braque, and Dufy have made frequent use of 10 rhythmic linear patterns superimposed upon a tone and colour lay-out of painted and, sometimes, of *papier collé* shapes. Klee and Kandinsky (in his *Improvisations*) seems consciously to emphasize the similarities of visual counterpoint with those of the interwoven melodic patterns in music. The technique of Jackson Pollock's Action Painting, by which one physical sequence of brush movements was 18 cast across another set of statements, lent itself naturally to this kind of complex design. Even in a much reduced reproduction some of these interwoven lines and tones can be seen as they are splayed, splashed, and twisted in layers above each other like the underwater weeds and darting fish which perform counter-movements to the drifting flotsam and surface currents of a swift stream.

In everyday life we see other counterpoint patterns of tone across those of line, texture, and colour; whenever, for instance, shadows are cast across a flower-bed. And we witness a contrapuntal movement of colour in play against a tonal sequence whenever a pattern of coloured light thrown down from a stained-glass window breaks across grey stone steps and pillars in a church.

In a diagram I have analysed the composition of a Rembrandt 9: (*A Scholar Studying*), which in subject, setting, mood, approximate size, and date is almost a companion-piece to his *Interior* (reproduced 8: here in black and white.) In this diagram I have illustrated the chiaro-scuro counterpoint which by *scumbles* and *glazes* is spread across a geometrical linear pattern in the same way that Rembrandt played

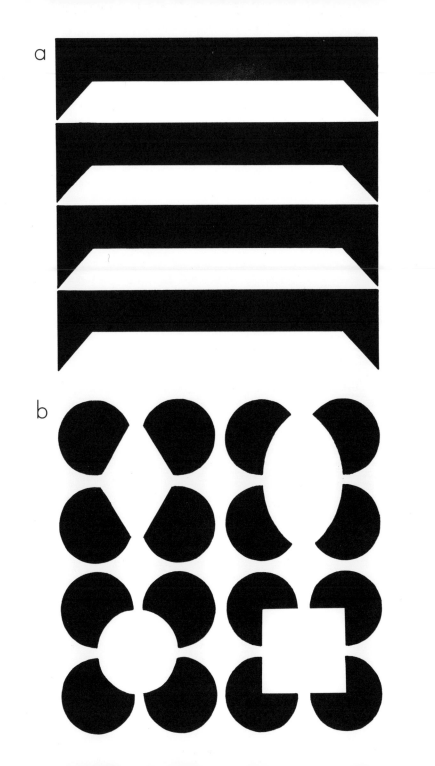

his watered-ink washes against a quill-and-brush linear design in many of his tonal drawings.

Manet's *Olympia*, whilst also an example of a tonal pattern in counterpoint across a linear design, is composed, not of cast shadow shapes, but of areas of natural tone and subdued local colour. Although this figure composition is clearly based on similar designs by Giorgione and Titian, its colour scheme of muted pinks, ivory, greys, and tinted blacks and the boldness and simplicity of its flat tonal pattern are reminiscent of the two-dimensional design of Japanese woodcuts. Indeed this picture might almost have been painted in a technique similar to the systematic overlaying sequences of block-printing. Therefore I have separated the contrapuntal patterns of line and of tone to demonstrate how the contour definition of some of Manet's forms—the cat, the servant's head, the hanging draperies 93 and the background features of the bedroom—have been 'over-printed' or obscured by broad areas of tone relieved, in the original, 93 only by slight local colour distinctions.

As a contrast in style and mood, another scheme shows the restless 93 Baroque vortex-pattern of tones which binds the complex groups of tossing, thrusting, falling forms in the Rubens battle-piece. It will be 13 noticed in this diagram that in some areas of the composition (e.g. 'A') the tonal counterpoint coincides with, and enhances the movement expressed by the picture's forms and contours. In other passages the superimposed areas of lights and shadows create new shapes across parts of the hurtling figures and horses to unite these with light and dark fragments of other forms in the painting (e.g. 'B' in the diagram) to merge in tonal counter-movements which interact with the picture's colour-pattern. 11

We have seen that in the overall pattern of a painting the various properties of tone may act against or in support of the other pictorial elements of line, shape, colour, and texture. In a later chapter I shall refer to the ways in which, with these other elements, tones also function as forces of balance, movement, contrast, tension, conflict, and harmony in the full orchestration of a picture.

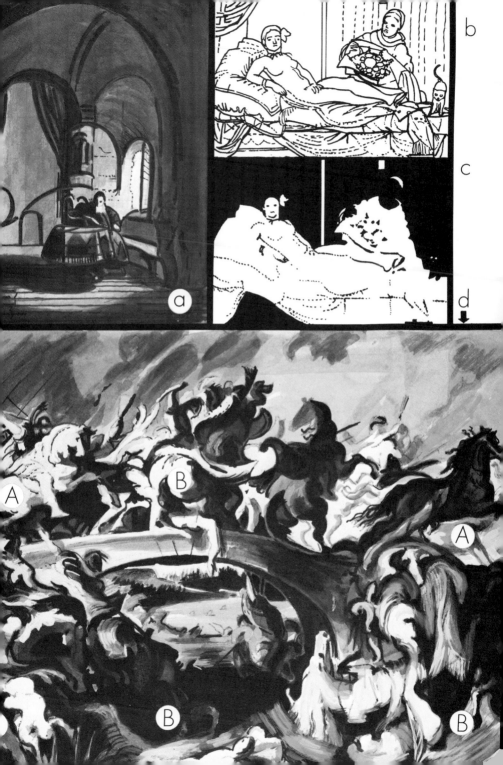

CHAPTER 4 Colour

Until the beginning of the nineteenth century colour was considered by theorists to be merely an embellishment to composition. Indeed in many styles of painting in the past the essential message of some pictures might well have been almost as adequately expressed in mono-chrome. The present century, however, has come to regard colour as a primary element of form as well as a primary expressive element of the painter's language.

In the early traditions of studio painting—those of Byzantine icons, Eastern miniatures, and Gothic manuscript illuminations—a picture was regarded, both by the artist-craftsman and by his patron, as a precious artifact to which colour was added almost as a beautifying agent. The artist's pattern of outlined shapes might, therefore, be en-riched with gold leaf and with such rare pigments as malachite and lapis lazuli, very much as a ceremonial cloak would be embroidered in gold thread and extravagantly studded with jewels.

This attitude to colour as an ancillary means of enrichment sur-vived into the early periods of Renaissance painting, when the more brilliant and costly of the apothecary's pigments, like vermilion and pure ultramarine, would be used at their maximum purity and restricted to the important parts of the composition. The intensity of these isolated hues would then be enhanced by the areas of moderate, quieter colour surrounding them.

Oil painters first favoured a technique by which the main problems of drawing and design were solved, and the illusion of space and volume satisfactorily accomplished, in an initial monochrome tempera underpainting. Figures and background features would be coloured later with overlaid transparent glazes of oil pigment. Colour played but a minor part in these paintings until the essential aims of the artist had been worked out in terms of the hard, precise linear model-ling technique made necessary by the quick-drying nature of the tempera medium. Because of the physical limitations imposed by this method colour had, therefore, much the same status in a painting as the 'penny plain, twopence coloured' value given to a hand-tinted woodcut or metal-engraving. Since these colour glazes in Renaissance painting represented the local hue of things—the green colour of foliage, for instance, and the pink and brown pigmentation of human flesh—their main role in a picture was initially that of defining and identifying individual images more clearly for the viewer.

This intellectual concept of the purpose most suitably served by colour in painting was shared by Classicist French artists of the seventeenth and nineteenth centuries. If we compare the black and white reproduction of the Poussin with a diagram of its colour pattern, 96, 110c we find that the areas of colour are used more to clarify and decorate a composition expressed primarily in lines and tones than to make any contributions of their own. Indeed, had Poussin's choice of colours not had a special symbolic philosophical significance for him, he might well have replaced his colour scheme by one which was visually just as harmonious, decorative, and innocuous. It is interesting to note that when such expressive colourists as Renoir, Degas, and Picasso turned, for short periods, to the formal disciplines suggested by a study of Poussin and Ingres, their colour also served mainly to supplement the linear and tonal expression of ideas.

We realize how far removed was Poussin's concept of colour from the changing attitudes to it elsewhere in Europe since Raphael, if we contrast his colour pattern with that of Rubens, his contemporary, 110c, 110a whose colour masses were spread freely across the linear and tonal boundaries of his Baroque compositions. Chronologically an even more striking contrast may be drawn between the use of colour by Poussin and by Titian nearly a century before, since the Venetian master had already realized that different colour combinations might express emotional states and create sensations of movement and space. It was Titian's revolutionary use of colour which influenced the Mannerist painters Tintoretto, Veronese, and El Greco, and 109 contributed to the remarkable emotional character of their unusual colour relationships.

The mastery of direct oil-painting techniques which had been achieved by the end of the sixteenth century encouraged artists to explore tentatively the expressive possibilities of colour. El Greco, with his roots in the pre-Renaissance culture of Crete, his Italian apprenticeship and the maturing of his creative talent in Spain (where he foreshadowed the dramatic colour orchestrations of the Baroque painters), provides us with a convenient summary of the various attitudes to colour in European painting. For in most of his compositions we find a use of colour which points both to previous conventions and to those roles it was to assume in future styles. In the colour 109 reproduction, therefore, we see a pattern created from almost geo- 110b metrical units of colour, similar to those in the Byzantine icons and 135 murals he would have seen in Greek churches. In the strange, shrill 263e contrasts between the colours of these oval, lozenge, and triangular shapes there is an emotional expressiveness which he may have

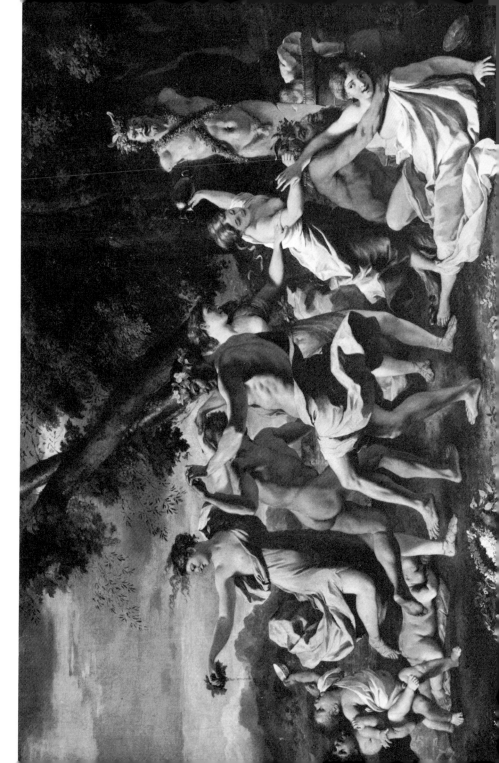

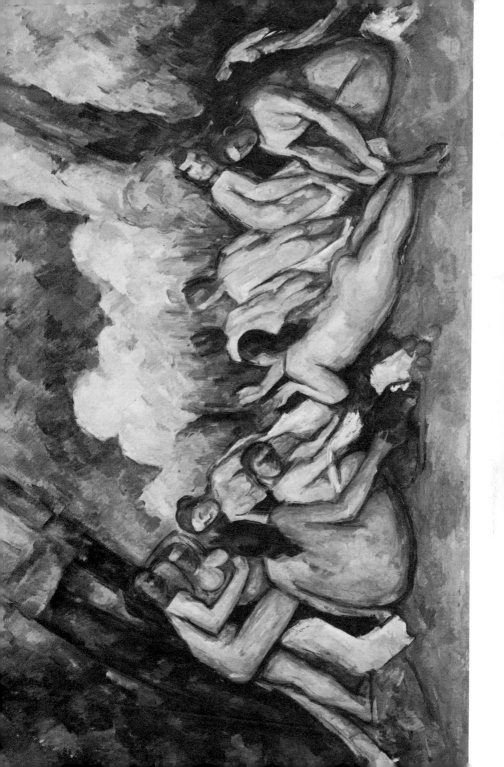

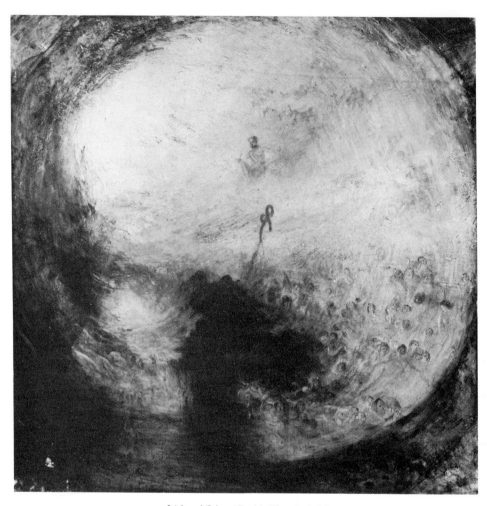

TURNER: *Light and Colour (Goethe's Theory): the Morning after the Deluge* (exhibited 1843). Tate Gallery, London

learned from his study of Titian's work in Italy, whilst in the distant, misty landscape, seen on the far right of the picture as if through a rent in its surface, the lightly brushed streaks of broken colour anticipate the atmospheric colour shorthand of Rubens, Watteau, Gainsborough, and Turner. [17]

The progressive artists of the seventeenth and eighteenth centuries, if they did not yet fully appreciate the expressive possibilities of

colour, did at least regard it as an integral part of the painting. They therefore introduced colour in the early stages of a painting, scrubbing opaque dry scumbles and washing transparent glazes of pigment freely across a ground tinted in warm ochre or deep red earth. The immediacy and flexibility of this method enabled painters to interpret something of those transitory colour effects of light, reflection, and atmosphere in nature which were beginning to interest them. Their direct brush-strokes not only served as accents in the picture-pattern to create sensations of movement and space but, since these statements represented both local colours and areas of reflected colour, might be merged to form broad colour masses which were spread across the shapes defined by line and tone, to become the units of a colour counterpoint-pattern. The use of broken colour in the pastoral landscapes of Rubens and Watteau was later studied and developed by Gainsborough, Constable, Turner, and Delacroix.

When artists have new ideas to express they have to find a new visual language through which to communicate them. In past periods this has generally involved a change in the function and character of shapes, lines, and tones, together with new ways of composing or arranging these elements on the picture surface. But in the nineteenth century painters began to concern themselves more with the possibilities of colour as a means of communication. This was also a period of intensive colour research in the field of science. Thus it was natural for some painters to make use of the findings of physicists in their efforts to get into their pictures the luminosity of light, the transitory effects of the weather, and the vibratory colour intensities of nature. Laboratory research into the nature of colour provided perhaps as great a stimulus and encouragement to the investigations of the Impressionist painters as had the sciences of perspective and anatomy to the Renaissance artists.

Turner made a series of colour experiments based on Goethe's 98 colour theory. Delacroix studied the results of Chevreul's research into dyes and weaving mixtures, and from these developed a technique of 'weaving' strands of pure pigment in order to create more luminous greys and more intense colour mixtures, even inventing his own *chromomètre*, or pigment sequence, based on the spectrum wheel.

New and more intense chemical colours were available to the Impressionists, giving them a range of hues and tones closer to those of nature than had been possible before. We do not know, however, to what extent their choice of pigment colours was influenced by current scientific theory. Possibly it was later that, in the published

99

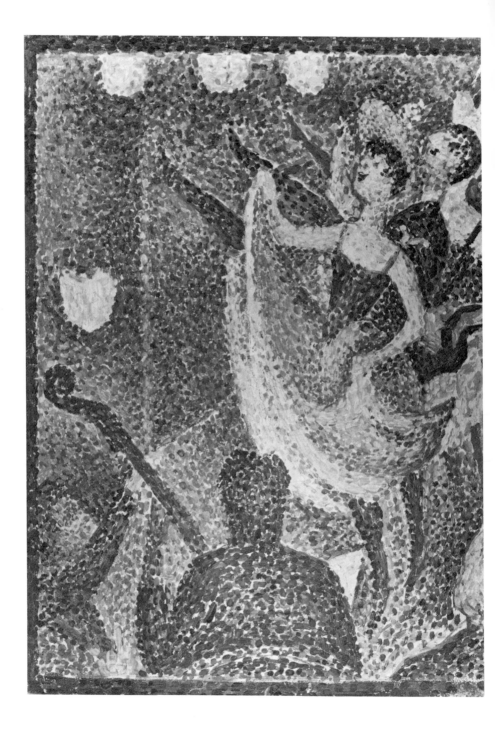

findings of physicists, they found confirmation of the colour analysis of the effects of sunlight which they had already discovered from their own observations of nature. These scientific findings would certainly have seemed to them to justify their attempts to eliminate black and all earth-colours from the palette and to use only those pigments which approximated as closely as possible to the pure spectrum hues. Certainly the colour technique of the Neo-Impressionists (also known as Pointillism) was derived from a systematic grammar of colour based upon the results of scientific research.

Seurat had studied Delacroix's notes on colour and his broken-colour technique; he had also read Rood's summary of the latest colour theories (*Modern Chromatics*), a book which emphasized and explained the essential differences between the behaviour of colour as light and of colour as pigment, between the additive colour mixtures of nature and the subtractive mixtures of pigments. With Signac, Seurat evolved a technique of painting in small molecules of pure pigment as a more scientific, precise, and classical version of the less controlled, more intuitive Impressionist methods of streak, dash, and comma brush-strokes. Placed tightly together on the canvas like skin-pores, these colour spots produced a surface vibration and created sensuously appealing textures over the whole picture ground, as if the design had been worked in *petit-point*. In a landscape painting this granulated texture also captured the hazy shimmer of warm sunlight. To enhance the colour intensity of the sun-bathed areas of their pictures, the Neo-Impressionists interposed dots of complementary colour in adjacent passages of shadow. Unlike the sprinkled highlights Constable used to interpret the sparkling reflections of light, they carefully planned their landscapes as simple patterns of broad light and dark masses in order to give maximum effect to an intricate colour embroidery.

As their research continued, Seurat and Signac began to realize that painters need not be content merely to re-create the colour effects perceived in nature, but that they could make use of the dimensions of colour, its varying degrees of purity, tone, and temperature, and of the dramatic contrasts and enhancements of complementaries, as new elements of balance, tension, and contrast in the design of their pictures, and that the emotional symbolism of certain colour combinations and relationships might be exploited to extend the expressive possibilities of the painter's language.

Monet, though not as directly influenced by Pointillist theories and techniques as his fellow Impressionist Pissarro, also held this concept of colour as an abstract language, and expressed it in his

URAT: Study for *Le ahut* (1889). Courtauld stitute of Art, London

100

declared wish to have been born blind in order to gain his sight and thus be able to paint objects without knowing what they were. It was also implicit in his advice: 'When you go out to paint you must try to forget what objects you have before you—a tree, a house, a field— merely think, here is a little square of blue, an oblong of pink, here is a streak of yellow, and paint it just as it looks to you.'

Monet, of course, was concerned with the colour phenomena in nature which excited him. Seurat, however, in his latest period imposed his own range of colours on the subjects he painted. Since his choice was determined by the intellectual, emotional, and sensuous functions which he expected colours to perform in his pictures, rather than a wish to recreate the colour effects seen in nature, his paintings were attempts to demonstrate his belief that a language of colour might be evolved for expressing the emotional qualities of nature. Thus, where before only lines, tones, and textures had been considered capable of expressing emotions, creating illusions of volume and depth and, with shapes, of providing the qualities of balance and tension which are essential to pattern, it now seemed possible that, by the exploitation of their special qualities, colours might also perform these functions.

The possibilities presented by this new concept of colour as an expressive agent were explored by painters for different ends. So Cézanne used his 'plastic' colour to create illusions of volumes and weight; Gauguin and Van Gogh, influenced by Seurat and by the aesthetician Henry, were as much concerned with the psychological meanings of colour-relationships as with the physiological possibilities of colours, and therefore used them to express certain emotional states—an emotive colour-symbolism which inspired Redon. Excited by the bold coloured shapes of Japanese woodcuts, Degas and 36, Lautrec, and also the Nabis, Bonnard, and Vuillard, composed 260 their 'snapshot' paintings in patterns of flat colour; and while after them the Fauvists re-discovered the sensuous delights of colour, the Futurists used it in their search for the mechanics of movement.

The beginning of the twentieth century saw colour established as a *primary* means of pictorial communication. Matisse, for instance, found that colour could not only interpret the intensities and vibrations of light, the structure and volume of forms, and express the artist's emotional response to a particular visual event in nature, but that it could also create its own events on the picture surface. Thus colours, by their relationships, could provide their own kind of balance, rhythm, structure, texture, and spatial dimension indepen-

MONET (1840–1926): Detail from *Water-Lilies*. National Gallery, London
© SPADEM, Paris

dently of any forms or recognizable themes defined in the painting in terms of line and tone.

Braque also insisted that colour should be used only for the sake of the optical sensations it could provide and, following the almost monochromatic schemes of his Analytical Cubist period, said of his own and Picasso's Synthetic Cubist *collages*: 'We reintegrated colour

with paper stuck on canvas. What we were trying to do has not always been very well understood, yet it is very simple. We wanted to make colour independent of form, give it autonomy.'[1] This abstract use of colour was carried still further by the Orphists and Delaunay. 249

In many paintings today even pigment textures provide no counter-attraction to the dominant importance of colour, since the growing preference for acrylic emulsions because of their greater range and intensity of colour over those of oil-bound paints is offset by the matt, uniform, and impersonal surfaces they produce. Whether it is perceived intellectually in its more descriptive role in Pop Art narratives, emotionally in the colour pyrotechnics of Abstract Expressionism, or sensuously by surrender to the visual teasing and physical excitement of Op Art and the colour interplay of Hard Edge abstracts, we find not only that colour has become the most important expressive element in much of contemporary painting but that the optical sensations of colour are fascinating enough to be able to provide the very subject-matter of a picture. This discovery has been a particular contribution of the American abstract painters, whose ideas have dominated international movements since the mid-century. Their works have often been on the heroic mural scale of Monet's last pictures.

The glowing rectangular fields and horizontal bands in a Rothko, for instance, and the vast, shimmering surfaces of Olitski seem to envelop the spectator in seas and skies of colour. As Monet's interpretation of the play of light on water invites us to watch a continuous 103 optical performance taking place between his patches of luminous colour, so in a Morris Louis we seem to witness a perpetual unfolding of petals of colour, or experience the illusion that vertical bands of stained-colour are rising and falling through some hidden mechanism, as if the picture surface had become a polychromatic pianola keyboard. When we see a Noland target painting we may feel that his colour-banded circles are beginning to turn and to pulsate like a timeless catherine wheel, while as we become absorbed in the pattern of an Albers or a Youngerman of the early nineteen sixties an optical 106 conflict seems to take place between the two or three great shapes of intense colour which share the picture space, as first one asserts its 197f dominance as the primary image, only to retreat and become the 197g supporting field for its rival.

The expressive language of colour, whether used consciously or intuitively, and whether in abstract or in representational styles of

[1] Quoted in Jacques Damase: *Braque* (London, 1963).

QUE: *Oval Still Life Violon)*, 1914.
eum of Modern Art,
York: Gift of the
isory Committee;
DAGP, Paris

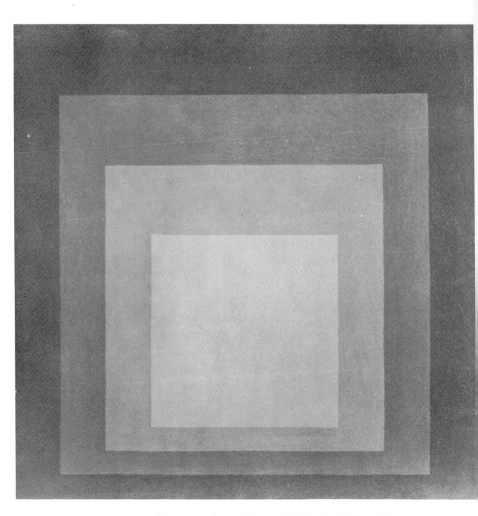

ALBERS: *Homage to the Square: Departing in Yellow* (1964). Tate Gallery, London

painting, depends upon the tensions and harmonies, the subjugations and enhancements brought about by the different ways in which colours react upon one another in the picture pattern. Since we do not see the colours of everyday things in terms of the relationships which exist between them within the closed society imposed by the physical limits of the picture-surface, our casual, everyday colour perception may not always be adequate for appreciating these dynamic qualities in painting. We should, therefore, re-examine our attitude to colour,

f

d

g

h

e

and remind ourselves of its basic physiological and psychological principles.

Some people, perhaps, are interested only in the more striking manifestations of colour in the bizarre display of a sunset or a rainbow, in the novelty of exotic blooms or brilliant plumage, and are scarcely aware of the continuous carnival of colour which many painters see in the same environment. Unconsciously most people tend to acquire prejudices and preferences determined by personal sentiment and experience or imposed by fashionable taste. But for the painter—and for the viewer, also, if he is to understand the various functions performed by colours in painting, and learn to enjoy the sensuous pleasures they offer and become receptive to their emotional symbolism—no colour can be regarded in isolation as intrinsically more important, more useful, or more beautiful than another. Individual colour preferences are not out of place. Nor are there in painting any forbidden colour liaisons. For, to the artist, an individual colour has intellectual and emotional significance and a sensuous quality *only* in terms of its relationship with the colours surrounding it. Since each colour becomes a member of a special company immediately it enters the arena of the picture-surface, its inherent characteristics will certainly be changed in some degree by the influences of its neighbours. A colour which exhibits certain traits in one relationship will, like the human personality, have these subdued and others brought out in another. For example, the lemon pigment which makes a soothing harmony in the yellow-green area of a painting will produce a shrill vibrating contrast if it is placed against a violet in another part of the same composition.

Each colour in a picture-pattern should, therefore, be observed by the viewer as it would have been considered by the artist; as an integral unit of a whole colour-structure—an organization unique to each painting.

Since the colours of things are transmitted to us by light radiations, objects lose their colours under moonlight or in a dimly-lit room, even though their spatial form is still clearly perceived. Unlike qualities of shape, volume, weight, and texture, colour is not a permanent property of the things we see but is the most elusive and subjective of all the visual elements in nature.

Because our colour memory for the things we see is poor we usually think of things and refer to them in terms of local colour. Thus we speak of *green* grass and of *red* or *yellow* brick even though we would be

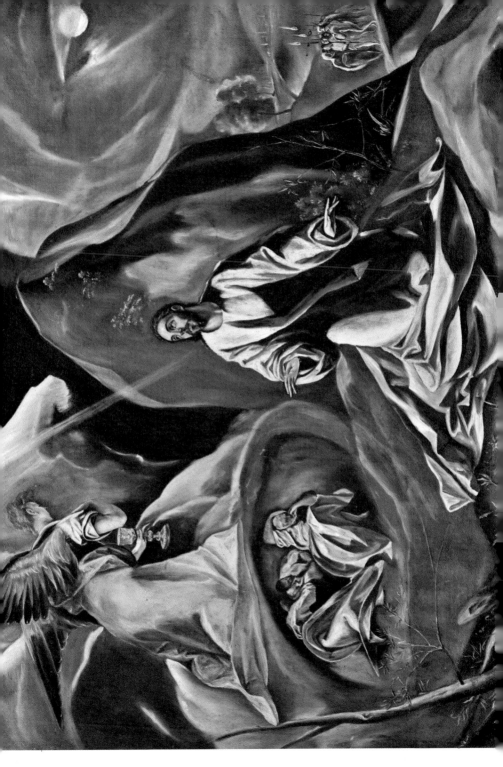

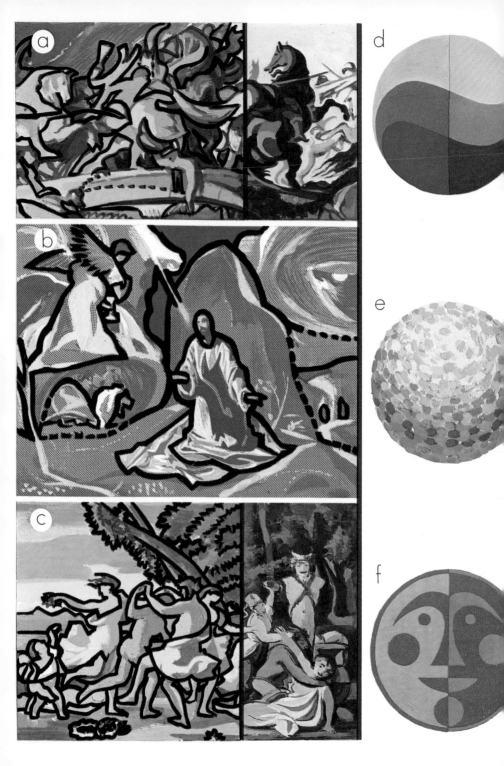

unlikely to see their inherent colour except under unchanging light at noon on a clear but overcast day. Under all other conditions the colours with which we associate things are modified by the effects of sunlight, reflection, and shadow; and in some degree also by the retention in our eye of the colour we have seen immediately beforehand. Yet so irrevocably are certain hues associated with certain things—and vice versa—that we name some things by their local colour and some colours are named after particular things; oranges, lemons, roses, violets, apple-green, sea-green, sky-blue, daffodil-yellow, lavender, lilac, and so on. Since we often mentally anticipate the colour by which we 'know' an object, we tend unconsciously to adjust our perception to these modifications in nature and so we may be surprised to find, for example, a green-shadowed face or a blue-tinted horse in a painting, even though we could have observed such phenomena in nature ourselves.

So used are we to 'seeing' only the colours we expect of the things in our environment that we tend to remain insensitive to many of the ten million or so different colours around us, and to see the colours of things in accordance with our mental concept of them for most of the time. This is the 'natural' way of seeing many aspects of the outside world. Yet we can, at least, become more sensitive to the different dimensions of colour, and this sensibility is essential to the appreciation of colour in paintings.

A simple exercise helps us in this and also alerts us to the colour dimensions in paintings. For it is easy to make our eyes serve almost as colour-filters of the things around us. In order to practise this latent ability we have only to relax and allow our eyes to be drawn to the area of most intense colour in our immediate environment. On that area we should then concentrate, seeing and thinking only of its particular hue. If, for example, our attention has been drawn to a yellow object, we should become aware after a few moments' concentration upon it of yellow signals flashing from a number of points within our immediate field of vision—an unsuspected yellow within the light brown of a chair, the presence of yellow in an object we have always considered white, a previously unnoticed yellow highlight and the 'call' from the yellows within all the orange and green objects around us. After a minute or two we should then be conscious of insistent countersignals from the blue-violet range of colours—the complementary of yellow asserting its own presence.

The painter expects us to be able to respond to the colours in his picture in this manner also. Therefore by allowing our eyes to find, and to remain fixed upon, his focal point of colour, we should become

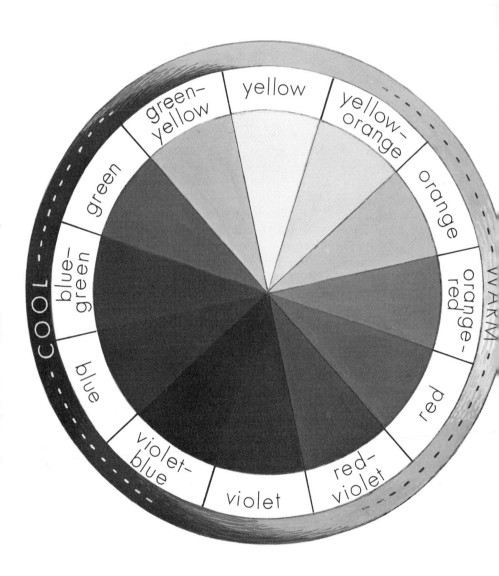

Colour wheel

conscious of the colour signals flashed from carefully placed accents, of the muted background chorus of supporting 'family' colours, and of the opposing voices of contrasting colours.

Since this orchestration or debate arranged between the colours of a great painting exploits the various characteristics of colour, we must now examine these distinctive qualities. The chief of these dimensions of colour are known as the three variables of hue, saturation, and brightness.

A hue is the basic type of colour; yellow, orange and red are therefore hues. The saturation of a colour denotes its degree of hue intensity; when we speak of a rich green, or an intense red, we are referring to its density, the strength and amount of its distinctive hue. For example there is a higher level of yellow saturation in the colour of a lemon than in that of a banana. Brightness is the tonal quality of a cf. 107g, b hue—its relative lightness or darkness.

HUE In physics the colours of the spectrum may be obtained by various mixtures from a triad of coloured light-beams. Red, green, and blue-violet form one of a number of these light triads; if all three of these light-beams are mixed, white light will be transmitted. These light triads are known as the additive primaries and their behaviour is important to those concerned with stage lighting, psychedelic happenings, colour television, some aspects of cybernetic art, and the continuing research into our colour vision.

The only triad of pigment primaries, however, is red, yellow, and blue, and from these all other colours on the painter's chromatic scale can be made by mixtures. With mixtures between two pigments each pigment absorbs a certain range of light, and only those wavelengths are reflected back which neither pigment absorbs. For example, if white light falls on violet paint—that is, a mixture of red and blue paint—the blue pigment absorbs everything except the range blue-green, blue, blue-violet and violet, and the red pigment absorbs everything except the range orange-red, red, red-violet and violet. We therefore see the common element of violet because everything else is absorbed, or subtracted, from the colours of light by one pigment or the other. The pigment primaries are, therefore, known as the subtractive primaries.

Because pigments are opaque substances their colours behave differently in mixtures from those of transparent light-beams. For instance, in light the addition of red to green produces yellow; in pigments this colour mixture makes a dark grey. In light an inter-

mixed triad of additive primaries produces white; in paints the mixture of the primaries makes a brown-black.

The mixtures of pairs of pigment primaries produce the secondary colours of the chromatic scale: orange, green, and violet. By increasing (theoretically, doubling) the amount of one primary in each mixture the so-called tertiaries of yellow-orange, orange-red, red-violet, violet-blue, blue-green, and yellow-green are produced. In practice it is not in fact possible to make all of these secondaries and tertiaries from three basic paints, since there are no available red, yellow, and blue pigments capable of producing them all accurately. There are no true mid-blue pigments, for example, and so to make the secondaries and tertiaries derived from blue we would have to use both a blue tending towards violet (ultramarine or cobalt) and one containing an element of green (prussian or monastral blue). But this is a technical point. What is really important to our full appreciation of the interaction of colours in a painting is our understanding of their family relationships and of the contrasts between opposites in the whole colour-pattern of a painting.

In examining these relationships and contrasts we can refer to a colour wheel in which twelve hues are arranged in segments. Placed 112 between the primaries are the secondary and tertiary hues which two primaries create by mixture. We therefore have a gradated sequence: yellow to yellow-orange to orange to orange-red and so on. A colour range made between two primary or parent hues—red-violet, violet and violet-blue, for example—will usually provide a harmonious family relationship in a picture. A painter may interpose such a colour range if he needs to avoid a contrast between two primaries in a certain area of his picture. Conflicts can also be avoided, if necessary, between other colour pairs, red and green for instance, if they are separated by a colour mixture of the two—which in this case would produce a grey—or by a neutral corridor of grey, black, or white; in this way each colour would retain its autonomy, though we may be still aware of the flickering optical tension between them across the dividing no-man's-land of neutral colour.

BRIGHTNESS In daylight the local colour of a solid object is modified both in those areas where its planes face the light-source and in those where they are in shadow. Therefore the lightest folds of a creased yellow fabric would under normal conditions appear cream-coloured, whilst its shadows would seem olive-green. Naturally the painter can match his pigments to these colour variations by adding white to his yellow pigment to produce the lighter tone and black or grey to make its

darker values. In painting we define a lightened or brighter tone of a hue as a tint, and the darker or shadowed tone as a shade. Since additions of grey, white, or black reduce the intensity of any pigments, the tints and the shades should be seen as degraded or de-saturated hues.

Tints are familiar to us in everyday life as the pastel colours of pink, lavender, lilac, powder blue, pale turquoise, ice-green, cream, peach, and salmon; and shades as the greyish colours of mustard, olive, russet, burgundy, maroon, slate, mistletoe, and moss. We may have our own vocabulary for these, based on personal experiences, or acquired from some fashion change in dress or interior decoration—changes probably heralded at the time by new evocative names coined for familiar tints and shades.

Attempts have been made to establish standard colour vocabularies for use in industry to avoid the confusion brought by the many current romantic, and often ambiguous, descriptions. The British Colour Council publish a 'Dictionary of Colour Standards' for textile and dye industries and a 'Dictionary of Colour for Interior Decoration' as well as a 'Horticultural Colour Chart'. There is also a 'British Standard Institute Colour Dictionary for Building and Decorative Paints'. But whatever names and associations we give to colours seen in everyday life, it is important that we should neither allow ourselves to look at any colour in a painting in isolation or associate it with some specific object or event in real life or with some pleasant or unpleasant personal experience. We should perceive all colours and colour combinations only for the part they play in the picture.

It will therefore be found more helpful to our appreciation of the interdependence and interaction of all colours in the structure of a painting if we can consider these tints and shades in terms which relate them immediately to their parent hues rather than identifying them by names which merely refer to particular objects in nature. If, for example, the kind of sombre crimson some people call 'ruby', and others 'port wine' or 'deep cherry', were instead to be thought of and seen as a shade of red violet, we should then be already thinking of and seeing that colour in terms of its component colours—that is as a mixture of red, blue, and black. We should then be able to anticipate a relationship between this dark crimson and any areas of red, blue, and black which might be present in the painting.

The ability to analyse tints and shades as the derivatives or modifications of particular hues—that is as pure colours with the addition of black or white—may be developed simply by observing the manner

in which a shadow (or shade) falling across any intensely coloured object or surface will not only, by its contrasting greyness, enhance the intensity of the hue, but will call out a response from any neighbouring area of black or grey. We should also find that the lightest section of a coloured object (its tint) seems to be drawn towards any surrounding white shapes since white is part of its mixture. By exercising this perceptual skill we prepare ourselves for the fascinating interplay which so often exists in a colour-pattern—like a conversation or a part-song—between tints and shades, both with their hues and with surrounding areas of black, white, and grey.

I have said that when secondary and tertiary colours share a common hue they form a family group. By the same principle the addition of white or black will reduce the contrast between opposing hues so that the conflict between two unadulterated hues, which might be likened 110d to a fierce argument, would become more of a low grumble as a contrast between their shades, and a high-pitched twitter when between their tints. Painters often use background areas of tints and shades as distant or muffled echoes of a main colour theme stated in the hues; the strong reds and blues of the Rubens are echoed in the dusty pinks 110a, and slate-blues of the sky, for instance. Thus the viewer whose attention is held by a focal point of two pure hues in strident contrast will often find himself half aware of their muted accompaniment by a background chorus of greys tinged with the same hues: violet and yellow surrounded by area of lemon-grey and purple-grey, for example.

These optical sensations between hues and their tints and shades, with their obvious parallel to certain experiences in music, may be felt in the El Greco. In this work we find that when our attention is 109 focused on the intense blue of Christ's cloak we are conscious of a 110b muted echo in the slate-blue grey of the surrounding clouds, and that when our eyes are fixed on the yellow triangle of the angel's dress we become aware that this hue is finding a response in the yellow shaded triangles of rock.

Used in a representational work like the El Greco, the relationship of hues to their tints and shades has often a narrative and an emotionally expressive significance as well as being an exciting optical sensation. In this painting the most intense colours are given to the two principal images and the shades and tints of these to the bleak landscape setting, thus emphasizing the symbolic isolation of Christ and the angel. In an abstract work the sensuous play between a hue and its shades and tints may be the very purpose of the painting.

When tints and shades are placed in these relationships against their

hues they become the most subtle and elusive of colours. The tints are capable of expressing the rare lyricism and opalescence of a frosty dawn sky and the shades the glowing and mysterious splendour of garden colours in the moments before sunset. Some painting-patterns contain no pure hues at all, being composed almost entirely in tints like a Marie Laurencin or a Ben Nicholson, or in shades like many Chardins, Daumiers, and Braques. Such colour schemes are retrieved from anaemic pastel prettiness, or murky earth drabness, by striking tonal contrasts and subtle colour tensions. Since the lightest tint of a hue is a colour-tinged white, and the darkest shade really a colour-stained black, we often find that in addition to the colour induced in a grey, a black, or a white by surrounding influences, the apparently 'neutral' areas of pigment in a pattern may in fact be a very deep or a very high-keyed colour—like the purple-black shapes of sky in the El Greco or the colour-tinged blacks and whites of Manet and 109, 110b Velazquez. 75

THE NATURAL
TONAL SEQUENCE
OF HUES

Whilst the intensity of every hue can be modified by various degrees of tone, each has its intrinsic tonal value in relation to others. We think of yellow, for instance, as being inherently lighter than violet and of blue-green as darker than orange. On the colour wheel I have indicated 112 approximately this 'natural' tonal order of the basic hues; from this it can be seen that the most saturated hues in the blue range are darker than those with a high content of yellow.

Perhaps the strangest, and in some relationships the most disturbing, of colour sensations are those created when this tonal order is changed between colours which are adjacent in a painting. Blue, for example, is perceived, both in the spectrum and in the range of pigment colours, as a hue inherently slightly darker than red. If, however, blue is lightened in tone to equal the brightness quotient of red, and these are contiguous in a painting, a restless conflict between them will animate that section of the pattern. Since each of these colours is autonomous in the sense that neither is a mixture containing part of the other, in finding themselves uneasily linked by a common tonal value it is as if they were determined to assert their independence of one another.

Therefore if we stare fixedly for a moment or two at the right hand half of the red and blue mask image, we should become aware that 110f along the dividing edge of each colour area thin lines of great intensity emerge—a pale contour on the blue shapes and against these a dark line of rich red. When, however, we stare with concentration at the left side of the image, the red shapes seem at first to be reduced in colour

intensity until within them a fiery orange begins to glow, whilst blue shapes seem to float around the red against a sea of lavender.

Sensations of this kind have been consciously contrived in many Op Art paintings. An optical shock is also experienced, though to a lesser degree, when a primary and a secondary or a tertiary colour are given the same, or a very close, tonal value and are placed together. Matisse was particularly fond of enclosing a shape of pink (i.e. tint of red) in an area of the secondary hue, orange, and Bonnard often used a texture composed of close tonal values of pink and blue scrubbed in streaks across a field of pale violet to create an optically dazzling surface.

Comparable optical effects of this kind are also found in paintings of earlier centuries, and complete reversals of inherent tonal values were common in compositions depicting a tense dramatic event. In many passages of the El Greco, for example, we find the 'natural' tonal sequence upset, with the result that oscillating tensions are created between the acid pink lights of the crimson gown and the adjacent shaded yellow (or mustard) areas of rock, and the dark blue-green shadows of the cloak. There is also a tone/hue conflict between the lighter tones of the blue cloak and the surrounding areas of shaded yellow whenever these colours meet one another. These dramatic colour dissonances make an important contribution to this painting's mood of tense spirituality.

INTENSITY The degree of saturation (or intensity) of a pigment hue in a painting is affected by the artist's methods and materials and by the colours he selects to surround it in his pattern. Most of his colour media are made from the same earth and mineral substances, and with the same vegetable and chemical dyes. Whether the medium is known as watercolour, tempera, oil, pastel, gouache, cellulose, enamel, or acrylic resin is determined by the type of binder and thinner employed to make the powdered pigment a workable substance on the painting ground. The physical properties of these additives may modify the natural intensity of a particular type of paint. Oil-bound pigments, especially, if further thinned with oil and if their final layer is later varnished, tend to darken with time, whilst pastels, being ground pigments bound only with gum, may retain in spite of their powdery frailty their original brilliance and brightness for centuries.

The technique by which a painting medium is handled will also affect the inherent intensity of colours. A large expanse of pigment spread directly across a brilliant white painting ground will usually give the impression of a higher degree of saturation than will a smaller

area of the same physical type of paint used thinly over a dark earth or grey ground. Gauguin, Rothko and Ellsworth Kelly are among those artists who have endeavoured to envelop the spectator in expansive fields of colour, whilst the members of the Pre-Raphaelite Brotherhood aimed to re-create, on their carefully prepared gleaming gesso grounds, the colour intensity of Gothic miniatures.

In the Renaissance period the range of intense pigments was very limited compared to the number available to the artist today. The Renaissance painter therefore delighted in using an intense pigment for its own sake, according it the most important position in his composition and surrounding it with those colours which would most enhance it.

In the previous chapter I referred to the Classicist method of modelling a form by the use of tonal values (or shades) of its local hue. By the *alla prima*, or direct oil painting, technique these darker shades were often made by degrading the pigment on the palette by the addition of an opaque grey, black on brown, or its complementary hue. One of the reasons the Neo-Impressionists used different coloured spots of colour for areas of shadow was to avoid the loss of intensity which resulted from the mixture of opaque shades in the palette. But by the earliest oil-painting techniques there was less loss of intensity, since all tonal modelling was first completed in a monochrome underpainting and the local hue subsequently washed over as a transparent glaze of thinned pure pigment. The difference in degree of intensity between the palette-mixed opaque shade and the transparent glaze, which becomes darker where it passes over an area of shading, is like the difference between a shaded patch of material sewn on an intensely coloured fabric and the glowing shades produced when a grey and white patterned fabric has been dipped in a strong intense dye.

Although the *alla prima* method of applying paint might result initially in areas of degraded colour, the intensity of a particular hue might be restored and even enhanced by the skilful exploitation of certain characteristics in the other colours surrounding it. Just as the audience of a stage-illusionist enjoys its deception, so the viewer may have to grant exasperated admiration to the artist who can make him accept an earth-brown as a brilliant red or force him to see a commercial, mass-produced green as some unique and secret pigment because of the unusual glowing intensity it has acquired through its contrived relationships with the colours around it. We have only to mask the colours surrounding two of the brilliant hues in the El 109 Greco—the yellow of the angel's gown and the blue of Christ's

cloak—to appreciate the skill with which this apparent alchemy has been achieved. For without the shaded yellow of the rock units in the pattern the ferocity of the purer yellow is tamed; and the jewel-like brilliance of the blue fades to the softness of weathered distemper when the slate-blue areas of sky, which had provoked this illusionary intensity, are hidden.

In some paintings a hue will be given its maximum intensity by its situation against a field of neutral grey as in a Velazquez, or of black, as in a Manet, or of white, as in a Mondrian or a Malevich. In others full 271 intensity will be retained by framing an area of colour in a black contour like a Rouault and some Picassos, or by embracing it with the 71 white outlines sometimes used by Braque, Matisse, and Dubuffet. 156



COMPLEMENTARY COLOURS

The complementary to a pigment-primary is the colour made from a mixture of the other two primaries. For example, since green is a mixture of yellow and blue, it is known as the complementary of red. This is because green and red together complete the pigment primaries of red, yellow, and blue. The main pigment complementaries are easily found on our colour wheel, since they are those hues 112 which are opposite to one another. Therefore yellow is complementary to violet (blue mixed with red) since all three primaries would be represented in this combination. Blue is complementary to orange (yellow mixed with red), yellow-green is complementary to red-violet, yellow-orange to blue-violet, and so on.

When complementaries are placed adjacent to one another they not only create a vibrating contrast of opposites, but produce an effect of mutual exaltation or enhancement. The effect whereby a red contiguous to a green would make the red appear more fiercely red, and the green to be more intensely green, was termed 'the law of simul- 107 taneous contrast' by Chevreul, whose findings influenced the colour theories of Seurat, Signac, and Van Gogh. Seurat also frequently exploited Chevreul's 'law of successive contrast': namely, that any sequence of colours would be enhanced if placed adjacent to a range of its opposites—a sequence of red, orange, and yellow contrasted with one of green, blue, and violet, for example.

Of course the complementary pairs used in painting are not limited to those I have referred to from our colour wheel. A painter may, for example, use a yellow pigment faintly tinged with green—a yellow-yellow-green—and for this the complementary colour would be one which we might term a violet-violet-red. The shades and tints have their opposites also, the complementary of pink (the tint of red) being 11 pale green (that is, the addition of white to green), and that of russet

(a shade of orange) being slate-blue (or the shade of blue). When a pair of complementary tints or shades is equally de-saturated the optical sensations between them are less dramatic than those created between the opposites of pure hues. This is because the effects created appear to take place beneath a shadow of black, if they are shades, or through a white mist, if they are tints. Yet, the throbbing sensation of complementary shades, and the shimmering effect produced by opposite tints, may be essential aesthetic qualities in the colour relationship of a particular painting.

The effect of a complementary relationship may be modified in a painting by the colours surrounding it, and in nature the local colour of an object is influenced in varying degrees by the colour of the prevailing light. Therefore the most accurate visual evidence of a colour's complementary is provided by the familiar optical phenomenon of colour after-images. This sensation is like that of the tonal negative pattern we can see before our eyes immediately after staring fixedly at a black and white picture. Thus if we *fixate* an area of colour for about ten seconds and then look across to a neutral surface, we see the image glowing upon it in its complementary colour. If the original colour of the image is yellow-green, its after-image will be in red-violet, if violet-blue it will be yellow-orange, and so on. We can demonstrate the accuracy of such complementaries if we stare at one or two of our colour diagrams and then turn our eyes to the white margins of 107, 110 the facing page, where we should then experience the sensation of precise colour after-images apparently floating on the surface of the paper.

Just as a complementary after-image will appear to tinge a white surface with colour, it will also induce a complementary hue in areas of grey. For example, in the red/green mask combined here, the 107a neutral field of the red-featured 'face' appears to be tinged with green and cooler than that of the green-featured face, which seems to be influenced by red—although, in fact, both images have the same 107e neutral grey ground. If we stare at the green flower with its violet centre and pink leaves we see in its after-image the colours of a wild rose.

Velazquez and Vermeer, and many other painters whose colour-patterns were composed of large areas of black, white, and grey pigment, employed this principle, consciously or not, to create from neutral colours the sensations of pearly greys and subtly tinged blacks. In order to experience fully the optical effect of such after-image colours, the viewer should stare into these paintings long enough for the complementary action to take place before his eyes.

In the outside world this after-image effect is demonstrated drama-

tically in the blue-violet hue of the shadows cast across snow and white-washed walls by intense yellow-orange sunlight. The Impressionists observed that, in a clear atmosphere, the shadows on objects of even the most saturated hues are influenced by the complementary of their local colour. By introducing separate patches of complementary colour into the shadowed areas of their landscapes—blue into the shadows of an orange roof, for instance, or violet into the darker side of a yellow haystack—the Impressionists endeavoured to interpret the colour qualities of sunlight, just as Constable had shown the changes effected by transitory weather conditions when he echoed the dominant colour of his skies in parts of the landscape below.

When complementary colours are placed near together in a painting —especially when one of these is a primary and both are intense hues—violent optical vibrations are produced as each seeks to assert its special qualities and dominate the other. As a result of this conflict each becomes more intense in hue. This phenomenon of mutual enhancement is demonstrated by a comparison between the strident green of the red and green disc illustrated here with its weaker vibrations when seen against the grey ground and against yellow. This principle of reciprocal action is exploited in many fruit-markets where as an eye-catching sales-booster a few red tomatoes will be placed among a massed display of green grapes or apples, the 'sun kissed' warmth of a pyramid of oranges is emphasized by interspersed accents of blue paper, and the golden yellow of ripe grapefruit is reinforced by showing part of its violet wrapper. By similar means El Greco, in placing the red-violet robe of Christ against its complementary in the yellow-green shade of the rocks, draws our eye irrevocably towards it as the colour focal point of the picture and at the same time brings out its maximum intensity.

Even when a pair of complementary hues are widely separated in a painting a tension will still be felt to exist between them. Painters often exploit this odd phenomenon both to carry the viewer's eye from one part of the picture to another and also to reinforce a narrative and pictorial relationship between images. Thus in the Chagall, for instance, the impression that the lovers are floating above the ground is enhanced by the tension set up between a small patch of green in the upper figure and its complementary in the red floor below him. In their narrative context, and by their spatial relationship to one another in the pattern, the red and green shapes exert a tension which seems almost as strong as a gravitational force.

In this Chagall the green, being the smaller area of colour, performs a different role from that of the larger patch of red, and seems to be

CHAGALL: *The Birthday* (1915). Museum of Modern Art, New York: Lillie P. Bliss Bequest; © ADAGP, Paris

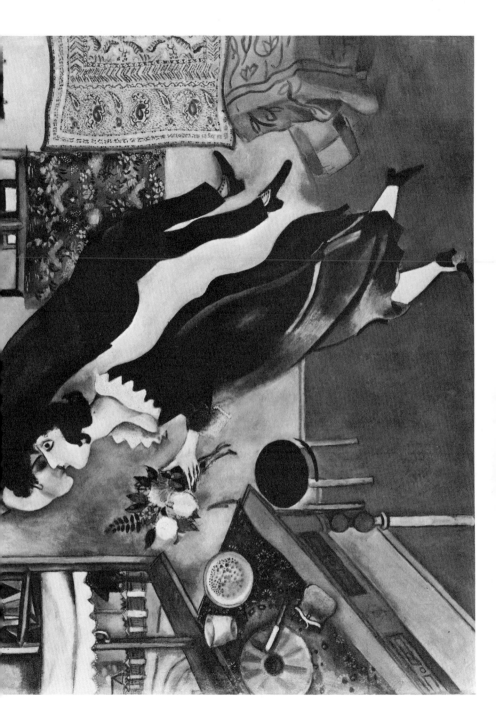

attempting an escape from domination by its complementary. But when equal areas of two complementaries exist together in a pattern each demands to assume the principal role and action of the picture. So the purpose of some Op Art paintings is to present the viewer with a continuous spatial shift as first the areas in one hue advance, only to retreat as those painted in the complementary colour become more vibrant and move forward. The optical changes which occur when *equal* areas of two complementaries are placed together in a picture is demonstrated by the comedy/tragedy theatre-mask diagram in red and green, where the facial expression alternates between joy and sadness as each complementary hue in turn asserts itself.

TEMPERATURE Colours are also distinguished by their relative warmth or coolness. On the colour wheel I have indicated by two perimeter arcs the approximate temperature zones of the basic hues. For various physical, psychological, and physiological reasons colours containing a quantity of blue appear cooler than those containing a higher proportion of yellow or red.

These are relative distinctions, of course, since few paintings are composed of the full range of basic hues. Yellow-green, for example, is seen as a cool colour when in the company of reds, but in a pattern dominated by blue or blue-grey it would appear comparatively warm. But since in most pattern-relationships an area of warm colour will appear to advance in front of a cool one, painters concerned with creating an illusion of depth and volume will often use colours from the blue range to interpret receding planes, and colours from the red-orange-yellow range to indicate an advancing plane.

FORM AND SPACE Everyone is familiar with the bluish-grey veils of intervening atmospheric layers which exert a progressively cooling and degrading influence upon the hues of distant landscape features. It was already a convention in early periods of Chinese and European studio painting to exploit this optical sensation of aerial perspective in order to create an illusion of depth on a two-dimensional painting surface. By the eighteenth century it had become an automatic device to define the spatial dimensions of an outdoor composition in three bands of colour: the foreground in dark orange-brown, the middle distance in pale green or yellow and the most distant zone in grey-green and bluish tints.

Cézanne, however, being more concerned with the analysis of volume and structure than with the representation of vast distances, exploited the temperature, tone, and intensity of colours in a dif-

ferent way. Whilst containing his forms predominantly within their local hue, he built their volumes in brush-marks like coloured *tesserae*. Every surface change was represented by a carefully considered modulation of tone and colour, which produced the necessary impression of projection or recession. A plane inclined towards the viewer would, therefore, be defined in facets of light, warm, and relatively intense tints; a vertical plane would usually be represented by a pure hue, whilst the receding surfaces would be carved back from the picture plane in cool, dark shades. By extending the technique of the Impressionists, Cézanne raised the intensity of these modulated colours by introducing a few brush-strokes of their complementary hues; so we find patches of red and pink placed within an area of green foliage, streaks of lavender tint on a cream-coloured plane, and blue contours emphasizing the forward thrust of an orange form. If we allow time for these colour modulations to react upon one another as we watch, the sensation of weight and solidity created by their optical interaction is astonishing.

The Analytical Cubists, extending Cézanne's research into form and structure, relieved the monochromatic schemes of their pictures by using accents of the 'advancing' colours of pink, orange, and cream for their projecting surfaces and by introducing patches of blue and cool green on the receding planes. The spatial movement between warm and cool colours, between intense and degraded, and between complementaries has become the very subject-matter of recent abstract paintings. Much reduced colour illustrations would not reproduce satisfactorily the spatial sensations of these usually very large works. But some idea of the fascination of their optical metamorphoses may be grasped by the monochrome reproduction of 126 Vasarely's *Banya*, since the original is relatively small and, although partly dependent upon the complementary interaction of its reds and *front cover* greens for the dazzle and shift of shapes upon its surface, its tonal variations make an essential contribution to the dynamic illusionism of the painting.

As we stare at this picture, what was at first seen as a two-dimensional grid-pattern of chequer-board squares becomes a diamond-shaped surface activated by endless spatial changes as the shaded bands suggest first the vertical planes of a folding screen (a), then a flight of 127 steps (b), and then sequences of interlocked forms (c)—each, as soon as it is found, dissolving into another. We become aware that, superimposed upon this ever-changing structure, the inset parallelograms move first with and then against the momentarily prevailing spatial position of the shaded bands—at times even dominating the grid-

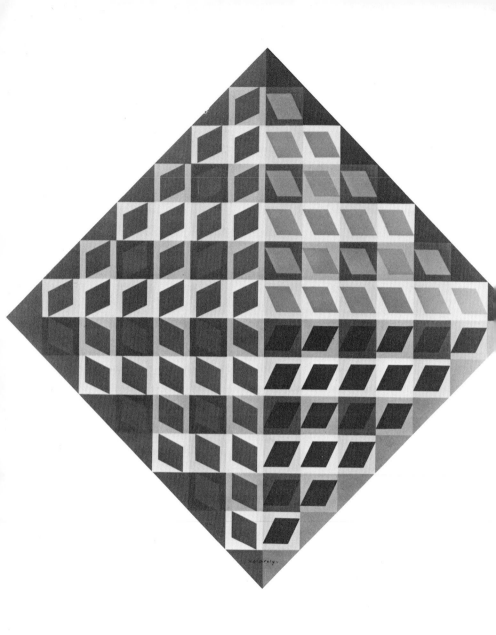

VASARELY: *Banya* (1964). Tate Gallery, London

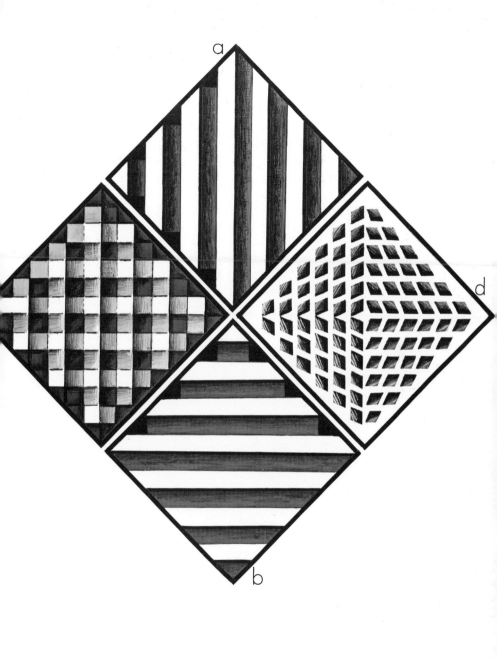

pattern as gleaming interwoven forms apparently floating above the picture plane (d).

1

MOVEMENT
THROUGH COLOUR

I have referred to the ways in which a painter communicates different kinds of movement by the use of rhythmic lines and repeated shapes and tones, or by developing sequences of these. He may also express these ideas by the use of repeated colour accents, or notations in colour variations. For example he can encourage the viewer to scan his painting in a particular order by using colour signals which function very much as colour-coded directional lights may do in subways or in large department stores. So in the El Greco the path of movement across the colour-pattern begins at the point of maximum contrast in hue and brightness, the harsh pink of Christ's robe against the mustard yellow of the rock. From this dramatic accent the eye is led to the weaker pink and stronger yellow of the angel, and from the colour of the angel's gown to another note of yellow which combines with blue to represent the sleeping disciples. Blue is then taken up and extended in the colour of Christ's cloak, where it is interlocked with the crimson robe. From here the eye is led to the shaded echo of these three primaries in the right-hand figure group, to the distant mounds, and up to the convex blue-grey clouds which push against the yellow-shaded central rock to complete the colour circuit.

In some paintings the whole colour-pattern seems to have been organized in order to create diving, plunging, flying, whirring, and darting movements. In a Franz Marc, for instance, the eye is directed by gradated yellow/orange/red sequences of arcs and shafts which leap against and penetrate contrasting forms created in facets of violet, blue, and green. In a Delaunay *Eiffel Tower* the planes of intense colour are so tilted against each other that the skeletal structure seems to lurch towards a fragmented sky with a zig-zag shudder. The tendency of the colour sequences of natural organic forms to reach a climax of intense hues at their apex, in contrast to the shades and tints lower in the stem—the flower of a plant, the blossom and leaves of a tree, for example—is a principle sometimes used to create a sense of striving growth or aspiration in a painting.

COLOUR
METAMORPHOSIS

'Actually, one works with few colours. But it makes them seem a lot when each one is in the right place'.[1] By the juxtapositions to which Picasso refers, a picture may seem to have been painted with a very wide range of colours whilst in fact achieving an underlying pattern har-

[1] Christian Zervos, *Conversations with Picasso (Cahiers d'Art:* 'Picasso 1930–1935').

mony and an expressive force by the use of very few. The colour metamorphoses created by a limited palette are among the most intriguing aspects of colour in painting. Therefore in following a particular colour around a painting the viewer should watch for the apparent change of identity it undergoes each time it passes through fields of different hues, tones, temperatures, and intensities to create tensions and harmonies with them in the whole pattern. A yellow, for instance, may seem to brighten and become more intense as it enters a dark zone of colours in a painting, and to darken and become greyer when it is surrounded by a white area. Or a secondary hue such as green will appear lighter and warmer if blue shapes and lines embrace it (since blue will have the effect of enhancing the green's yellow content) but will become a darker, colder colour when it is seen against yellow and its blueness is called out. Even the isolated crimson in the El Greco seems to move towards a cooler violet where the yellow 109 shade is against it, and by a similar complementary action to become a warmer, almost red-orange hue where it is surrounded by an area of blue.

COLOUR
SYMBOLISM

In early narrative painting a particular colour would often be used to indicate an important character, or some feature of special significance. Therefore in even the most elaborate decorative mêlées in an Indian miniature the presence of Krishna will be clearly stated by the traditional blue of his skin; and in the El Greco, as in most Euro- 109 pean religious paintings, Christ's robes are in the conventional blue and red, whilst the angel appears in yellow, the hue symbolic of Christian hope and aspiration.

Conventional colour symbolism is a very complicated and intriguing subject. The Chinese was perhaps the most intricate of all symbolic colour languages, but almost every country has had its conventions of colour symbolism. But the interpretation of these colour codes is really the concern more of the historian and the student of world religions and philosophies, knowledge of such intellectual, literary symbolism contributing little to an appreciation of visually expressive colour qualities in painting.

The emotional symbolism of certain colour relationships will, however, generally evoke a universal and primeval response. It is a common experience that the personality, character, or mood of people will sometimes appear to change with a change in the colours of their clothes or with the colours of their surroundings. When people select special colours to match the spirit of an occasion or to express a personal mood of the moment, they are, of course, following

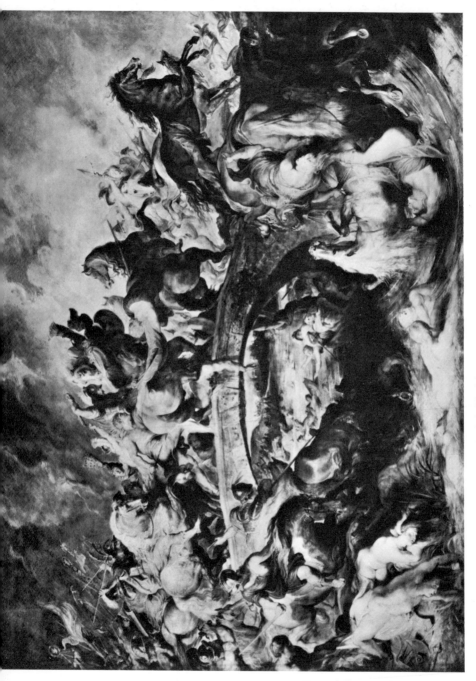

RUBENS: *The Battle of the Amazons* (c. 1618), Alte Pinakothek, Munich

ancient traditions of ritual dance and drama, in which colour combinations of costumes, masks, and facial make-up were used to symbolize emotional and spiritual forces.

Were they to compare the three identically drawn 'faces' illustrated here, most people would probably consider that the combination 107h, g, f of hues in the third suggested a powerful, warm, and exuberant character, that the second evoked a mood of peace and restrained optimism, but that when the same image appeared in the colours of the first it became a disquieting, almost threatening force. Since these three images are the same in form, and yellow is present in each of their colour schemes, it seems that their emotional message is created by the total relationships of all the colours within each image. Certainly in these examples no emotional force is inherent in any one hue—the yellow, for instance, contributes to the sense of tranquillity in the second, of energy in the third, and of danger in the first.

A painter may therefore use, consciously or intuitively, a particular range of colours, in certain proportions and juxtapositions, which will express the emotional mood of his subject or his own temperament and philosophy. Whilst the combination of colours in a Velazquez or a Chardin is sober and restrained and in a Grünewald or an El Greco creates strange, tense relationships, one of Rubens's typical colour-schemes expresses a spirit of ferocious joy—whatever the subject of 110a his painting. And when the emotional message of a picture is communicated through the interaction of lines and shapes of contrasting character—curving contours against a rectilinear background pattern, for instance—the contrast will be carried through the colour pattern, also. In the Bihzād, for example, the poignant contrast between the 205 hysterical misery of the mourners and the stability and splendour of their setting is expressed not only through the play of curved, jerky silhouettes against the calm, static rectangles of walls and courtyard but also through the colour-theme of blacks and sombre earths against gold and gay pastel pinks and blues. And the drama of Giovanni's contrast between the jaunty shapes of the two St. Johns, 240-1 drawn in confident curves, against the aggressive, razor-sharp rocks is echoed in the colour-scheme of gold and intense pink against a green and blue-grey ground.

Kandinsky insisted that the artist could communicate ideas and feelings through a language of colour as forcefully as by means of his lines and shapes: 'Colours and forms of themselves awaken powerful psychic reverberations. The beholder should regard a painting as a combination of form and colour which reflects a spiritual state and not an external reality.' The colour-pattern of an abstract painting

may therefore express a spiritual or emotional state. The intense yellow of a starburst shape in an Arthur Dove creates an invigorating sense of joyful optimism against its oppressive ground of murky greens and ominous purple-blues,[1] whilst in a Motherwell snaky threads of acid green creep between shapes of blue, black, and grey, setting a mood of impending tragedy.[2]

In Op Art and Hard Edge painting colour is used primarily for the physical sensation it produces. The impact upon the spectator will often induce feelings of exhilaration from the contemplation of one of these Abstracts or of drowsy euphoria from another—just as in real life the movements of coloured lights across water or an evening sky will induce a therapeutic state of peace and calm wonder or we are immediately invigorated by the explosive visual excitement of raging red and orange flames and the strident colour-clashing exuberance of carnivals and flower festivals. The mural scale of most of these paintings produces the hallucinatory effect upon the spectator that he is submerged in mists and currents of intense, vibrating hues. As he stares into these immense fields the spectator finds that it requires no conscious effort of surrender and no highly developed skill of empathy to be visually intoxicated. In a Bridget Riley, for example, red/green/white, red/blue/white striped sequences create a vast shimmering curtain which will begin to advance and surround him like a paradisean forest of brilliant creepers[3] whilst the coloured button-units sprinkled across the intense ground of a Larry Poons wink hypnotic after-images, like darting marsh-flies, from within the picture surface.

COLOUR-PATTERN In the over-all design of a painting qualities of tension and harmony may be expressed as much through a relationship of colour as through an arrangement of shapes, lines, and tones. Therefore the tension which may be felt between an angular and a rounded shape, or between a dark tone and a light one across the pattern of a picture, may be experienced also between various kinds of colour contrast—the interaction of complementaries, for instance, or the play between pure hues, and their shades and tints or against areas of neutral grey.

In the El Greco, for example, the figure of Christ dominates the composition as its pivotal point and centre of interest as much by the fact of its being the only area of crimson in the picture as by its central position on a cross-roads of lines threaded from edge to edge of the design. The colour plan of this picture can be considered as an abstract pattern—a scheme of the three primaries in three dominant

[1] *High Noon*, 1946. [2] *Irish Elegy*, 1965.
[3] *Late Morning*, 1968.

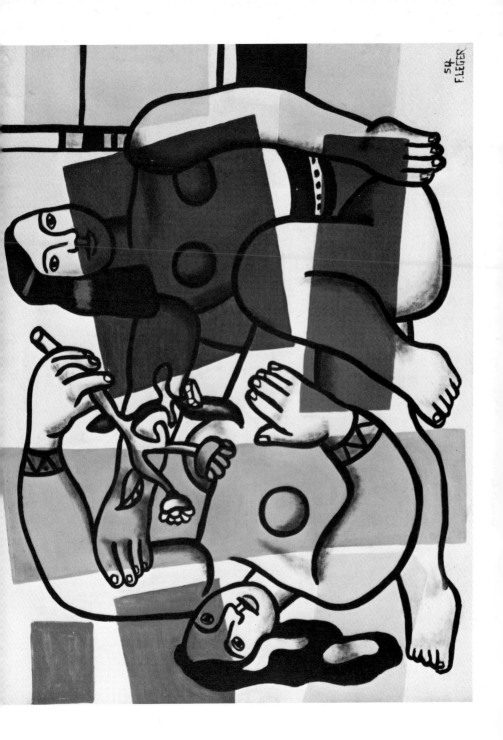

triangular shapes laid upon a field of shades and tints of blue and yellow, which in turn is placed upon a ground of black. Although in the Poussin shapes of local colour serve primarily to reinforce a com- 11 position conceived essentially in terms of lines and three-dimensional forms, a pattern analysis reveals that this too is a colour scheme of considered relationships and interactions between the three primaries—the focal colour being the central, isolated yellow—and a supporting orchestra, or chorus, of shades and tints and of greys and whites.

Whilst the colour patterns of both these works reinforce the patterns of lines and shapes, the arrangement of colours in other paintings will often provide a stimulating counterpoint design. The colour shapes in the Rubens, for instance, weave and twist in arcs and dia- 11 gonals across an almost symmetrically balanced composition of three-dimensional forms, whilst those in the Léger are rectangular 13 films of intense red, yellow, and blue, which provide a static foil to the rhythmic pattern of thick black lines which weave across an immaculate white ground.

A colour, by its relationship with other colours around it, will often enhance the relative scale and physical character of the form it covers, and so strengthen the part played by the silhouette in the overall pattern of the picture. For example there is often the optical illusion that a shape will appear to be smaller when painted in cool, dark or degraded colours than when expressed in warm, light, or pure hues. If we refer to the colour diagrams, it might be assumed that the warm yellow-orange-red disc was larger than the cool green-blue-black 10 one, although in fact both circles have the same diameter. It would be possible, therefore, to alter the scale, character and function of the forms in the El Greco by a redistribution and counterchange of 10 colour areas. The angel, for instance, would seem smaller and less reassuring if painted blue, whilst the surrounding clouds would appear to be larger, but less aggressive or portentous if given the angel's yellow hue. If the areas of crimson and yellow-grey in the centre of the picture were transposed, the focal dominance of Christ's silhouette would be reduced but the emotional significance of the rock would be very different, and the character, weight, and function in the composition changed. Braque made experiments of this nature in different colour versions of the same subject. In everyday life it ·is a common experience to witness an apparent transformation effected in people by a change in the colour of their clothing and in a familiar room by redecoration; and we feel intuitively that the characteristic form of a particular vehicle, building, or piece of furniture is better expressed in one scheme of colours than another.

Russian icon, ? late 13th century.

When people speak of texture in everyday conversation they are probably referring to the feel or tactile quality of a thing—that its surface is rough or smooth, coarse or fine, pitted or prickly, grooved or ridged, furry or silky. But whilst many artists have certainly been concerned with simulating the appearance of these relief qualities, 'texture' has a much wider meaning in painting. As an important expressive element of the painter's language it may be perceived in all those parts of a picture which are animated and enriched by patterns of one sort or another.

In some styles of painting these patterns are made up of lines or small shapes which are massed together as symbolic codes to represent certain natural phenomena. The wavy and scalloped lines used 143 for water, the forked shapes of fire, the white spots of snow, the parallel streaks of rain, and the star-clusters for night skies are familiar examples of such conventionally symbolic patterns.

With varying degrees of realism, painted patterns may also record the intrinsic, applied, and transitory textures of things—the markings 137 on animal fur and bird plumage, for instance, the grain of wood and the veins of leaves and marble, the printed and embroidered flat patterns of fabrics, the relief-patterns of architectural ornament and rock-strata, and the decorative sequences made by breaking clouds, wheel-tracks, footprints, railway-lines, frosted cobwebs, and fallen blossom.

Patterns in painting may represent those seen in nature whenever things are closely grouped together—a row of books, a pyramid of oranges, a phalanx of flying birds, a shoal of fishes, a crowd of people, 139 or a spray of cast shadows. Or a pattern of geometrical motifs, creating striped, mottled, freckled, latticed, checked, or stippled surfaces may be used to contrast with and to enhance flat silhouetted images in an abstract painting or a highly stylized representational work.

Sometimes textures are created as a result of the painting technique employed—a pattern of palette-knife marks or of streaked and spotted brush-strokes. Or the plastic properties of the pigment may be exploited so as to turn the picture surface itself into a low-relief of modulated thicknesses of paint. Varying pigment textures may be intended either to simulate the tactile qualities of natural surfaces or to convey the visual sensations of light, volume, space, or movement.

By whatever means they are created and whatever additional func-

tions they may serve in a painting, all of these different kinds of texture can be enjoyed in themselves for their sensuous, decorative quality alone. On this level of appreciation textures in painting are experienced as visual sensations of vibration and enrichment, just as the static uniformity of a deserted city square may be suddenly enlivened by an unexpected flurry of leaves and flutter of pigeons or brought to life by a flicker of illumination. Sensations of buzzing vitality such as these may be appreciated as much in the flat geometrical patterns of an icon, an Indian miniature, or a Mondrian as in the darting tonal accents and the sculptured impasto paint of a Rembrandt, a Turner, or a Riopelle.

In the outside world we always enjoy the mutual enhancement which results when two surfaces of very different character are brought together: starched lace worn against soft skin, sparkling diamonds displayed on smoky black velvet, flints laid between corner-stones, a sinuous vine intertwined across the geometrical symmetry of a trellis or the contrast of the black bands of branches against the glittering lights of foliage. Such effects make an important contribution to paintings as well.

In some works—a Pollock or a Dubuffet, for example—texture has become the chief expressive element. In others the interplay of textured and plain areas is an essential quality—as in the Matisse, where a geometrical check-pattern dramatizes the figure's sinuous silhouette and in the Chinese landscape, where visual onomatopoeia suggests the play of staccato twigs and sharp rock-folds against the murmur of delicate tonal gradations in the misty background. Textural enrichment is a sensuous quality of even a severely classical Poussin where, for example, flickering foliage is played against smooth skin and draperies and a prickly garland is bound across a marble torso.

We can develop our sensibility to the way in which the texture of things around us may be both sensuously decorative and vividly expressive: a tree-bark pattern seen as the crinkled skin of a growing form, the fierce action of a star-burst ink-splatter, the dramatic energy implicit in skid-trails, ripped fabrics, and splashed mud. For example, empty a box of matches on to paper and you witness the plain surface animated and enriched by a pattern of linear motifs (a). The pattern will express a sensation of movement like a firework-rocket's trail or like a racing river of jostling logs if the matchsticks are guided into the shape of a narrowing arc (b); or it will be like a spinning vortex if they are spread symmetrically in the form of a wheel (c). Again they might be arranged in bonded repeat-patterns, like those in bricklaying and tile-setting, in thatching, weaving, and basketry (d). Or if

they are laid systematically in progressively contracting and expanding interval-sequences, in zig-zag or in wavy rows, an illusion of corrugated surfaces receding and advancing in space may even be suggested (e).

All of these matchstick-patterns are texture-creating. After playing variations on linear textures such as these we should then stare intently at some blank area in front of us—losing ourselves, as it were, in the empty sensation of a wall, a table-top, or a ceiling. If after a few seconds of intense concentration we were then slowly to scan all the surface areas immediately around us, our eyes would receive a flickering signal each time they passed across a surface which was in any way broken up by the highlights and shadows of a relief-texture or by the lines and flat shapes of a decorative pattern. Later, we might be surprised to find that we had seen patterns where none would have been suspected—in the wreath of black numerals around a clock-face, perhaps, or in the shadowed mouldings of a doorway, in the creases of a crumpled cloth or in the fluted folds of a curtain, and that even these printed words could be seen as a linear texture framed by the white margins of the page.

After this kind of visual exercise it is much easier to appreciate the sensuous and expressive interaction between textured and plain areas across the picture-surface in any of the paintings reproduced here. We might now examine some of the different ways in which textures are created in painting, and the various expressive functions they perform.

DESCRIPTIVE TEXTURES The most simple visual method of describing a group of things, a natural force, or the character of a particular surface is by a two-dimensional code of repeat-patterns in units of line or shape. In a purely conventional form these symbolic patterns are found in maps —when they may, for example, identify a forest as deciduous or coniferous—in geological diagrams—where they distinguish between different types of soil and rock-strata—and in weather-charts, where they show prevailing conditions of sleet, rain, wind, frost, sunshine, and so on. Of course in this form the patterns have primarily an intellectual purpose rather than any aesthetic or representational pretensions. In painting, however, these flat patterns have sensuous and expressive qualities and may also to some extent have a natural symbolism in that they look like the things they represent.

By this technique natural phenomena can be indicated by two-dimensional patterns, and it is a method found in most decorative forms of visual communication designed in terms of line and flat

shapes in line and colour. The textures of an iced fruit-cake in a cookery-book illustration (a) might therefore be described in much the same kind of symbolic language as that used by an Indian, a Persian, or a Gothic miniaturist to represent surface features in a dramatic narrative.

There is an affinity also between these drawn and painted textures and those dictated by the technical disciplines of certain crafts. In the Indian miniature, for example, the conventional rendering of flowers and blossom resembles jewellery whilst the foliage of trees and shrubs is represented in interwoven textures like those of basketry. The stylized drapery-folds and the decorative borders used in early Gothic illuminations, as well as the geometrical fabric-patterns and mannered facial modelling of many icons, are conventions also found in Byzantine mosaics, while the incisive background textures of Persian paintings are reminiscent of the inlaid ivory, mother-of-pearl, and silver motifs of marquetry panels. And in some styles of painting water is traditionally interpreted by patterns of rhythmic lines similar to the flowing decorations which enhance the rounded surfaces of pottery forms; we find these linear patterns in the undulating curves of a Gothic and a Chinese painting, in the wandering ripples of an Indian illustration (c), and in the turbulent spirals of an icon (d).

Textures built up from symbolic patterns are also to be seen in those styles of painting in which a greater degree of spatial depth and volume is present. In a Botticelli, for example, the sea is described in neat rows of overlapping waves like roofing tiles or a scalloped wall-relief (f), whilst the leaves and branches of a background shrubbery are tied neatly into an interwoven screen (e). In the Giovanni di Paolo the narrative significance of a stony path is indicated by a confetti-spotted pattern, and in a Fragonard a mass of foliage becomes an embroidery of sequined and curly-petalled brush-strokes. Springing tuft motifs are universal symbols for grassy surfaces, and in the Uccello detail it can be seen that these are used both to describe the character of a distant landscape and to tie its undulating fields to the echoing curves of the curling foreground banner like exuberant stitches in an *appliqué*-tapestry.

Many European painters since the Renaissance have been concerned with simulating the tactile quality of relief-surfaces. The physical characteristics of these surfaces are usually identified in life by the different ways in which light is observed to play across them —breaking into dots of highlight and shadow across a glistening, gritty surface, for instance, or evenly diffused across a matt, smooth one—and many western painters have expressed these different

textural qualities by the use of varying degrees of tonal contrast. In the Rubens details, therefore, streaks of white impasto paint can be 12, 234-5 seen drawn across a dark ground to represent the glitter of polished metal in contrast to the subtly gradated tones suggesting the softness of wool, feathers, and smoke.

Some artists have been obsessively concerned with the minutiae of nature and have crowded their paintings with such an extravagance of descriptive detail that these have the catalogue-unreality of a sharp-focus photograph in which every leaf, pebble, button-hole and twig is defined with equal clarity. Filled edge to edge with the meticulous portraiture of natural textures, the picture surface itself assumes a shimmering texture like that of lace-embroidery or a mosaic of enamel chips.

In a Flemish Book of Hours, a van Eyck, a Holbein, or a Nicholas Hilliard, this effect was probably sought as proof of exquisite crafts-manship for the pleasure and approval of a patron. In the work of later artists—a Holman Hunt, for example, a Stanley Spencer, a Grant 146 Wood, or an Andrew Wyeth—it is more the expression of a personal vision and philosophy. In the macabre inventory of every wrinkle, wart, crack, wound, and blister in a Grünewald, a Bosch, an Otto Dix, or an Albright it is the relentless record of the awful decorative beauty of destruction and decay. In Surrealist pictures by Magritte, 201 Delvaux, or Dali this exaggerated textural fidelity is contrived with immaculate craftsmanship to create decorative patterns which both enrich the smoothly painted surfaces and bring a disturbing convic-tion to poetic, erotic, whimsical, and nightmarish fantasies.

WORD-PATTERNS Since any sequence of repeated units creates a visual pattern of some kind, artists often make use of passages of formal lettering and manuscript as areas of texture in their paintings. Such lettered tex-tures are a feature particularly of Islamic and Christian miniatures since these paintings were at the time regarded primarily as illustra-tions to a written narrative. The passages of calligraphy were thus considered essential components in the design of the page. In the Bihzād, for instance, a narrative-caption has been written on a painted 205 inset panel fitting into a corner of the picture's inner frame, as a postcard or a telegram might be tucked into a mirror-frame. In another, the script-pattern might be used like a wall-decoration or as part of the background setting of the picture or as an embroidered device on a hanging banner. Often the lines of manuscript would be written on the vertical or horizontal margins of the page, like an ornamental stage-proscenium for the action depicted within—as at

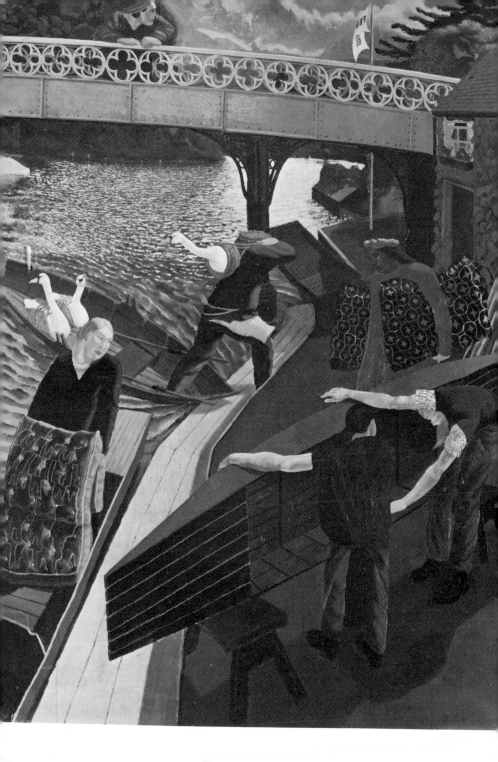

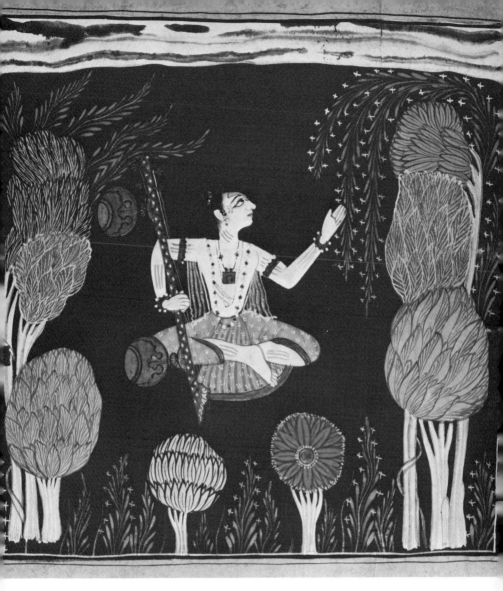

the top of the Indian miniature, for example. In western painting, a [257] more formal pattern of lettering would sometimes be used to provide a frame along the edges of a picture, and this created a rich linear decoration rather like the tasselled fringe of a carpet—a favourite sign-writing device used around the portraits and allegories of itinerant early American Naïve painters.

I have also referred (Chapter Two) to the harmony established in Chinese and Japanese painting between brush-drawn word symbols and calligraphic linear textures; and of course in any style of painting designed primarily in terms of line and flat shape, passages of script would be easily integrated as linear textures in the overall pattern. But in paintings designed as spatial compositions considerable ingenuity was required to combine linear inscriptions with the representation of solid forms. An attempt to overcome this problem is seen in the Lorenzo Monaco illumination, where an initial letter 'B' [149] is expressed as a sculptural structure, its two halves becoming twin niches to enclose the painted figures. In Renaissance and Neo-Classical painting it was a convention to suggest by skilful illusionism that a lettered caption was in actual fact an inscription carved on a plinth or some other architectural feature of the painted setting; or that it was written on a curling scroll or banner which seemed to float in the simulated space of the picture. In this way words might be incorporated as a decorative enrichment without destroying the expression of volume and depth.

Lettered textures have been a special feature of certain twentieth-century paintings: the stencilled letters in Synthetic Cubist works, for [104] instance, Klee's script-pictures inspired by Chinese poems, the *graffiti* slogans of Dubuffet and Ben Shahn, Jim Dine's patterns of super-im- [156] posed scribbled names, and a Jasper Johns panel of numbers. When the word-textures used are in a language unknown to us we can more readily enjoy their sensuous interplay as vibrant linear patterns against a scheme of coloured shapes. But the writing in Pop-Art painting is usually in a familiar language and often witty—like the anatomical notes scribbled on a Larry Rivers, or the written asides drawn on a [150] David Hockney—or they may have some special social, historical, or philosophical significance like Kitaj's esoteric slogans and the poems painted by Robert Indiana with the machine finish and to the scale of commercial sign-writing. It is interesting to note, however, that once they have been read and understood these inscriptions will then usually be seen only as abstract decorative textures. Such a change, from the intellectual perception of lettering shapes as word-meanings to the sensuous appreciation of them as linear patterns, is noticeable

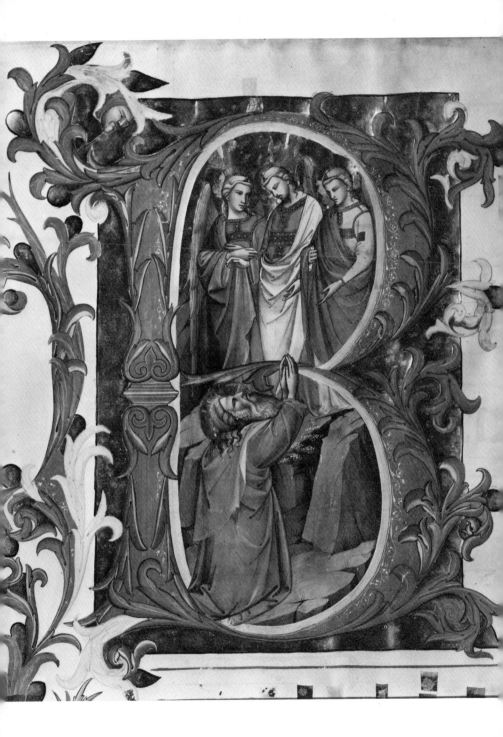

The image contains the following labels: CHEVEUX, FRONT, SOURCIL, CIL, OEIL, NEZ, JOUE, DENT, LÈVRE, MENTON

RIVERS: *Parts of the Face: The Vocabulary Lesson* (1961). Tate Gallery, London

once we are familiar with a painting like the Lichtenstein, where the inset narrative commentary (which at first sight few of us could resist immediately reading out of curiosity and as a clue to the significance of the action portrayed) is later perceived only as a delicate filigree pattern, making a satisfying foil to the more emphatic textures elsewhere in the picture.

EXPRESSIVE
FUNCTIONS
OF TEXTURE

Textures, like the other elements of shape, line, tone, and colour, can be used to evoke sensations of volume, space, and movement in a painting. We have seen that a combination of lines—that is, a linear

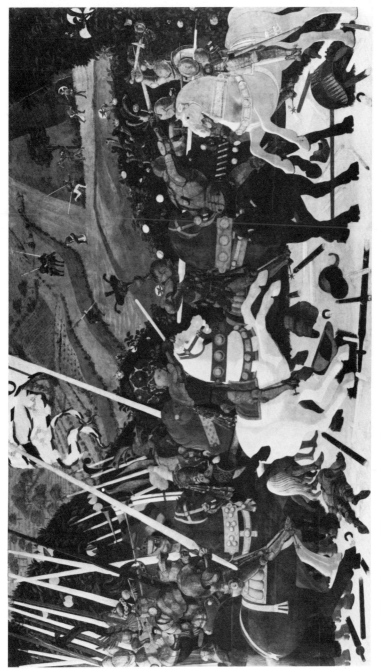

UCCELLO: *Niccolò Mauruzi da Tolentino at the Battle of San Romano* (1456). National Gallery, London

texture—will create an illusion of volume. In everyday life many people will have noticed how columns of type and printed fabric-patterns are distorted when newspapers and curtains are twisted and folded, and how an applied decoration may describe and enhance the rhythmic forms of pottery and furniture and emphasize the proportions and spatial design of buildings. Painters can, therefore express the volume of things and the spatial recession of planes in their pictures by systematically distorting a regular pattern. This technique enables them to use colours at maximum intensity, since their hues need not be degraded in the service of tonal modelling and aerial perspective. The curling emblems on Uccello's pennant, which 14 describe the waving surface of the flag, and the check-patterned table-cloth in the Bonnard, which establishes the picture's spatial depth, are 26 obvious examples of this.

The Op Art painters have shown that textures created from linear sequences (for example, the Riley) and from geometrical shapes (for 33 example, the Vasarelys) can be so arranged as to convey extraordinary 89 sensations of kinetic action. The use of texture to express movement is found in many different styles of painting: the wave-swirls in a Russian icon, for instance; a flight of swans in a Sassetta; the 14 excitement and restless movement expressed by the entwined curves and diagonals on the left-hand side of the Uccello; the energy 15 expressed in the bottom-right corner of the Rubens, by means of 15 linear patterns of arrows splaying from an upturned quiver, of a falling mane and the repeated curves of splashing water; the spacing of the squares and rectangles along the ribbon-routes of the Mondrian, 27 creating an optical, metronomic throb; and the strip-cartoon conventions for speed and explosive force used in the Lichtenstein. 15

TEXTURE AS
AN ELEMENT
OF DESIGN Textures, like the elements of mass, line, tone, and colour, contribute essential qualities of contrast and balance to the design of a painting. These design qualities of texture should, therefore, be experienced as visual sensations across the whole layout of a painting in much the same way as that in which we are conscious of the effect of the contrasts and harmonies in the arrangement of the other pictorial elements. That is to say that when we are staring at a picture we should be as much aware of the play within it of one texture against another, of one pattern repeated in other parts of the design, and of the action between the patterned areas and the plain, as we are conscious of the relationship of a light tone against a dark, of a warm colour against a cool, or of a curved shape against an angular one.

If we look for these qualities in paintings designed essentially on a

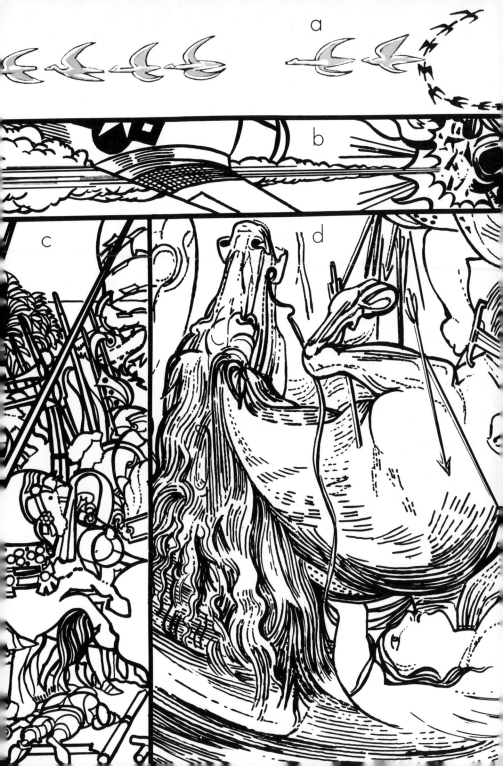

two-dimensional plan—such as the icon and the Indian miniature, the
Matisse, the Kandinsky, the Klee, and the Chagall, we should after a
few moments' concentration become aware of an almost musical
flute-and-drum interplay between textured areas and plain.

But equally important are the textural schemes of paintings con-
ceived as spatial compositions. In the Caravaggio, for example,
repeat-motifs of dark curves run throughout the design in the creases
in clothing, in the chair slats and the tablecloth border. In the Ingres,
the luxuriant floral dress pattern enhances the immaculate smoothness
of the arms and head and in the Titian the flickering surface of a
quilted sleeve provides a similar foil to flat light and dark shapes. It
can be an exhilarating visual experience to follow a route of pattern
units repeated across a picture and watch them contract and expand
in almost kinetic sequences—like the discs sprinkled like sequins
across the Uccello in contrast to a textural theme of short, stabbing
lines. There is also a sensuous variety of texture in the Chinese
landscape as we look from the flickering, spiky texture of trees to the
soothing passage of blurred tones in the background, and in the
counterchange textures of the Matisse as we look from the white
check of the couch to the dark squared pattern of the window-frame.

In some styles of painting texture preponderates over other design
elements. In Riopelle's line and blob *Trellis*, in Bridget Riley's rippling
lines, and Jackson Pollock's paint-scarred battlefields almost the
texture *is* the design. Texture is obviously the primary expressive
quality of Dubuffet's *Texturologies* of fork-scratched sandy surfaces
flecked with drops of fluid paint, and of his Art Brut *assemblages* of
patchwork pieces of patterned canvas and paper stuck to the picture-
ground, the jigsaw images camouflaging grotesque figures. Expos-
ing the squalid splendour and neurotic bustle of over-crowded cities,
Dubuffet's paintings of scuttering, restless people are scribbled with
the ferocious caricature of *graffiti*; and the stained brick and flaking
stucco of the walls on which such drawings are chalked and gouged
in real life, are re-created on canvas with the loving craftsmanship of
an early illuminator.

There are some representational painters who have found a special
beauty and significance in the textures of familiar things: the micro-
scopic portraiture of pebbles, button-holes, and blades of grass in an
Arthur Hughes or Holman Hunt; the Pop-Art patterns of Jasper
Johns's *Stars and Stripes*, Andy Warhol's dollar bills, or Lichtenstein's
Ben Day dotted comic-strips. And in his pictures based on sensational
news-photos, Juan Génoves has shown the decorative horror of
frantic crowds scattering like breeze-blown seed.

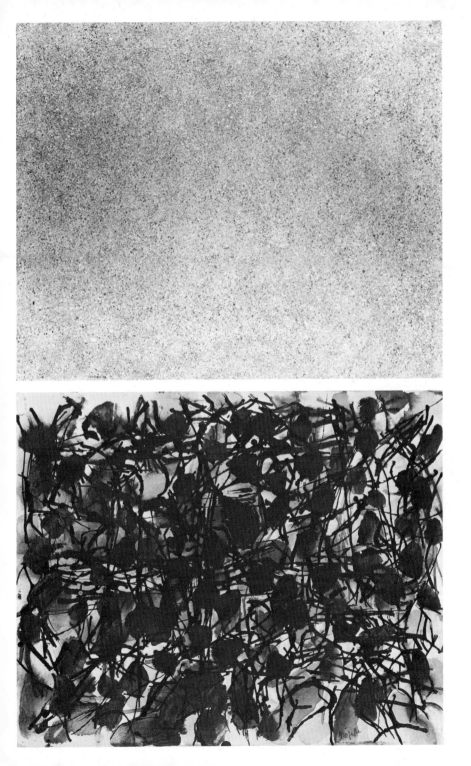

Sometimes it is the artist's technique that causes the whole picture surface to vibrate with flat or relief textures: Seurat's spot-mosaics, 100 Tobey's Zen white-writings, Michaux's mescalin-induced black ink-blots or Auerbach's and Riopelle's impasto reliefs built in hills and 184 valleys of paint. In the next chapter I shall refer to the surface textures which result from traditional studio methods and those which are created by exploring the plastic possibilities of unconventional materials.

As an artefact a painting acquires surface textures as a result of the technique, skill, medium, tools, and ground employed in making it. Some knowledge of these various methods and materials will be helpful to the viewer in his appreciation of the special qualities of surface textures in painting and to his understanding of the limitations which different media impose.

Whilst some painters deliberately subdue the sensuous quality of their materials, the decisions and afterthoughts of others are so clearly revealed by the expressive handwriting of their brush-strokes that their pictures seem, like a poet's or a composer's original manuscript, to suggest the living presence of the artist. And so organic do the surfaces of some paintings appear that we could believe their textures had been formed by some natural process and would no more consider them the result of sophisticated manual skill than we would remark on how admirably a tree expresses the nature of wood.

The sensuous appeal of a painting may be immediate when the physical possibilities of pigment are brought out by certain techniques: the immaculate suede-evenness of tempera; the dragon-fly transparency of a watery watercolour that seems still to be wet; the plasticity of oil-paint, thick as icing-sugar, smooth as enamel, or staining like a colour dye. But an understanding of the various techniques that we may expect to find used in studio painting will help us to appreciate as well the qualities of materials and craftsmanship in those works whose paint-textures do not attract our eyes so easily.

In periods when the artist was regarded rather more as a skilled craftsman than as an individual creator the physical properties of the accepted medium, the demands of the patron and the influence of traditional practice determined the character of the picture surface.

TRADITIONAL TECHNIQUES The technique of painting may be studied in terms of an established and continuing tradition only in a few countries. In folk and tribal painting, and in those cultures that for geographical, sociological, religious, political, or ideological reasons were less affected than others by foreign influences, we find that traditional skills and techniques were passed on for long periods. The methods and materials used by Eastern artists, for example, scarcely changed for centuries compared

with the technical experiments and innovations of western painters since the Renaissance.

There has been also an unconscious tradition of careful craftsmanship and tight delineation common to the unsophisticated pictures by itinerant professional 'primitives' and untutored amateur 'Sunday-painters'. Some of the finest examples of naïve journeyman painting of the eighteenth and nineteenth centuries are in American museums. Perhaps the best known of these innocent masterpieces are by Edward Hicks—such as *The Peaceable Kingdom* and *Penn's Treaty with the Indians*. But in the portraits by Winthrop Chandler, Reuben Moulthrop, and many unknown artists of that period we see in their enamelled surfaces, in the loving portraiture of costume as much as sitter's features and in the classical refinement of the silhouette, qualities which rank them with the works of Ingres and the Elizabethan Court. Also to 11; 40 be found in museums are the meticulously executed visions of more recent 'primitives' like the Douanier Rousseau, Bauchant, and 160 Bombois, the 'patchwork-quilt' landscapes of Grandma Moses and the vigorous seascapes of Alfred Wallis, which are often examples of 160 craftsmanship as careful in preparation and as precise in application as the work of master-decorators and sign-writers.

Unique in Western painting, however, was the prolonged survival of Russian icons. The subject-matter, technique, and function of the 135 painted and gilded panels known as icons were governed by the Greek Orthodox Church. From the sixth century these were made by methods unaltered for over a thousand years. In these holy portraits and figure-groups on wood-panels heads and hands are tonally modelled with glittering highlights to give an illusion of relief and weight, but everything else is expressed in flat areas of colour which often were enriched with gilded textures and painted against a field of gold leaf. Many icons were protected by a hinged door in beaten metal inlaid with jewels; a small 'port-hole' was cut in these, through which the painted head would seem to stare—an effect, by candlelight, that was hauntingly alive in spite of the conventionalized Byzantine features.

In medieval manuscript illustration we find a similar technique used to create pages of exquisite craftsmanship. In these the artist was given little opportunity to communicate a personal vision of the outside world or further to exploit the expressive possibilities of a medium by experiment and change. For since these miniature paintings were commissioned by the Church and the Court and dedicated to the glory of God and of Princes, medieval illumination was essentially an esoteric art, elaborately limned pages, like the Lorenzo

Monaco illustrated here, painstakingly created as precious artefacts 149
for the pleasure of a privileged few.

Now that these Gospel-books, Calendars, Biblical commentaries, Psalters, and the Lives of Saints are no longer reserved for the delight of aristocrats and church dignitaries, we should look for them wherever they are displayed in museums, universities, and cathedrals. And if we are to enjoy the surface richness of these gleaming, cheerful pages, we should examine them as closely as we would if we were reading the Latin script that is woven into their design. Then it is possible to see that the vibrating patterns on the vellum are often created by the play of burnished gold leaf against areas of dry, opaque egg-tempera washes enriched with minute stippling. In Romanesque-style illuminations, like the leaf from the early English Psalter 162-3 shown here, the colour brilliance was often intensified by the use of thick black contours—as in mosaic and stained glass—and the form suggested by white lines carried across the silhouettes as conventionalized highlights. The gold leaf was usually laid on to a built-up gesso ground and, when serving as a background field or setting, was often tooled and embossed into decorative textures until its swelling surface was richly pimpled and quilted. Close examination generally shows that where the leaf has been rubbed away a red ground shows through, giving greater warmth and depth to the gilding. These Romanesque paintings were first outlined in flowing patterns and the shapes created were filled, as in the cloisonné-enamel technique, with glowing colours and the background enriched with an elaborate embroidery of heraldic textures. Gothic illuminations inspired William Blake to invent a tempera technique, probably binding his 274-5 pigments with glue rather than egg-yolk and in some of his narrative panel-paintings he achieved a jewel-like richness with the use of encrusted tempera and gold-leaf.

In later Gothic painting the individual illuminator emerged from dedicated anonymity thanks to royal patrons like Jean de Berri (who appointed the illustrator and sculptor Beauneveu his artistic director) and his brothers. Artists were now named and reputations made, and manuscript pictures by Matthew Paris, Lorenzo Monaco, the brothers 149 Limburg, and Jan van Eyck were painted in more delicate and detailed techniques in order that a degree of spatial realism might be expressed. Atmospheric landscapes and interiors replaced decorative background textures and the brush was used on the vellum page to render form in soft glazes (i.e. transparent washes of pigment mixed with oil), modifying and modelling the dry tempera underpainting; gold leaf was used descriptively, rather than chiefly for textural

Two enlarged details from a leaf of a Psalter depicting the life of Christ, English (probably Canterbury or Bury St. Edmunds), c. 1130–50. Victoria and Albert Museum, London: Crown Copyright

effect, for costume-trimmings, crowns, and inscriptions; the heavy contours disappeared and the decorative borders, that previously had been woven into the overall flat pattern, became weighty frames, impersonating vine-trellises or architectural forms through which to view the pictorial dramas.

As painting skills increased, figures and floral motifs took on the illusion that they were set in half-relief *into* the vellum. Thus we now find the characteristic Gothic initial letter transformed from a flat decorative device into an almost sculptural unit; like the page from a Choral Book ascribed to Lorenzo Monaco, where the 'niches' built 149 by the letter 'B' convincingly embrace, without absurdity, naturalistic rocks and figures of some weight and substance.

The intimate nature of illumination is inherent also in the portrait-miniatures by Elizabethan craftsmen such as Hilliard and Oliver—an intimacy retained even in the life-size *Cholmondeley Sisters*, a strange 40 work at once whimsically humorous and classically monumental. The miniatures were usually painted on card with a tempera medium thinned with water and made opaque by the addition of white paint ('body-colour'). Later these painted 'jewels' were often executed in oil on metal and by the eighteenth century the familiar oval 'keepsake' portraits appeared. These were made by minute dabs of transparent water-colour on ivory, customarily concealed in lockets and often displayed today as 'jewellery' in museums—a tribute to their craftsmanship as much as to their original purpose as private treasures or adornments.

When the right of a craftsman's guild to determine the technique and output of the artist was challenged by the great Renaissance individualists, the traditional methods of constructing a picture were undermined. But in Eastern cultures the social status and official function of the painter remained the same and the accepted skills and aesthetic philosophies continued to flourish under the patronage of ruling Rajahs, Sultans, and Emperors for the enhancement of their courts and royal households. That these fragile miniatures from India and Persia and the perishable Chinese and Japanese calligraphic paintings on silk and paper have survived in almost perfect condition is due in part to the care with which they were guarded. For these were not public works but treasured artefacts, usually to be brought out and handled for contemplation in an atmosphere as intimate and select as that of a chamber-music recital.

The books and albums produced by Indian and Persian manuscript- 164, 205 illustrators were therefore expected to boast extravagant use of gold and silver leaf and of precious pigments such as malachite and lapis

lazuli. The texts to these love-poems, legends and contemporary and historical narrative-sequences are, as in medieval illuminations, inextricably tied to the pattern of the whole page, since they are made to serve not only as commentaries but as calligraphic textures. The linear character of these miniatures is at once formal and delicate, incisive and sinuous and may seem, in contrast to the tense urgency of line in much Gothic painting, to belong to a more assured and classical style. The painting technique, however, is similar, though the decorative margins around the illustrations are enriched either with geometric repeat-motifs or by gilded-gesso fillets raised from the page in half-relief to form substantial frames. The sharp highlights of these gold mouldings act as a foil to the matt surface of the tempera colours. The miniature reproduced in Chapter 7 is attributed to the great Bihzād, the fifteenth-century Persian master.

Many of the painters of China and Japan served apprenticeships in the handling of brushes and inks that included exercises for manual control as disciplined as those of a ballet-dancer's at the *barre*; and printed 'models' of instruction were studied like text-books—like the Chinese seventeenth-century forerunner of our present-day 'How-to-do-it' booklet, *The Mustard-Seed Garden Manual of Painting*. Though such autocratic restraint over technical experimentation inevitably resulted in long periods of repetitive academicism, there were creative individualists who broke down the rigid canons of acceptable craftsmanship to revitalize and extend the expressive art of calligraphy. With his bamboo-handled brush and gum-bound carbon ink-block the master-craftsman so identified himself with his medium and his subject that his materials and his hand movements responded to the interpretation of an idea like the limbs of a dancer instinctively reacting to the moods and rhythms of music.

In these calligraphic paintings an intuitive prompting seems to guide the strokes, to lift and spread the brush-tip to express sensuous contrasts of fat scribbles against fine, tapering lines, of the imperceptibly gradated wash against the jagged shorthand of staccato dots and emphatic dashes. These may be enjoyed not only for their physical exploitation of watercolour but as brilliantly economical descriptions of texture, atmosphere, and space that seem to have found inspiration from the very medium itself.

DEVELOPMENT
OF TECHNIQUE

Since the base of most paints is a finely ground powder, it is the type of binder and thinner used by the artist that makes it manageable in a particular way. The ingenuity and skill with which a certain paint-

medium is handled, and the ground on which it is worked, will also, of course, affect the final surface quality of a picture.

Though precious pigments such as lapis lazuli (pure ultramarine) and malachite (green) are no longer in use, the artist has today a greater range of permanent colours available to him than had his predecessors. It is therefore the technique employed, rather than the pigment-colour, that gives particular paintings their special physical quality. We have seen that the painter exploits the optical behaviour of colour-relationships and tonal contrasts in order to transcend the limitations of his palette. Of equal interest to us, therefore, is the skill with which he overcomes the limitations of his medium, extends its expressive possibilities and invents new techniques to deal with new pictorial problems.

The pigment, though now mass-milled by machine-powered rollers, was once weighed by the apothecary and hand-ground by the artist or his assistants. Tempera, the medium in general use until the sixteenth century, is finely powdered pigment mixed with fresh egg-yolk and thinned with water. It was applied with soft-haired brushes on wood panels prepared with *gesso* (chalk and gum priming). Because tempera becomes hard and unworkable almost as soon as it is applied, atmospheric effects and naturalistic textures are difficult to interpret convincingly and subtle gradations of tone and colour are usually obtained by a shading technique of fine streaks and cross-hatchings like those of a pen and ink drawing or an engraving—as in the Botticelli and Giovanni di Paolo details. 36;

Although true tempera painting has been practised by only a few artists in this century—notably by Salvador Dali, who has exploited its capacity for meticulous definition in order to create his 'dream-photography'—*gouache*, popular as a medium in the last fifty years, has a surface quality of the same dry opacity. Gouache-paint, ground with gum-arabic crystals, is thinned with water into a paste or used ready mixed from tubes and jars and applied, freely or with precision, to paper or card. Some painters add honey or starch to retard drying so that thick impastos and soft edges are more easily obtained.

Also water-soluble, but with a greater textural range than tempera or gouache, are the recently developed *acrylic resin* or *polyvinyl emulsion* paints. These dry without brush-marks and are workable on any absorbent surface and across very large areas. Their quick-drying properties and the even consistency and impersonal appearance of their painted surfaces have made them particularly suitable as a medium for Hard Edge and Op Art painters (for example, Bridget Riley's *Fall* painted in black and white emulsion on hardboard). 33

GOTTLIEB: *Blast* (1960). Victoria and Albert Museum, London: Crown Copyright

168

Watercolour paints are made by mixing pigment with a water-soluble gum. If we compared a true watercolour with a tempera painting, we should see a difference in degree of flexible handling like that which we would expect to find between a sculpture modelled in wet clay or plaster and one that had been carved with chisel and mallet from wood or stone. Only in England has watercolour been the medium shared by a whole school of painting. The watercolours of Cozens, Girtin, Cotman, Bonington, Turner, and Constable were executed with a spontaneity and an economy of effect which rivalled the great Chinese ink-painters. Later on there was a general tendency among minor artists to manual dexterity and shallow trickery which contributed to a decline. But when we see the finest examples of this deliciously sensuous medium their colour-washes seem to have been flooded across the paper only moments before we approached them. For true watercolourists rejected white paint and, like the Chinese and Japanese artists, utilized the sparkle from patches of untouched paper or the thinnest stain of a watery wash for their palest tones. This medium is therefore ideally suited for expressing the essence of dampness, the poetry of translucent lights, imperceptible horizons and forms half-realized in rising mists. It can be seen here that Bonington's brush-drawn lines have the calligraphic vitality, economy, and certainty of the Japanese ink-painting. In this century the textural possibilities of watercolour have, perhaps, been best exploited by Klee and in Marin's semi-abstract seascapes, which anticipated the large Abstract Expressionist colour-stains, dribbles, and splashes of Sam Francis.

Artists have also combined transparent washes of ink and watercolour with textures of wax crayon and pastel or with lines in quill or metal-nib pen. In the pen and wash paintings of Rembrandt, Rowlandson, Daumier, Dufy, and Picasso the drawn lines are often used at once as a textural enrichment, as a means of spatial definition and as rhythmic movements counter pointing the broad statements in tone and colour masses. Opaque white (body-colour) is sometimes added to extend the textural range of watercolour and in Samuel Palmer's *Shoreham Garden*, reproduced here, blobs of almost edible sugar-icing blossom provide a tactile foil to his unique spot-and-dash linear textures and glowing, stained colour-washes.

Oil pigment remains the most responsive and adaptable of all painting media, producing both deep stains and the most feathery of brushstrokes, enabling the artist to create a porcelain smoothness—as Ingres did—or to build up an encrusted glitter—as in the Rembrandt portrait. It is usually thinned with turpentine (to which some painters

add copal varnish or stand-oil). Oil pigment, like 'plastic' paint, is workable on almost any surface. Traditionally this is wood or stretched canvas primed with a white or tinted matt undercoat, but masonite (Albers), strawboard (Toulouse-Lautrec and Alfred Wallis), 160 hardboard (Peter Blake and Richard Hamilton), and glass (Gainsborough, Klee, and traditional folk art) are among the grounds that affect the handling and surface quality of paint—used on paper, for instance, oil paints dry to a matt surface like gouache and pictures by Constable, Degas, and Gottlieb in this technique have a special 169 fluency and freshness.

By the beginning of the Renaissance period painting in Europe was no longer an occupation mainly of the anonymous craftsman but was becoming the profession of the individual artist, relatively free to interpret his patron's commissions in terms of a personal vision. A spirit of scientific research urged the painter to experiment with new techniques; the interest in structure, light, and space demanded a medium more flexible than tempera. Painters found in oil paint a medium that would do more than serve as a softening finish over the sharp-cut shapes of tempera pictures. In the sixteenth century Venetian painters were using oil both to begin and to complete a work, but it was not until the middle of the seventeenth that its expressive qualities were fully realized. The smooth glowing surfaces we see in early schools of oil painting had therefore been achieved by a mixed-media technique in which the picture was first underpainted in tempera and then completed in thin transparent oil-washes—rather as a house-decorator 'finishes' with a top gloss-varnish enamel paint over a wood-primer and a matt undercoat. The fifteenth-century Giovanni di Paolo used oil-glazes but with his gold leaf and floral borders was still painting very much in the manner of a Gothic illuminator—as we can see by comparing his *St John in the Wilderness* with the Lorenzo 24 Monaco. Paintings by this method have something of the strange, still, filmy quality of a hand-tinted photograph; but in a Titian, an El Greco, 23 and a Rubens we find this thin glaze reinforced by pale tones loaded in thick, opaque pigment, anticipating the vigorous, direct brush-strokes of Rembrandt. 17

The plastic nature of oil paint lends itself to close imitations of the tactile qualities of certain natural surfaces. The adhesive properties of the medium have enabled artists to build relief-textures in mounds and whorls of thick paint which may glitter with highlights and cast small shadows on the picture-surface—the Van Gogh and the 21 Riopelle, for example. Chardin used dry, crumbly paint to represent 18 the dry, crumbly texture of a broken loaf of bread and Velazquez

REMBRANDT: Detail from *An Old Man in an Armchair* (1652). National Gallery, London

172

dropped beads and loops of thick pigment to simulate the jewellery 75
and lace worn by his sitters. To obtain the various textures in a
portrait Rembrandt smudged and scumbled his paint to achieve the xii
smoothness of skin, imitated the wiry growth of a beard with a torrent
of fine brush-lines and dragged a creamy *impasto* to represent the linen
texture of a head-band. In the Rubens thick, opaque paint is played 12,
against transparent, smooth paint against gritty and broad brush-
strokes against delicate ones to suggest the distinctive surface quali-
ties of metal, feathers, wool, and flesh. And in the Van Gogh the 38
wooden frame of a chair seems carved in slivers of paint, its seat
rushed in strands of thick pigment.

It is not until we look at paintings produced after the middle of the
nineteenth century that we may expect to find many pictures produced
by direct brushwork on a white-primed ground. For even when the
tempera base had been finally abandoned painters continued to work
on grounds tinted by a stain of an earth-pigment like ochre, umber,
terre verte, or Venetian red. This technique established a colour
harmony throughout the picture, of course, and it also enabled the
artist to produce a wide range of tones and varying colour intensities
with the use of a restricted palette. For example, if we closely examine
a late Rembrandt, a Rubens, an El Greco, a Watteau, or a Gains- 10
borough, we can see that patches of this initial under-tinting have 17
often been left untouched to serve as areas of colour in the scheme
of the completed painting and that in parts the stained ground had
been lightly covered with pale pigment—the technique of scumbling
—to produce pearly half-tones. Since this practice produced colour-
harmonies and surface-textures so different from those of the direct,
or *alla prima*, methods of the last hundred years, we may appreciate
its special surface textures better if we compare it to the similar
techniques of pastel-painting.

Pastels are pure pigments bound only with gum and dried into hard
sticks. Drawn across vellum, coloured paper or strawboard, each
differently coloured pastel stick used in the picture is capable of
producing a number of tone and colour variations on its original hue
according to the amount of manual pressure exerted by the artist;
this is because as more or less of the tinted ground is allowed to show
through the inherent tone and saturation of the chalk colour is
modified. For example, if a yellow pastel is drawn across blue-grey
paper with varying pressures, it will produce a middle-toned green-
grey where it only thinly covers, and is therefore changed by the
blue-grey ground; it will be modified to a yellow-green where it is
more densely cross-hatched or pressed more firmly; and it will reach

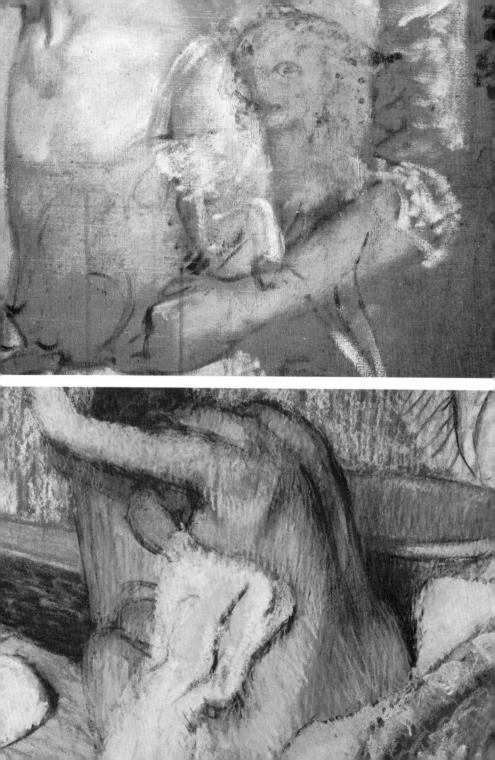

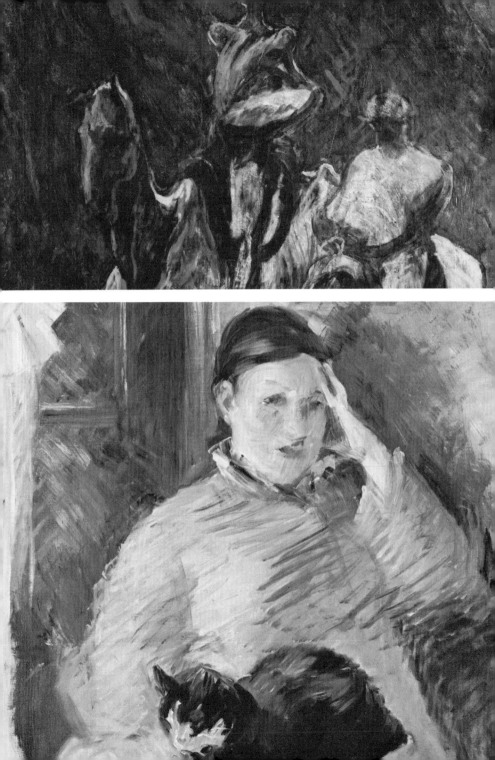

its maximum intensity only where it is drawn thickly and heavily enough for the coloured ground to be obliterated completely.

In the eighteenth century pastels were usually worked into the ground and thoroughly blended with a rolled paper stump. By this method pastellists such as Perronneau and Quentin de Latour created smooth, creamy textures deceptively like those of some oil-painted surfaces. Later its essential graphic quality was expressed by artists like Redon, who exploited its powdery properties with hazy opalescent smudges, and by Degas and Lautrec, who drew in long crossing streaks of chalk like lines of lamp-coloured rain. Because pastels contain no oil and are not varnished their colours do not darken or *bloom* with time. Unfortunately a pastel-painting is composed of little more than coloured particles of dry dust lying on a thin ground and though Degas often fixed his chalks by working on turpentine-soaked paper, gum-varnish fixatives tend to change tone and colour values and pastels have perhaps therefore been considered too fragile a medium for extensive use. 36, 175

The staining and binding properties of oil paint, however, make it possible for artists to use a similar 'coloured-ground' method. Therefore the dexterous brushwork of Velazquez and Rubens derives not from a proud display of manual cleverness but from a master-craftsman's exploitation of a most expressive and economical technique. An examination of the surface of the confident, mature works by these artists enables us to follow the tracks of paint-marks as the brush is lifted to skim, and is then pressed in order to skid, across its middle-toned ground. Something of this gestural plasticity is seen in the El Greco and Rembrandt details, and in the scrabbled lines of the Daumier. In the present century artists as diverse as Walter Sickert, Francis Bacon, and many of the Action Painters have also made use of a coloured underpainting or of a stained ground. 75; 234-5 67; 173, 21 176

Once the expressive possibilities of oil pigment were discovered the painter found that he could change and adjust his forms and colours as the work progressed. An old painting will seem strangely alive to us today whenever we discover on its surface such evidence of overpainted corrections, of glazed and scumbled afterthoughts and improvisations, and when we come across an unfinished picture in a museum—the Cézanne *Still Life*, for example—it is as if we were witnessing its progress over the artist's shoulder and might anticipate his next brush-strokes. 220

There were a few wilful or over-reaching craftsmen: like Watteau, who sometimes bothered too little, working impetuously over partly dry paint to leave some pictures that have therefore since cracked or

crinkled; and over-conscientious Joshua Reynolds, who bothered too much and rashly experimented with bitumen in order to achieve an Old Master's 'golden glow' but often found instead only the bloom of dry pitch and the gloom of brown gravy. The lure of patina misled many lesser painters into an excessive use of black and brown; obviously the original qualities of colour and tone can be appreciated only in works that have been kept clean: a painting is rarely enhanced by dirt, discoloured varnish, or clumsy restoration.

The 'open-air' palette of spectrum hues and the working routine of the Impressionists demanded the purity of a white canvas for the expression of light, atmosphere, and movement. A purity essential to the full effect of Monet's flecks of broken colour, for instance, to the 103 scribbled vivacity and immediacy of Manet's brush-strokes and to 176 Cézanne's method of first placing his dark tones throughout the picture surface, the unpainted areas of canvas meanwhile serving as the lighter, advancing planes (see his unfinished *Still Life*). With the 220 new status won for colour as an expressive element most paintings from the middle of nineteenth century to the present time have used a white ground, the wider range of available pigment hues combined with the underlying gleam of snowy priming enhancing the expressive freshness and colour intensity of the direct *alla prima* technique.

THE PAINTED SURFACE

Select a prepared ground originally for its brightness, and renovate if necessary with fresh white when first it comes into the studio, the white to be mixed with a very little amber or copal varnish. Let this last coat become of a thoroughly stone-like hardness.

Upon this surface complete with exactness the outline of the part in hand.

On the morning for the painting—with fresh white (from which all superfluous oil has been extracted by means of absorbent paper, and to which again a small drop of varnish has been added)—spread a further coat very evenly with a palette knife over the part for the day's work, of such consistency that the drawing should faintly shine through. In some cases the thickened white may be applied to the pieces needing brilliancy with a brush, by the aid of the rectified spirit over this wet ground; the colours (transparent and semi-transparent) should be laid with light sable brushes and the touches must be made so *tenderly* that the ground below shall not be worked up, yet so far *enticed* to blend with the superimposed tints as to correct the qualities of thinness and stainness which, over a dry ground, transparent colours used would invariably exhibit. Painting of this type cannot be retouched, except with an entire loss of luminosity.

This recipe, by Holman Hunt, for obtaining the smooth finish and submarine quality of a Pre-Raphaelite painting is an example of the

serious consideration given by some artists to the chemistry of paint and the physical character of the picture-surface. Hunt was, of course, writing as a member of a self-styled 'Brotherhood' or latter-day Guild. All painters are not necessarily such self-conscious craftsmen, but most of them are concerned with the 'skin' of their work—a surface finish that will either reveal clearly the method and materials used or act intentionally as an anonymous membrane to conceal their technique.

We may appreciate this distinction more easily if we relate it to our everyday experience of the capsule-wrapped, machine-tempered surfaces of twentieth-century goods compared to the raw textures of nature and the 'home-made'; the difference between the perfect finish of polished metal alloys and the organic roughness of the bark of a tree; between the plastic 'pre-pack' and the kitchen-baked crust; between the machine-swept agricultural geometry of the aerial-photograph of neat fields and the irregular coastline erosion in the photograph in Chapter 3; between the impersonal techniques of the icon, the Ingres, the Ellsworth Kelly and the vigorous brush-strokes of the Rembrandt, the Van Gogh and the Manet.

The very different functions that artists may make pigment perform may be seen by comparing the stony Albers to the passionately 'written' Pollock. Albers obtained the unvarying colour intensity he needed from oil paint by spreading it with precise economy on hard masonite, on the back of which he would write, either with self-mocking efficiency or as a sensible precaution in case of future restoration, the name not only of each colour used but also that of its manufacturer. But for Pollock the painting-area was an unstretched canvas laid upon the studio floor to become a choreographic battle-ground across which, with a baseball pitcher's skill, he tossed and dashed his paint from dripping brushes and looped a cryptic calli-graphy from a swaying perforated can. For Turner, also, the nature of paint itself is part of his picture's subject, his two *Snowstorms* being as much maelstroms of pigment as representations in paint of the movements, tones, colours, and textures of sleet and foam.

If the surfaces of some works seem to mask their artists' technique, there are as many where their construction is clearly recorded, almost brush-stroke by brush-stroke. A Seurat is seen to be built up in systematic confetti-spots of colour, a late Rembrandt trowelled in gleaming scales of paint, a Rubens oil-sketch in a pyrotechnic display of shooting brushmarks. But what seems to be relaxed and elegant play on the surface of a scratched and scribbled Bonnard or Matisse is a masquerade to hide the hard professional labour beneath; the

POLLOCK: *Painting (1952).*
Tate Gallery, London

effort of creative interpretation is scarcely concealed in a Van Gogh, 21
however, whose desperate marks, in paint so thick they cast shadows
on the canvas, seem governed by dynamic forces in paths and patterns
like iron-filings drawn into a magnetic field or logs driven by a
torrent. Cézanne's eventual triumph would be understood whenever
we are able to compare the tense, heroic fumbling of his early work
with the final mastery of a brush-stroke construction as convincing 22
and inevitable as a rock-built wall.

WORK IN PROGRESS Exhibited in many museums are the studies made by painters in
preparation for a major work. These are always worth looking for
because of the spontaneity and brilliance of their execution (an
autographic immediacy that may be absent from the final work).
Before the miniature gessoed wood panels that Rubens painted as 61
'models' or 'roughs' for selection by a client, the preparatory oil-
sketches and tone-schemes by Daumier, Seurat, and Chagall or the 10
oil and watercolour notes and full-size oil studies for a Constable 17
landscape, we may feel that we are closer to the artist in his studio
than when we stand in front of the formidable veneer of the highly
finished final version.

Whilst some painters, by choice or technical imposition, make
preparatory tone and colour notes, squared-up scale drawings and
working instruction-sheets, others wrestle with and resolve their
pictorial problems on the picture-surface itself, so that the tensions of
destructive and creative execution may be kept. Filmed progress-
records, X-ray photographs, and often our own close examination
of the painting in a gallery, may reveal the drama of this struggle.
Serial-photographs have, for instance, shown the working proce-
dures of Picasso and Matisse and illustrate vividly the former's
description of his creative process as one of 'advancing by a series of
destructions', whilst a pictorial diary made during the painting by
Matisse of his *Pink Nude* shows the figure expanding and contracting 2
across the canvas, and shapes wiped out or changed to new relation-
ships, until the design finally achieves its lake-and-mountain grandeur
with yet the pattern simplicity of a flag.

EXPERIMENTS By walking through the usual chronologically planned order of
IN TECHNIQUE galleries in a large museum we can see that successive painters have
extended the possibilities of their media over the past five hundred
years. But it was not until the Cubist and Dadaist technical innovations
of this century that artists posed the riddle: 'When is a painting not a
painting?', and proposed that it need not be made from pigment

alone, or even of pigment at all. With their new materials and equipment modern painters have created a new vocabulary of textures. Just as colour is today no longer regarded merely as a pictorial enrichment or as a useful aid to identifying representational images, so painters do not create flat decorative patterns on relief-surfaces necessarily to symbolize or to simulate textures observed in nature. And when these textures *are* borrowed from real life their essential function is to create areas of varying optical vibrations within the whole design of the picture. The textures in a Synthetic Cubist painting by Picasso, Gris, or Braque, for instance, are certainly based on the patterns and relief-surfaces of everyday things. But these areas of wood-graining and marbling, of combed and sand-mixed paint and the applied pieces of real corrugated card, glasspaper, newsprint, and wallpaper are chosen and arranged primarily for their abstract values just as areas of colour are used in these pictures for their sensuous rather than their representational qualities. The literal identity of these everyday textures tends to fade as soon as we begin to appreciate their emotive and decorative functions. Later, in the early nineteen-twenties, Schwitters created relief-surfaces from unrelated odds and ends, combining and superimposing tickets, labels, nails, feathers, and pieces of string, wood, and cork. These revolutionary extensions to the artist's studio equipment, with Paul Klee's brilliant exploitation of unconventional materials and unlikely combinations of media, encouraged later abstract painters to find, in the new opportunities for creative craftsmanship, a stimulus to replace the emotional and intellectual springboards of subject-matter and the interpretation of natural phenomena that they had rejected.

Klee has been probably the most inventive painter-craftsman of recent times. His use of oil paint over tempera in *Around the Fish* is a straightforward, orthodox technique compared to the complex permutations of much of his pictorial cookery, a random inventory of some of his picture-ingredients reading like formulae from an industrial laboratory: watercolour on paper, set on gauze backed with cardboard; oil and distemper on chalk, over jute; oil and water-colour, covered with wax, on canvas; watercolour and gouache on canvas, over chalk, backed with cardboard; oil on paper, stuck on wood and plaster; watercolour and wax on muslin, stuck on wood; watercolour on blotting-paper, and so on.

In the patterns gouged from sand and paint on slashed canvases by Tapies we may imagine scoured desert-tracks and in the palette-knife bars of pigment laid in half-relief by Riopelle and de Staël, the aerial views of towns and highways. More direct references to urban events

are made in the multi-media combines of Rauschenberg and Dine, where photo-screen prints, transistor radios that play, plastic curtains that pull, fixed wash-basins, real road-signs and areas of real paint tease the viewer with their visual ambiguities between what is actual and what illusory. Richard Smith's large three-dimensional canvas structures suggest the giant relief cigarette packs of advertisement hoarding, his projecting units often casting umbra and penumbra shadow bands across the main support on which he has added his own *trompe l'œil* painted shadows. His technique and attitude heralded a general merging of the once precisely defined activities of painter and sculptor. For just as the Greek and Gothic sculptors painted and gilded their carvings, and painters once accepted the planes of walls, chests and screens and the curved surfaces of pillars and domed ceilings as legitimate three-dimensional working-grounds, so many contemporary artists may now be regarded as painter-sculptor technologists, creators of totemic and kinetic art-machines, designers not of the coloured canvas set in a gilded frame but of the painted free-standing solid object and the mass-produced 'multiple' in coloured plastics.

Just as many modern painters have discarded the brush, the mahl-stick, the easel, the palette, and the palette-knife in favour of the spray-gun, masking-tape, template, paint-roller, ruling pen, perforated can, and various tools and equipment from the factory floor, so other artists have expressed their ideas in hand-drawn cine-film, by 'painting' in coloured light-beams and through the single performance given by the auto-destructive event.

If at an *avant-garde* exhibition of works created by unconventional techniques we do no more at first than wander through as we might through a bizarre fairground or an exotic landscape, we should find that we have been enjoyably disturbed, and probably exhilarated by the dynamic charm, cool aggressiveness, and savage fantasy of these new methods and materials. If nothing else, the shock and novelty of such works will have sharpened our awareness of technique as a vital factor in the creative process. Later, the best of what may now seem flippant or extravagant iconoclasm will almost certainly be seen as examples of honest and expressive craftsmanship.

CHAPTER 7 Form and Space

Because art terminology is vague and loose, often ambiguous and always inadequate, I should explain that here I am speaking of form and space in the special sense of the illusions of three dimensions created on the flat surface of a painting. Therefore by 'form' I mean the representation in pictures of such qualities as the volume, structure and weight of things and the roundness and angularity, the convexity and concavity of their surfaces. And by 'space' I mean the impressions produced that the painted surface is not really flat but is an area of extending dimensions in which planes appear to advance towards and to recede away from us.

In previous chapters I have described some of the ways in which these illusions are created; the expression of form by means of contour variations, linear cross-sections, tonal modelling, colour modulations, and textural distortions; and of space by the use of diminishing scale and converging linear perspective and the atmospheric tone and colour modifications of aerial perspective.

Every good painting, whatever its style or subject, should be appreciated both as a flat pattern and as a representation in three dimensions. Indeed it is impossible to make a mark or two on a plain surface without producing some effect of form or space. Even the lines of type on this page, for instance, can be seen as textured planes which seem to float just above the white surface of the paper. Many people, however, are so used to seeing the three dimensions of things and places represented in paintings in terms of Renaissance perspective and as they are objectively recorded through the media of photographs and television that they tend to regard paintings which employ other perspectival systems merely as two-dimensional patterns. But paintings in the Renaissance tradition show things and places only as they are perceived from a fixed viewpoint and at a particular time whilst our own experience of form and space is not limited to momentary visual impressions but is enriched from a store of previous tactile and kinetic sensations. Even our perception of the formal qualities and spatial relationships of things and places around us at any time is considerably influenced by practical necessity and emotional reactions. And the spatial sequences into which we re-shuffle our impressions of the three-dimensional characteristics of things in recollection and in dreams will usually be very different from their measurable dimensions. Painters also work from these other levels of

KLINE: *Meryon* (1960).
Tate Gallery, London

188

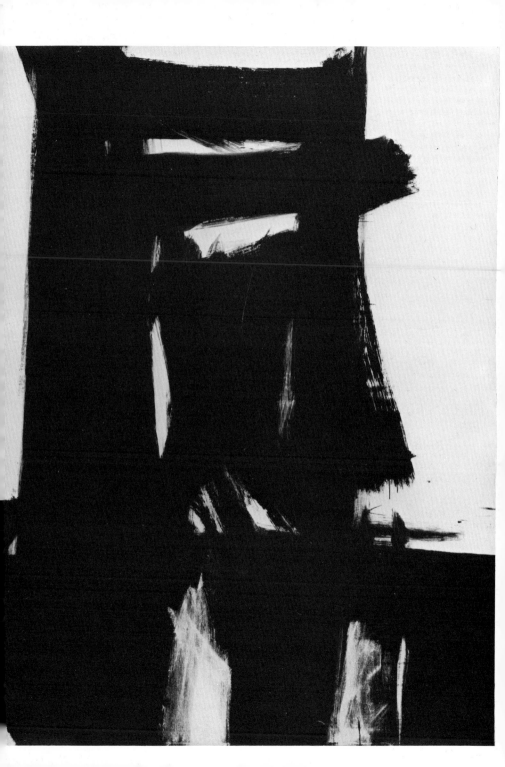

experience, using special perspective systems to create different degrees and kinds of spatial illusion.

THE PICTURE SPACE We can identify the kind of picture space a painter has attempted to create on his working surface (his canvas, panel, or paper ground) by noting the degree to which he allows us to be consciously aware of its essential flatness or has, instead, attempted to disguise this. Bihzād 2(and Lorenzo Monaco, for example, have left the margins of their 14 working surfaces unpainted in order to provide a kind of inner frame or mount to the subject of their picture whilst Matisse has decorated 2 a large area of his canvas surface with a flat repeat-pattern. These painters have drawn our attention to the flatness of their working surface in order to produce the impression that some of their images lie in front of this plane whilst others appear to exist behind it. This surface has therefore become a two-dimensional reference plane against which we can perceive the intended spatial position of things in the picture. But by various means other painters—Rubens and Poussin, for example—seek to deny the limitations of the canvas plane and therefore contrive to distract our attention away from its frame-edges in order to create the illusion of an imaginary picture space extending beyond the gallery wall.

The various ways in which the canvas plane is represented as an imaginary spatial field can be demonstrated by a few simple diagrams. A basic arrangement of a circle placed within a rectangle is repeated in each of this sequence of illustrations. The addition of a different ■ arrangement of lines drawn around this circle in each diagram changes its spatial position within the rectangle (or picture area). In (a), for example, the two-dimensional nature of the rectangle is emphasized by an extensive repeat-pattern. Because this flat texture appears to pass behind the circle, this image therefore seems to lie in front of the canvas plane. Matisse in his *Pink Nude* has created a similar effect of spatial projection by 'tying' the couch to the canvas plane with a pattern of vertical and horizontal lines arranged like lengths of string across a flat parcel. Since the figure is lying on a flat patterned surface which is identified with the canvas plane, it seems to be projected towards us (b).

In (c) the circle seems to rest across an aperture cut into the lid covering a shallow box. From the back of this box an inclined plane slopes to the lower edge of the aperture. Flattened images are slotted, one behind the other, into the sloping plane and into the back of the box. The page-margins of a Persian manuscript painting perform the same three-dimensional function as the box-lid aperture in the

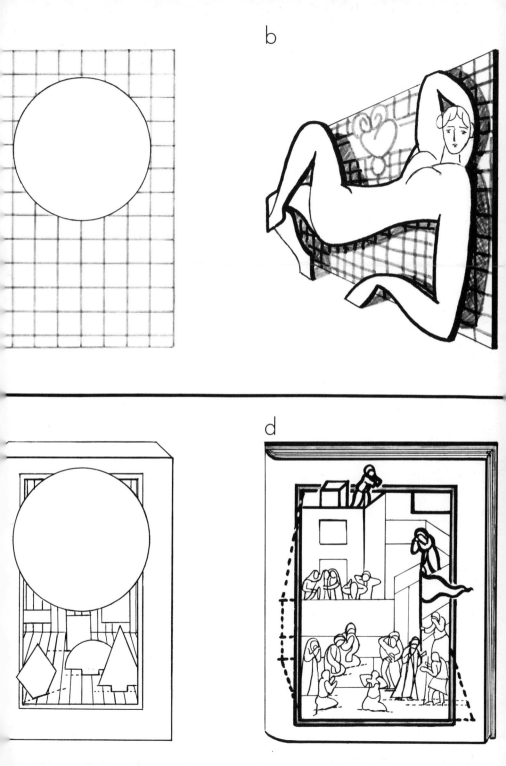

b

d

diagram. Using these margins as a fixed spatial plane, we can therefore
judge the spatial relationships of Bihzād's images to one another (d). 1ⁱ

The circle has itself become a window or porthole in (e), cut 1ⁱ
apparently into the plane of the rectangle. Some planes within this
aperture seem to continue behind the plane of the rectangle whilst
others seem to finish at the 'window's' edge, to lie at a level above the
plane of the rectangle. This kind of illusion is created in the Braque, 1ⁱ
where the spatial position of the overlapping shapes can be judged
by whether they touch the edge of his inset oval window, pass
beneath it apparently to continue behind the plane canvas area, or are
projected above it (f). A similar spatial function is performed by the
page margins of the Lorenzo Monaco, where there is the illusion 1
created that a shallow niche is recessed into the page containing a
three-dimensional letter-form. Leaves appear to grow from this form
out of the niche, to curl over and lie upon the plane of the page like
decorative hasps and hinges attaching the door-like form of the
illuminated capital letter to the edge of the recess.

The two-dimensional nature of the rectangle is convincingly denied
in (g), where the whole picture area becomes a transparent plane
across the entrance to a very deep box-space. This is an example of
Renaissance depth perspective, where the picture frame is regarded as
a window-frame and the painting's protective glass as a window-
pane. This perspective system produces the impression that the
viewer is looking through the picture-glass into a room, or across a
courtyard or landscape which extends behind the gallery wall. The
ground plane of this imaginary spatial world may seem even to be an
extension of the very gallery floor on which the viewer stands. This
system remained the method of spatial representation used by
European painters from the fifteenth century to the end of the nine-
teenth—the depth perspective of Rubens, for example, and of the
'stage-set' compositions of Poussin ('h' is based on his *Bacchanalian
Revel*).

In this perceptual perspective system the foreground, or nearest
edge, of the picture's imaginary space appears to begin on the plane
of the canvas or panel. From this position the forms appear to recede
into depth. But in icon-painting the picture space *begins* on the plane
of the gessoed panel and the painter's images appear to advance in
front of it. The forms in an icon are usually represented in two
different styles, the heads, hands, and feet of the figures being tonally
modelled in monochrome half-relief whilst their costumes are
expressed as richly textured flat shapes and the background field as a
gilded or diaper-patterned vertical wall. This fascinating spatial

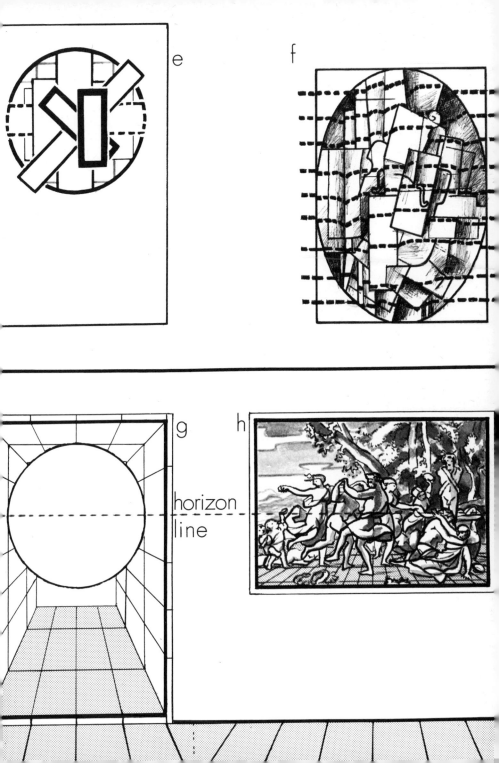

e

f

g

horizon
line

h

ambiguity is reminiscent of the technique of children's printed costume-sheets on which the clothes are represented as flattened silhouettes for cutting out and hinging to a cardboard figure which alone is given the appearance of a three-dimensional form by means of shading. The flat, stiff costumes in icon-painting so often resemble interchangeable sandwich-boards, and the conventionalized form of the figure is so rarely distinguishable from those on other panels, that we might irreverently imagine the figure being dressed from alternative ceremonial wardrobes to pose as a saint in one painting and as a national hero in another (a). In the next sequence of spatial diagrams, (b) represents a scheme of flattened, interlocked, and overlapping vertical and steeply inclined planes producing the effect that the circle has been thrust forward from the painting-ground. A similar illusion has been created in the Cézannes and in the Cubist Braque, where forms and planes seem almost to begin to encroach upon the real space between the viewer and the picture-frame ((c) is based on Cézanne's *Les Grandes Baigneuses*).

Through our knowledge and experience of the visual world we can read certain three-dimensional qualities into the most summary representation of things and places in paintings. Even the addition of a few skeletal symbols to our basic diagram provides enough information for use to be able to identify a landscape (d) or a still life (e), whose primary spatial relationships we can imagine for ourselves from our previous tactile and kinetic experiences of these subjects in real life. Any further statements in tone, colour, and texture made by the painter will therefore extend our appreciation of the three-dimensional qualities of these already familiar forms.

But obviously our experiences of three dimensions in the outside world will not be immediately helpful to our appreciation of these qualities in an *abstract* painting. Therefore in order to perceive and appreciate the form and space of abstract pictures we have to depend upon our sensitivity to the optical effects created by their linear, tonal, colour, and textural relationships alone. Since the spatial relationships of forms in an abstract painting cannot be pre-determined—as the spatial position of things can be in representational pictures—the possibility of alternative three-dimensional readings provides us with one of the most stimulating qualities of recent developments in painting.

Albers's *Homage to the Square*, for example, is much more than the symmetrical flat pattern of inset squares which the reduced monochrome reproduction might suggest. For, seen in the colours and dimensions of the original, it is a dynamic spatial structure, its central

a

A B

ST.
GEORGE

A B

ST.
BORIS

A B

b

c

d

e

square becoming at one moment the platform apex of a projecting pyramidal form and then alternatively the deepest, most distant plane within the picture space (f and g). 197

I have illustrated here a few of the many spatial ambiguities which are created when linear and tonal statements in a painting do not refer to things in real life. Fig (h), for instance, may be read as a white plane with a hole lying on a dark surface, as a dark circle and a rectangle placed on a white field, or as a sphere suspended in space above a horizontal plane like a sun over a landscape (cf. Gottlieb's *Blast*). 169 Fig. (i) can be seen either as a flat plane from which forms project or as a surface into which they are recessed. And (j) may be perceived either as a two-dimensional pattern of black and white counterchange motifs on a vertical grey ground or as a broken sphere suspended in undefined space above a skeletal kite-structure. And because we cannot bring preconceived ideas of the probable spatial relationship of things to the images in an abstract painting, our very viewpoint as spectators of the picture may seem to change according to the angle at which the images seem to be directed towards or away from us. Therefore when we see the plane of the rectangle in (k) as a panel in which a hole has been made and on which a four-sided form has been built, we are reading it as if observing the plane from an aerial viewpoint (position A). But if, instead, we see the rectangle as an area of free space in which a globe, circumscribed by an equator line, appears to float above a drifting roof-shaped solid, then we are reading the picture space frontally (position B). And if the circle appears to be a coin-like form in raised relief in a position on the rectangular plane above a trough-shaped structure, so that the whole picture-ground seems to have been tilted away from us, then we are reading the forms as if from a position below them (C).

The spectator's viewpoint in relation to the spatial world of the picture is also an essential factor in an appreciation of the three-dimensional qualities expressed in representational styles of painting. Western viewers are accustomed to looking at the things and places depicted in a picture as if from a fixed frontal viewpoint. But this viewpoint cannot be used for all styles of representational painting. For just as we speak of the imaginary space of a picture, so we may refer to the imaginary spatial position of the viewer in relation to the picture plane. A painter may represent the objects in one and the same picture from many different viewpoints. He will then have intended us to imagine that we are moving within his picture space and seeing his forms from these different visual angles also. I shall therefore explain briefly these various perspective systems.

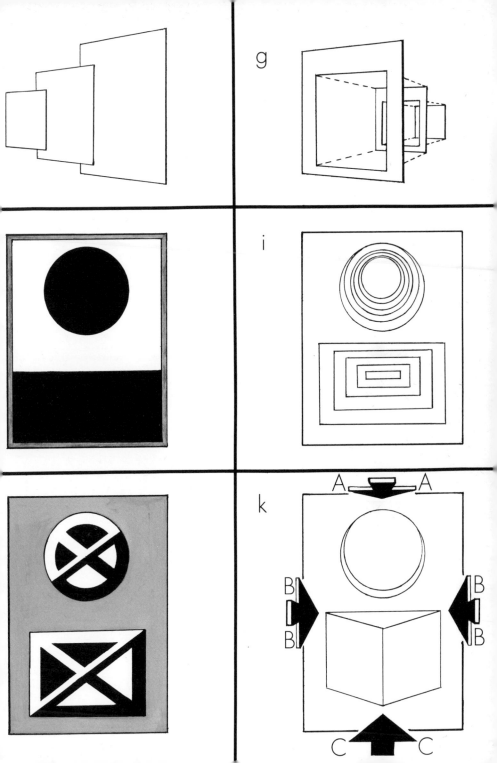

g

i

k

The scenic painters for ancient Greek drama were probably the first to exploit systematically the principles of optical perspective, using the techniques of converging lines and diminishing proportions in order to create an illusion of depth on the flat wall-plane behind the actors. In fifteenth-century Italy Alberti and Brunelleschi developed a quasi-mathematical perspective system which, because it shows the appearance of things as we perceive them in real life, may be referred to as perceptual perspective.

But the very familiarity of this system of representing the dimensions of things and places easily blinds us to the many different three-dimensional qualities it can express. The spatial relationships of forms and the degrees of depth expressed in a Giovanni di Paolo or a Lorenzo Monaco, for instance, are very different from those with which Rubens or Poussin were concerned. In the Giovanni the lines 240-1 defining the side wall of the foreground building and the neat paths across the miniature valley landscape appear to converge at points on the curved horizon line. This horizon line is assumed to be the spectator's eye-level. But Giovanni retained the conventions of 'interest perspective' in the scale-relationships of things: the figure of St John, for instance, has not shrunk in size at all during his journey to the wilderness; so that when he is shown again in the picture's middle distance he dwarfs the surrounding rocks and the landscape below to the incongruous scale of a toy model village. This is because for Giovanni St John was more important to the emotional and narrative expression of the picture than were the incidental forms around him. Yet in spite of his unsophisticated spatial technique Giovanni convincingly produces the impression that a box or stage- 198a arena exists beyond his two proscenium-like floral side-panels. Giovanni has enhanced this effect of recession by representing the wall of the building facing the viewer as being on the same plane as the two proscenium side-panels. The impression is therefore produced that the wall inclined away from us is standing on a receding horizontal surface. This ground plane appears to continue into the middle distance of the picture space, where it then disappears behind the right hand panel.

In the Uccello the horizontal ground plane is forcefully expressed 151 by the converging lines of the foreshortened fallen soldier and the pattern of broken lances. Compared to the 'domed-ceiling' space of the Rubens, the depth perspective in the Uccello is relatively shallow. 130 There is only room, for instance, for Uccello's well-schooled horses to move in close *dressage* formation parallel to the picture plane. But 198b Rubens's horses have space in which to charge towards and away 198c

from the viewer with fanwise urgency. Uccello's spatial plan of vertical planes set one behind the other expresses the gentlemanly spirit of a ceremonial jousting tournament rather than the uninhibited exuberance of Rubens's battle skirmish, where a complex construction of advancing, receding, rising, and falling surfaces suggests the furious energy of a rumbustious free-for-all.

In the seventeenth century the depiction of vast landscape expanses provided the *raison d'être* for pictures by Ruisdael, Claude, Canaletto, and Guardi. In contrast, the closed-in space of a Chardin, a Vermeer, a Caravaggio, and a Rembrandt produces an effect of domestic intimacy. This intimacy established with the viewer is characteristic also of a Degas, a Lautrec, and, of course, of the work of the Intimistes, Bonnard and Vuillard. Influenced by the accidental compositions of photographs—the close-up and the arbitrary frame-cutting—and anticipating the momentary, unflattering truth of the concealed 'candid' camera-shot, these later painters revealed the unexpected patterns and spatial relationships that may be glimpsed through a doorway or a curtain chink.

In the twentieth century painters have devised many other methods of representing three dimensions. But the perceptual perspective system has survived as the spatial language of many of those still concerned with depicting the appearance of the outside world: the dramatically converging deserted city-streets of Utrillo, for example, the winter-stripped country roads of Vlaminck, the river stretches of Kokoschka, the interiors of Bonnard, Vuillard, and Balthus, and the cages and the empty rooms in which Bacon has imprisoned his menacing figures. The realistic impact possible with this perspective system made it suitable for Surrealists' convincing representation of their 'dream-space' and for their combinations of familiar things into a disturbing mythology of mongrel forms. Thus the 'dreamscapes' of Chirico's haunted courtyards and cloister-labyrinths, Ernst's primeval forests, Delvaux's bizarre classical settings, Dali's deserts, and Tanguy's beaches which stretch to the tip of infinity seem as genuine as a High Street photograph. And to challenge our convictions about visual reality Magritte transposes the essential three-dimensional qualities of commonplace things: thus a piece of sculpture bleeds, an apple is inflated to fill a room from floor to ceiling, a castle lifts its mountain to float with it in the sky, and French loaves glide majestically in the sky like a fleet of airships. He also reminds us that the very perspectival system he uses is itself a fraud. Because European painters since the Renaissance had invited us to accept their picture-frame as a window-frame through which we

MAGRITTE: *The False Mirror* (c. 1929). The Museum of Modern Art, New York

could see a three-dimensional world, Magritte takes a window as his subject-matter and represents it with a shattered pane in order to show us that the landscape seen through the empty window-frame appears also on the splintered glass fragments. And when we look through the window painted in another Magritte we find that the anticipated panoramic landscape is obscured by rows of identical bowler-hatted viewers staring mockingly back at us. In his *False* 20 *Mirror* the eye itself fills the picture, the giant iris being both a mirror-image of a sky apparently behind the viewer and, with uncanny spatial realism, a porthole-window across which real clouds seem to pass behind the eye's pupil suspended like a black sun.

CONCEPTUAL PERSPECTIVE
: In the optical perspectives of photographs and Renaissance paintings the elements of form and space are represented very much as we would have seen them at particular times and from fixed viewpoints. But in conceptual perspective systems, things and places are shown in paintings as the artist knows them to be from the sum of his experiences of their other aspects. Most untrained people instinctively represent things in this way even when drawing directly from nature.

Fig. (a) illustrates a table, a plate of fruit, and a glass tumbler in terms 2 of *perceptual* perspective. This would be the view of a standing spectator in real life and the perspective in which a photograph would probably record them and as most European painters have represented things until recently. In contrast (b) illustrates the same subject purely in terms of conceptual perspective: all components of the forms are included in the picture and each is shown individually from its most formally characteristic and functionally expressive view. In this perspective convention a visual catalogue of information is provided: the square shape of the table-top, the roundness of the plate and the characteristic forms of the fruit are demonstrated by plan-views; the number and dimensions of the table-legs are explained by representing all four of them on the same frontal plane; and the tumbler is given a side elevation base-line to indicate that it is standing on a horizontal plane, whilst its rim is shown in plan as a full circle so that we know that this is a cylindrical glass.

This system was often used to express the three-dimensional character of things in Byzantine, Islamic, and medieval European painting. It is the means of expressing form used by young children and by naïve painters such as Alfred Wallis and Grandma Moses and 1 as a deliberate convention in early periods of Egyptian and Assyrian art, when a method of displaying an inventory of objects was also employed to explain the spatial relationships of things: the objects most

distant from the spectator being placed at the top of the picture and those nearest at the bottom.

An indication of an object's spatial displacement and structure is also given by the use, in some periods of Chinese, Persian, Indian, and medieval Gothic painting, of 'inverted perspective'. Examples of this are seen in the Bihzād, where the basket at the top, for instance, has been tilted towards us and part of the bamboo bridge in the Chinese painting has been turned over in order that we may see its underside construction. Unlike the principles of perceptual perspective by which the receding edges of forms and planes in a painting are made to converge *away* from the viewer to meet at points on the picture's horizon line, the edges of receding things in conceptual perspective often converge *towards* the viewer as if the horizon line were situated behind him. In this way the painter was able both to show the most typical aspects of his forms and to indicate how much of his picture space they occupied. Fig. (c) illustrates our table in this perspective system. In this century Picasso, Braque, and Matisse among other representational painters have used 'inverted perspective'.

SIMULTANEOUS AND ROTARY VIEWPOINTS

Not only do conceptual perspectives produce expressive and decorative overall patterns, but they enable the viewer to experience the sensation of being taken into the picture space and shown the forms from different positions within it (d). This is not unlike the experience of seeing a movie sequence filmed by a mobile crane-camera.

Bihzād, for instance, creates a montage of different viewpoints both to explore the spatial dimensions of his setting and to express the formal and emotive qualities of his figures. All the vertical forms in his picture—the building, the courtyard wall, the pennant, and the figures—are painted from various ground-level viewpoints. But the horizontal floor-planes of the courtyard and outspread carpet are represented from an aerial or plan view. And he has swung the receding building and courtyard walls towards us in order to show their geometrical textures completely; in perceptual perspective the patterns of these surfaces would have been distorted or entirely lost. It is interesting to compare this picture to the *Blue Ship* by the twentieth-century Cornish Primitive, Alfred Wallis, where the harbour-mouth and ship's deck are shown in plan-view and the lighthouse and ship's sails are drawn in elevation.

Each of Bihzād's figures is shown in the elevation view which most

Persian manuscript painting attributed to BIHZĀD: *The Mourning for the Death of Ibn Ul-Salam, the Husband of Laila* (15th century). British Museum, London

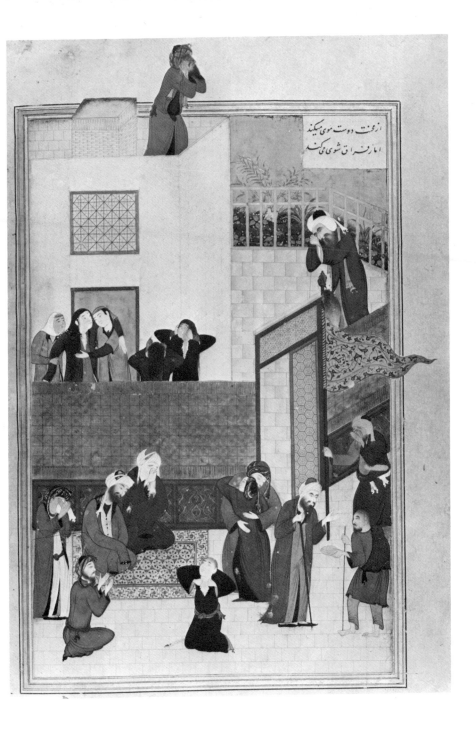

clearly demonstrates its physical action and emotive role in the narrative. A profile view is chosen for the figures moving *into* the courtyard (the attendant with his banner, the beggar proffering his bowl) because actions are immediately registered when things pass in directions parallel to the viewer's plane of vision. The frontal elevation is reserved for the group of mourners embracing one another and, as the focal centre of the tragedy, for Laila and her attendants. The distraught figure in the centre foreground is shown both from above to express the anguish with which he rends his clothes and from side view to indicate that he is kneeling. Finally, the incongruous 'interest perspective' scale of the two mourners at the top of the picture directs our attention to an emotionally symbolic silhouette, very much as an interposed deep-focus shot in a movie sequence is intended to do.

Simultaneous viewpoints are also used in medieval European manuscript paintings. In early examples the inner frame and margin were often richly textured in simulated low-relief repeat-patterns. Sometimes the page would be sub-divided by additional boundary lines like the frame-convention of modern strip-cartoons. In this way a narrative sequence could be depicted in two or more episodes on the same page. These additional picture divisions often produced an overcrowded effect appropriate to the intimate nature of this style of pictorial story-telling. In the pages reproduced from an early English Psalter two shallow compartments are represented on each, one above the other as if on shelves. When we notice that figures in two of the narrative episodes have jumped from their respective spatial fields to trespass on a dividing strip of neutral marginal ground their action produces a shock similar to that experienced when actors jump unexpectedly off the stage and into the auditorium.

This challenge to our acceptance of pictorial reality is often a feature of Persian paintings. In a battle or a hunting scene, for example, a horseman may gallop from the margin of the page and behind the inner frame, in pursuit of another rider who leaps over the opposite frame edge as if to the safety of his own margin. In another example the bushes, trees, weapons, battle-reinforcements, and casualties appear to be waiting in the margin area outside the frame like props in the theatre-wings before a scene-change and actors awaiting their cue. And in the Bihzād the top figure and basket and the pennant carried by an attendant defy their logical spatial positions by moving in front of the frame but, however, provide steps into the real surrounding space of the page—establishing links with the spatial world of the viewer similar to the movement on to the gallery-wall

created by the canvas extension to Richard Smith's twentieth-century
abstract painting. 227

THE ORIENTAL
URE-VIEWPOINT At first sight the Chinese landscape reproduced here seems to have 208
been painted in much the same perspective system as a European
picture. Yet we may find it difficult to see our way into its picture
.space, its picture plane seeming somehow to be turned slightly away
from us. This phenomenon is due to our being used to approaching
the focal centre of *Western* paintings horizontally from left to right—
the direction in which we read the pages of a European book. But
Oriental characters are read in vertical columns, from top to bottom
and from right to left. And Chinese and Japanese pictures are painted
to be read from right to left also. That is, the viewer should first look
at the top right corner and then move diagonally across the picture
plane to the bottom left corner.

For Western viewers to change the directional sequences in which,
instinctively, they have always read a picture may not be easy. Until
we are used to seeing an Oriental painting 'back to front' it will be
found helpful to look at our Chinese landscape reproduction reflected
in a mirror—when its forms seem immediately to sit comfortably 211
within the picture space. Looking first in the mirror-reflection at the
passage of calligraphic script, we should find our attention at once
drawn to the bamboo pavilion, from there along the tree trunk to its
frosted branches and the distant mountains, and then from the floating
curtain of the calligraphic passage down to the figure on the fragile
bridge—a bridge which seems to enter the foreground of the picture
space from a position in the real space behind us. The extent to which
unconsciously we look into the picture space of a Western painting
from the left half of the composition may be judged if we look at some
of the reproductions of European paintings, reflected in a mirror—
the Miró, the Rubens, and the Bruegel, for example. Most of us would 243; 130;
probably have some difficulty in finding in the picture space of the 17
reflected European painting a form on which to focus first. And even
when our eyes have found a focal point we might not know in which
direction to look next across the picture. Between this Chinese
painting and the Miró there are, however, interesting similarities in
the technique of representing flattened space and in the sensuous
qualities of vibrant, sinuous line and expressive silhouette.

208
G FAN: *Watercolour
Verse*, Chinese (late
century). Victoria
Albert Museum,
lon: Crown
right
209
ONELLO DA
INA: *St. Jerome in his
I (c. 1477). National
ery, London

RELATIONSHIP I have demonstrated that we are able to read three dimensions into
OF PLANES the most elementary combination of marks made on a flat surface.
And representational painters concerned primarily with the interplay

above
PICASSO: *Woman Seated in Red Armchair* (1932). Collection of Mr. and Mrs. Victor W. Ganz; © SPADEM, Paris

facing page, bottom right
WANG FAN: *Watercolour with Verse* (reversed), Chinese (late 18th century). Victoria and Albert Museum, London: Crown Copyright

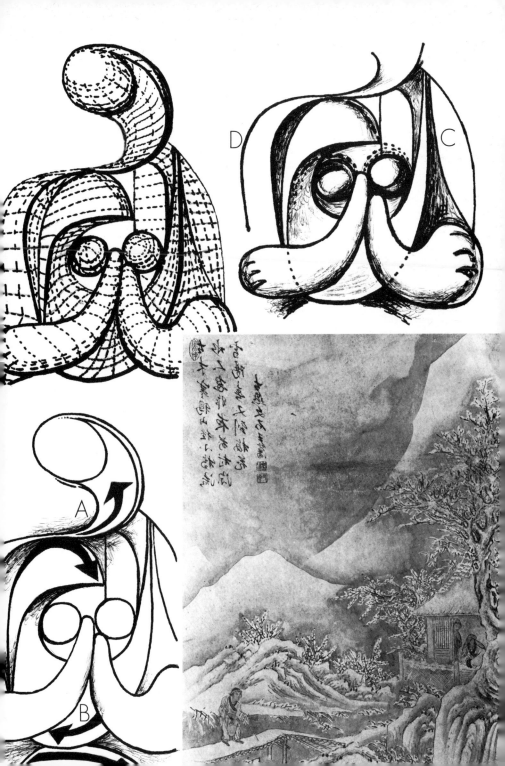

of colours, textures, and silhouette shapes—the pattern in dynamic contrasts of rounded images against angular shapes in the Matisse and the Bihzād, for instance—expect the viewer's imagination to provide the missing formal information. Therefore when we see images in a great painting elaborately modelled into three-dimensional forms of convincing volume and weight—like the Picasso and the Ingres, for example—we can expect to find an expression of particularly subtle surface transitions and complex planar relationships.

Picasso's precise definition of surface change and planar character in his painting makes it unnecessary for the viewer to add his own knowledge of form to such assertive sculptural illusionism. And the savage autopsy Picasso has performed upon his subject should enable us to enjoy the relationship of the planes undistracted by any associations with familiar forms in real life. The relative weight and surface direction of each of these forms is so clearly expressed that we can sense the delicate gravitational balance of one solid upon another and the spatial contrast of a convex plane against a concave and of a curved against a flat as if we were able to touch a free-standing carving.

Thus the combined sun/moon form of the ovoid head with concave crescent or embracing hood of hair rises above a 'mountain-landscape' of interlocked torso components. Opposing this apex form is the curving surface of the helmet-like main torso structure (A). The contrast of this curved surface against the hollowed segment of the hair is echoed at the bottom of the picture (B). The torso structure encloses a spatial void in which the swollen fruit and gourd forms of the breasts and arms support each other in tense balance against the rims of the large, scooped melon-slice shape. The organic character of these is played against the pointing spike of the melon-shape (C) and the sharp-edged curling segment of the chair arm (D).

This sensuous exploration of an illusory spatial world is also an important aspect in our appreciation of other paintings reproduced here. In the Ingres, for instance, there is an expressive tactile contrast between the sitter's heavy, cylindrical arms and spherical head with the brittle ridges and valleys of her dress and the flat wall and mirror plane behind her. In the Bruegel the plastic harmony established between the tilted disc of the table-top, the bulbous figures, and the swelling ground plane is enhanced by the angular contrasts of the shed and the diamond-shaped tablecloth. In the Chinese landscape the planar contrasts are between rounded, grooved rocks and the tree-trunk with barbed twigs and branches, and between sharp-edged mountain forms with cotton-wool clouds. Whilst in the Giovanni there is a tactile and emotionally expressive relationship between the

cubic building in the foreground and the curving sweep of the fluted mountainsides and again between the flat horizontal plane of the laundered valley-landscape (cf. the aerial photograph on p. 185) and the vertical, convex sides of the rocky ramp and the convex surfaces, shaped like Picasso's melon-segments, of the curling rocks. And 210 Braque, as if describing a cliff-face rather than a still life, plays void 43 against solid and recess against projection.

VOLUME
AND STRUCTURE The four portrait-details illustrate ways of representing volume and 214, 215 structure in different styles and periods of painting. Whilst the icon head is a conventional symbol and the Ingres a Neo-Classical idealization, the Rembrandt and Van Gogh portraits share a humanitarian concern for the emotional and physical characteristics of particular people. Comparisons also reveal certain aesthetic distinctions. Both the icon and the Van Gogh, for instance, emphasize the silhouette of the whole head, the former expressing planar changes by the scooped and scalloped cross-sections of conventionalized Byzantine tonal and linear modelling and the latter describing the direction of different surfaces by emphatic brushmark movements in thick paint. As we stare at the Ingres our eyes are held by those of his model and we are made aware of light breaking across the rocks and valleys of the facial structure around them; but the impassive stare of the icon saint makes us more conscious of the decorative function of the eyes as dark spots in a pattern of abstracted shapes. Ingres's Madam Moitessier sits like a marble sculpture in space whilst the icon head rests upon its background field like a half-relief wooden mask hanging on a wall. Each artist has used different kinds of textural contrast to emphasize special qualities of volume and structure: the tactile textures of fur cap, bandage, and woollen jacket which frame the bony Van Gogh self-portrait; the wiry beard, scarf, and head-band which enhance the facial volumes of the Rembrandt; and the sensuous play of starch-stiff patterned material against rounded cheeks and forehead in the icon and the Ingres.

Cézanne said: 'To paint a landscape adequately, I must first discover its geological foundations.' And Picasso, referring to his own and Braque's Analytical Cubist paintings: 'It would have sufficed to cut them up—the colours after all being no more than indications of differences in perspective and planes inclined one way or the other—and then assemble them according to the indications given by the colour, in order to be confronted by a sculpture.'

In everyday life most people are fascinated by occasional glimpses of the bones and mechanism of familiar things: by the graceful

214

RANDT: Detail of
Man in an Armchair
). National Gallery,
don

il of icon, late 13th
ry. Victoria and
rt Museum, London:
wn Copyright
215

RES: Detail of
ame Moitessier Seated
). National Gallery,
don

GOGH: Detail of
Portrait (1889).
rtauld Institute of
London

intricacy of scaffolding and the tough girder anatomy of building construction or by the exposure of a city's cable-arteries beneath the strata-bands of bitumen, concrete, rubble, clay, and chalk in a street crater. And there is a special pleasure in seeing forms painted in such a way that their interlocking construction, the elasticity and tension of their materials, and the strength and delicacy of their whole structure is expressed: the drawer projecting from the card-table and the indication of the form beneath the beautifully tailored coat in the Chardin, for instance; the expressive articulation of limbs with torso 264 in Blake's unique anatomy, Van Gogh's carpentry in paint, the dove- 274 tailed blocks of Cézanne's rocky structure and the bone construction 221 of Leonardo's angel's head. · 74

In the Renaissance the pervading spirit of humanism and the restless scientific curiosity stimulated biological, botanical, and geological research into the nature of form beneath the outward skin of things. In a Renaissance painting a man's hair appears to grow, his muscles to move, and his clothes to be securely fastened and wrapped around his substantial and athletic frame. There will be also a structural relationship between a figure and its immediate surroundings in the 209 painting: he leans against cemented pillars, climbs steps constructed to bear his weight, and walks through arches built by master-masons. In later paintings of the period even an angel's wing is assembled with aeronautical expertise. And when a holy group by Leonardo rests on hard stratiform rock in well-cut robes, even the conventional halo is made to spin around heads in golden orbit like a demonstration of gyratory theory.

In everyday life we usually turn over or walk around a form in order to understand its volume and three-dimensional structure. Painters who represented things in terms of perceptual perspective contrived various pictorial devices to overcome the limitations of their fixed single viewpoint. Sometimes they made use of mirror-reflections, usually with justifiable scientific inaccuracy—well known examples are van Eyck's *Arnolfini Couple*, Velazquez's *Venus and Cupid,* 268 Manet's *Bar at the Folies Bergère* and notably in Ingres's *Madame* 11 *Moitessier*, where the reflected profile is stylistically alien to the rest of the painting and bears an uncanny resemblance to a Classical Period Picasso. Painters like Michelangelo and Tintoretto put their figures into twisted poses, dramatically foreshortened, so that various frontal, three-quarter, and profile sections of a figure would be seen. Others, such as Crivelli, Titian, Rubens, and Renoir, have repeated their idealized figure-type or worked from different studies of the same model for all the figures in a *Three Graces* or a *Nymphs Surprised*

216

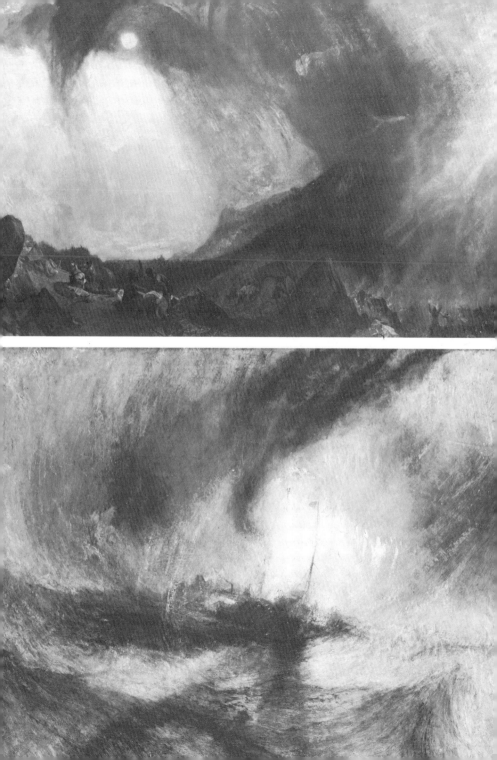

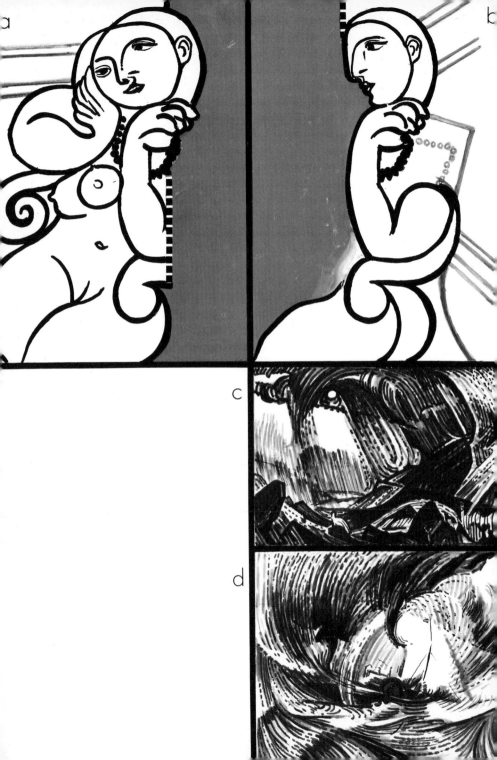

Bathing. This economical studio device enabled them to show many aspects of the volume and structure of a particular figure in one painted group.

But this problem was not resolved until Picasso and Braque expressed all views which would describe the complete structural form of things simultaneously in one composite image. The different aspects of their forms were rhythmically integrated, the frontal planes melting into or being interlocked with the side and back surfaces. The combination of different views of a form provided the spectator with a rotary impression of the form 'in the round' as if it revolved on a turntable set within a mirror-panelled display stand. In the Picasso, for instance, the figure's right shoulder is fused with the back 71 of her chair across which her necklace is continued, to become a row of upholsterer's studs across the chair. The arms of the chair are tied 218b to the figure like the sleeves of a coat. And the shaded half of her head defines her profile within the frontal view of her complete face. If we 69f mask the right half of this painting, the figure faces us. If we conceal 218a the left half, we see her three-quarter back view. 218b

Some painters are concerned with the structure of the ephemeral— like Turner's curling planes of water and snow which cut through the 217 picture space like the blades of a giant harvester. Others, such as 218c, d Poussin and Cézanne, have attempted to express the overall structure 96; 97 of the picture space itself so that the whole painting surface produces the impression of being a single structural form of which its components are the individual objects in the composition. Cézanne achieves this by accentuating all surfaces which are parallel to the picture plane. And by binding the contours of background forms tightly to those in the foreground, he brings his sky, or some other distant plane, forward like a vertical wall to press against the foreground forms. Thus in his *Les Grandes Baigneuses* the cylindrical form of the left-hand 41a tree-trunk is carried through the straightened leg of the standing bather and the forearm of the outstretched central figure leads our eye irresistibly back to the vertical plane of distant trees, as if her head were leaning upon it as it would in a low-relief carving.

The manner in which Cézanne set about transforming his flat canvas so that it would appear like an interlocked relief-panel is revealed by a comparison between his unfinished *Still Life* and his com- 220 pleted *Dans le parc du château noir.* The former shows the initial linear 221 scaffolding drawn in, with the area surrounding each part intended as a projected surface already 'chiselled' away in dark brush-strokes. At this foundation stage of the painting only the volume of the jug (the dominant form and obviously intended as the keystone of the

design structure) and one or two of the apples supporting it in the spatial balance of the picture have been completely freed from the white canvas plane and projected towards the viewer. Slowly and systematically Cézanne would then have balanced and contrasted each turning facet of the area between each of these forms, occasionally reinforcing, restating, obliterating, and adding lines to his basic framework, until each plane and planar division had been dovetailed as tightly into the structure of the whole picture as the rocks in the finished landscape.

220

Cézanne acknowledged his debt to Poussin and evidence of the kind of pictorial carpentry and spatial organization his study of Poussin must have given him may be be found in the latter's *Landscape with a Snake*. In spite of its dramatic narrative interest this work creates a mood of timeless tranquillity because each form is so firmly wedged into the overall spatial structure of the painting that even the reflected images are constructed as if they were submerged beneath the water surface as solid extensions of the forms they mirror. And when we look from the Cubist-like rocks and buildings to the distant pyramidal mountain, our eye is returned by an extent of sky painted not as a vertical scenic backcloth but as a curved plane enclosing the landscape beneath like an immense awning.

As soon as we identify things and their surroundings in a representational painting our experience of them in a real environment tells us their spatial relationships. But obviously the relative position in space between one form and another in an abstract painting cannot be predetermined in this way and sensations of projection and recession can then be created only by the optical effects of shapes, lines, and colours reacting against one another. Since the illusory space of an abstract painting need have no fixed dimensions (as a room or a cornfield in a painting has), nor need its forms be drawn in accordance with laws of gravity and perspective, the possibilities for creating spatial sensations should be limitless. Until recently, however, we have been denied many of the sensuous and spatial experiences which the purely optical behaviour of lines and coloured shapes might offer us in a non-figurative picture.

This is because many of the traditional methods of pictorial design and presentation were retained by the pioneer abstract painters. The Kandinsky and the Mondrian, for example, are painted on the rectangular and square canvases, respectively, of traditional easel painting—a convention surviving from the format of the medieval illuminated page and the Renaissance 'window-frame' composition. Their shapes are also arranged in spatial movements which respect the boundary limitations of the canvas edges and the frame—just as figurative forms are confined within the 'stage-set' composition of a Poussin, for instance, where they are so arranged that our attention will not stray into the space of the real world outside the picture-frame. The shapes in the Kandinsky and the Mondrian are still seen in relation to the limited spatial field defined by their painted backgrounds, as they are in a Uccello or a Rubens.

It has been the aim, therefore, of recent abstract painters—par-

above
POUSSIN (*c.* 1594–1665):
Landscape with a Snake.
National Gallery, London
below
Detail from *Landscape with a Snake*

ticularly in America—to challenge these pictorial conventions in order to remove all obstacles to our full experience of their shapes, lines, and colours as direct optical sensations. Their pictures are intended to provide unique sensuous and spatial experiences derived only from the physical reality of the artists' materials.

In order to render the spectator more vulnerable to these optical sensations, all references to other styles of painting and to visual phenomena in the outside world are excluded. A late Monet *Water- Lilies* completely fills the spectator's field of vision, to envelop him in blurred areas of vibrating colour. But these optical vibrations are created as an interpretation in paint of the natural effects of shimmering movement produced when light is reflected from the surface of water. The mural scale of a Rothko or an Olitski, however, is intended solely as a means of enveloping the spectator in luminous, tinted mists whose optical effects derive only from the fields of these particular colour-stained canvases; thus the sensations created are unique. And whilst the sweeping brush strokes in Turner's near-abstract interpretations of light and the rhythmic fury of storms resemble the trails and splashes of Pollock's scrubbed and thrown paint, the spatial sensations experienced in front of these two pictures are very different. The planes of paint in the Turners curl away from the picture plane to draw the viewer into a distant centre; the marks made by Pollock as he stood inside his canvas on the studio floor produced overlaid paint rhythms which whirl towards us vertically in a frontal attack. Turner's brush strokes were intended to express the spatial action of mountainous waves and breaking clouds; Pollock's record his own spatial actions as he moved within the space of his studio.

Pollock has created his free spatial movement across the canvas by ignoring the painter's traditional concern for the vertical and horizontal frame-edges as elements in the picture's design—a consideration still present in the overall pattern of a Malevich or a Mondrian, for instance. But because a Pollock is a record of a single physical performance given by an individual artist on a particular day his work retains one quality traditionally associated with earlier styles of studio-painting: the romantic connotations of the impetuous handwriting of the intuitive artist. In order to remove all traces of the painter's emotional and physical involvement with his materials, and in reaction also to the atmospheric qualities inherent in Abstract Expressionist techniques, artists such as Ellsworth Kelly, Kenneth Noland, Barnett Newman, and Darby Bannard have attempted to reassert the literal truth of painting: that it is the staining of a flat

10
21
18
2
2

below
Detail from *Landscape with a Snake*. National Gallery, London

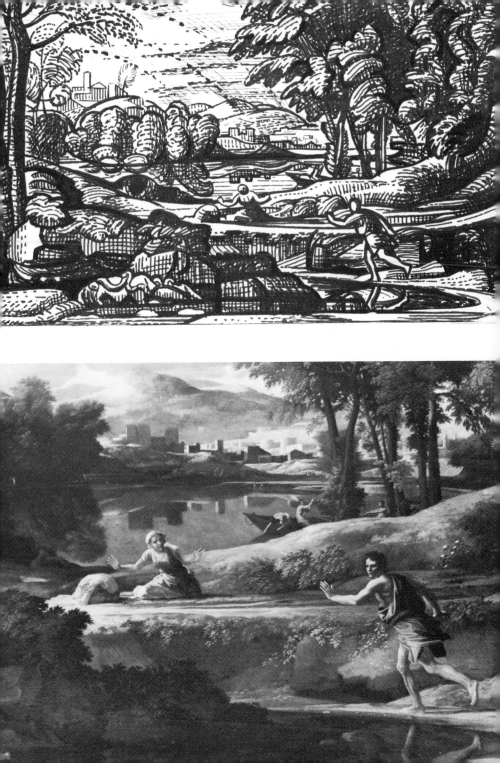

surface. Therefore unlike the Op Art painters whose canvas-surfaces appear to warp and disintegrate before our eyes, these Minimal, Reductive, or ABC-Art painters are concerned primarily with the form of the canvas itself and the space it occupies on the wall and in relation to the spectator. Their pictures are almost portraits of the canvas, their immaculately laid colour (usually at maximum intensity), their knife-sharp lines and hard-edge shapes exalting the physical reality of the painting-ground as a two-dimensional art object.

Whilst Mondrian's *Broadway Boogie-Woogie* evokes the checkered skyscrapers, winking lights, tat-a-tat ticker-tape, and honky-tonk rhythms of New York, we can find in Ellsworth Kelly's *Broadway* no emotive or intellectual references to experiences in real life. We experience instead a fascinating uncertainty about which of the two elementary shapes is the image and which the background, which advances and which recedes—for our spatial reading changes according to which of the two shapes we are most aware of at the time. Whilst we are staring at the red parallelogram this seems at first to be the image and to be resting upon a white ground, above which it then appears to hover and from which, almost at once, it seems about to rise upwards and leave. But when our eyes move across to the edges of this red shape it appears to be wedged into a white form to create an interlocked picture plane. As the vertical white splinters of the border come into sharper focus, the red area is seen as an oblique plane swinging back into white space as if hinged from the top canvas-edge. But as the white area continues to assert its optical dominance, it begins to advance towards us as the picture's image and become a frame through which we now see a *red* ground like a glowing fire.

Minimal canvases are therefore often unconventionally shaped. A polygonally-sided Frank Stella is in the form of a chevron or an arrowhead because that is the silhouette of its single image—the negative spaces which would have been left had the image been painted on a rectangular canvas would have suggested the spatial limitations of a predetermined background field. By shaping the canvas to fit the painted image, its spatial field is then the real wall on which the picture hangs.

Richard Smith makes an asymmetrically formed canvas by attaching an L-shaped smaller canvas to the top-left corner of his *Vista*, which provides the viewer with a tangible step into the real dimensions of the wall, completing a diagonal progression of similar right-angled bars painted one above the other from the centre of the picture. Smith has also used three-dimensional canvas structures whose

KITAJ: *Walter Lippmann*
(1964). Albright-Knox
Gallery, New York

jutting surfaces invade the space between the spectator and the gallery wall like real free-standing sculptures.

Until recently the qualities of form and space in a painting were usually expressed in terms of the technique and formal character of one particular style or another. But early in the twentieth century, Marcel Duchamp had already demonstrated in his *Tu M'* (1918, Yale University Art Gallery) that it was possible to combine successfully several very different methods of three-dimensional illusionism on one canvas, whilst a characteristic feature of Pop Art—a later extension of Duchamp's Dada philosophy—has been the references made to a number of traditional styles of three-dimensional representation, combined with commercial techniques and ad-man imagery. This pictorial Esperanto has enabled the Pop Art painter to invent spatial relationships and sensuous patterns of colour and texture not seen before in figurative painting.

R. B. Kitaj's *Walter Lippmann*, for example, can be appreciated 22 primarily for its sensuous qualities as a vibrant pattern of organic shapes played against a sharply defined, rectilinear field. Yet the contrasting idioms in which Kitaj's enigmatic images are expressed, and the formal and psychological tensions which exist between these images and with their setting, also create the haunting, illogical reality of things and events rearranged in the time-sequences of a dream. I suggest, however, that the full experience of Kitaj's pleasurably disturbing world comes not so much from our attempting to solve the narrative riddle his subject-matter proposes as from exercising our ability to accept and read the many spatial techniques he uses in order to see our way into the imaginary dimensions of his picture.

We can best understand the spatial position of things in this picture by relating each form to the spatial reality of the canvas plane. This surface is emphasized by the grid-pattern of the centre window, which stretches almost from edge to edge of the painting, like the rectilinear ground in Matisse's *Pink Nude*. In the foreground a man 2 and a woman are summarily indicated in the line and smudge technique of popular magazine illustrations and a ladder is represented in flat colour. As we stare at the window framework, these forms seem to lean towards us from the tapes which hold them from somewhere above the canvas. When we look past the figures we see through the window into a room expressed in Renaissance depth perspective: reminiscent both of the picture-within-a-picture convention of a Velazquez or a Nicolaes Maes interior and of a harshly lit movie-still photograph.

Just as things and places change their identity and relationships in

dreams, so the wall which frames this melodramatic movie confrontation like a theatre proscenium becomes, at the top of the painting, the front of an opening box. Hands, like those of a Petroushka escaping from his puppet's trunk, are thrust through the aperture and, with a luggage-strap, are projected towards us with almost stereoscopic realism by means of the cast-shadow device often used by chiaroscuro painters such as Rembrandt, Caravaggio, and Daumier. In contrast to this apparent slit in the canvas itself, the *trompe l'oeil* spring-clips and the draughtsman's T-square, in the top-left corner, seem to float above the canvas surface, whilst half-realized references to faces and clothes drift across the right-hand wall-panel like reflections of things behind us, glimpsed in a shop-window and momentarily superimposed upon the solid, static display behind the plate-glass.

Looking around the picture in this way, we become aware that, as in a Persian miniature, each section had been painted as if from a different viewpoint: the foreground figures and the stretching hands from a position above the picture, the window area from below and 203d the reflected images frontally. All this painting's conflicting styles, however, are so firmly integrated by a carpentry of design that the spatial movement and three-dimensional character of each image in relation to the whole seems as logical and as inevitable as in a Poussin.

CHAPTER 8 Movement

An illusion of movement is created in all good painting whatever its style or subject. In some pictures this quality is expressed in the vitality of lines and shapes and, as in the sprouting silhouettes of Giovanni's rocks, this may not be necessarily as representations of 22 things in action—indeed wholly abstract images are created whose vibrant contours can be appreciated for their rhythmic grace or the shuddering intensity with which they score the picture surface. In another painting the expression of buoyant or furious movement may seem its *raison d'être*—the exaltation of physical energy in a Rubens, 234 for instance, the flicker and shift of light in a Turner, the arrested 217 action of photography in a Lautrec and a Degas, the analysis and 36, mechanization of movement in a Duchamp, the momentary grimace 233 and gesture recorded in a Bacon or the thrust and splatter of paint itself in a de Kooning or a Pollock. And movement is always an 181 essential element in the pictorial organization or design-structure of paintings, creating tensions, dynamic counter-movements, and calculated rhythmic sequences which bring an organic vitality to a Chardin or a Cézanne still life, to Mondrian's static scaffolding, to the lazy 220 odalisques of Ingres and Matisse, and even to an expression of sleep in an El Greco, a Botticelli, or a Bruegel. 23;

When we watch a movie, or a ball-game, or are momentarily hypnotized by some unexpected movement around us—the darting urgency of an ambulance, for instance, or the vertical flight of papers in a high wind above city blocks and agitated flags—we are, of course, experiencing action as passive spectators. And in the everyday patterns made from skids, cracks, scratches, and splashes we not only read evidence of some dramatic action or other but by the dynamic interplay of these lines, shapes, and colours experience them also as irresistible optical sensations of movement. This optical action takes place in paintings when textures, whatever they may represent, are too complex for the eye and brain to register as individual units of a pattern and therefore cause the whole picture-surface to whirr and vibrate in front of us—as they do in a Pointillist Seurat and an Op Art 100 painting, for example.

But of course in real life we also compose our own kinetic sequences whenever we look from object to object among the things around us. And in our perception of movement in many paintings we have also to play this active part, allowing our eye to be led from shape to shape

facing page
DUCHAMP: *Nude Descending a Staircase, No. 2* (1912). Philadelphia Museum of Art
pages 234–5
RUBENS (1577–1640): Detail from *The Horrors of War*. National Gallery, London

252

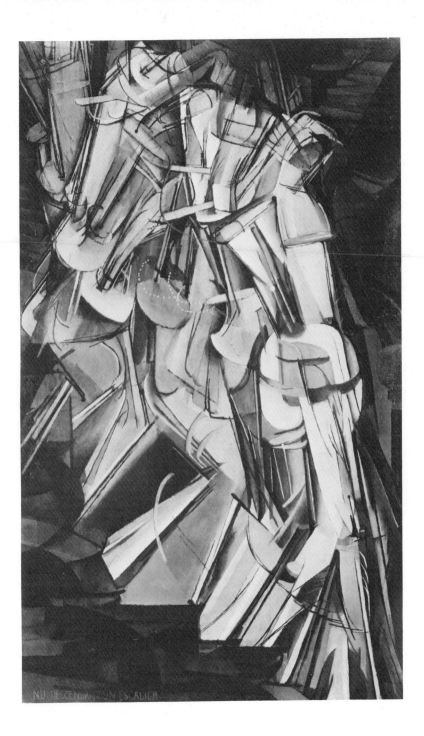

NU DESCENDANT UN ESCALIER

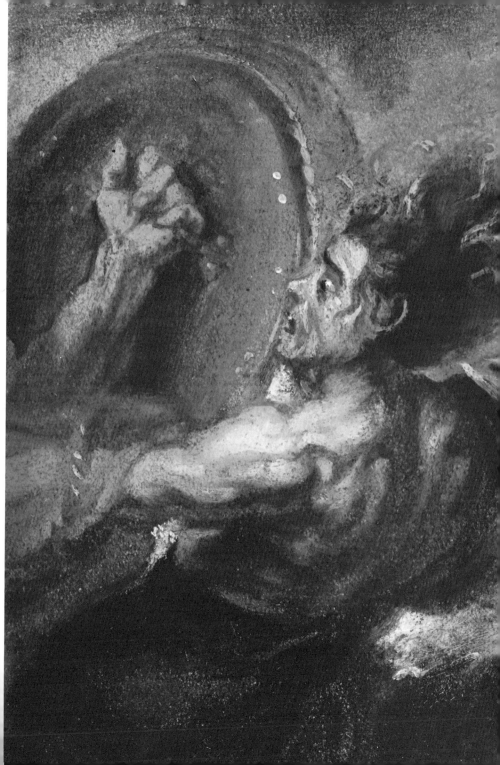

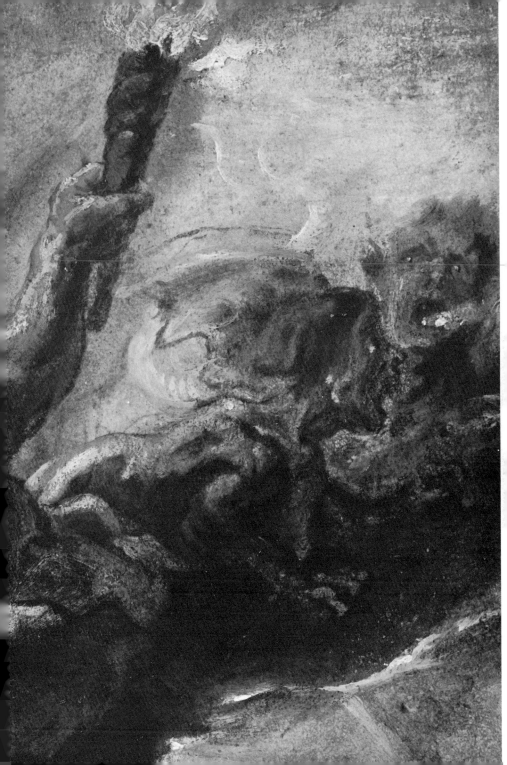

and colour to colour across, around, and often apparently into the picture plane.

'The act of looking at a work of art is also a function taking place in time. The viewer focuses on first one section and then on another, leaving what he has already viewed in order to be able to centre his attention on a new area. . . . The work of art, then, results from physical movement; it is a record of such movement, and is perceived through movement (of the eye muscles).'[1]

The painter cannot employ the physical time-space factors enjoyed by the composer, the film-director, the dramatist, or the poet. When we look at a picture in an art gallery we can see at a glance its entire 'plot' spread out before us. But as members of the 'captive audience' in a theatre or concert-hall we would, of course, be compelled to witness the development of the creative artist's idea step by step unfolding before us in exactly the time-sequence and tempo that he has planned. The painter must therefore find means to ensure that we see the things in *his* work in the order that he intends. And whilst a kinetic idea is interpreted for the choreographer by his dancers moving in space across a defined area and for the film-maker by the time-sequences captured by his camera, the painter has to extract a sensation of motion from the two-dimensional, static nature of his picture-surface by various pictorial techniques.



MOVEMENT BY ASSOCIATION

Just as an event recorded in a photograph will imply movement when the 'frozen', time-suspended images are recognized as things caught at a momentary point in a rhythmic sequence, so the painter's subject, if it is a familiar one, will co-operate in the expression of movement in a picture. For example a sharply defined photograph of a fast sprinter is acceptable even though, as spectators of the actual race, our retinal image of him would in fact have been blurred. For we would know, by the visual clues given in the photograph, that he was running and not standing motionless and awkwardly on one leg, as he might otherwise appear to be. And if the sports photograph had shown the sprinter at the finishing tape, our eyes would instinctively have travelled from him to his nearest rival in order to measure the margin of his victory.

In painting, by a similar association of effort with result, cause with effect, object with related object, we would look from a standing group of *Three Graces* to the figure of their adjudicating Paris, from one end of a procession to another, from the pursuer in a hunt to the pursued, from a pointing finger or a turning head to the forms they



POUSSIN (*c.* 1594–1665): Detail from *Landscape with a Snake*. National Gallery, London

[1] Paul Klee, 'Schöpferische Konfession' in *Tribüne der Kunst und Zeit*, vol xiii (Berlin, 1920).

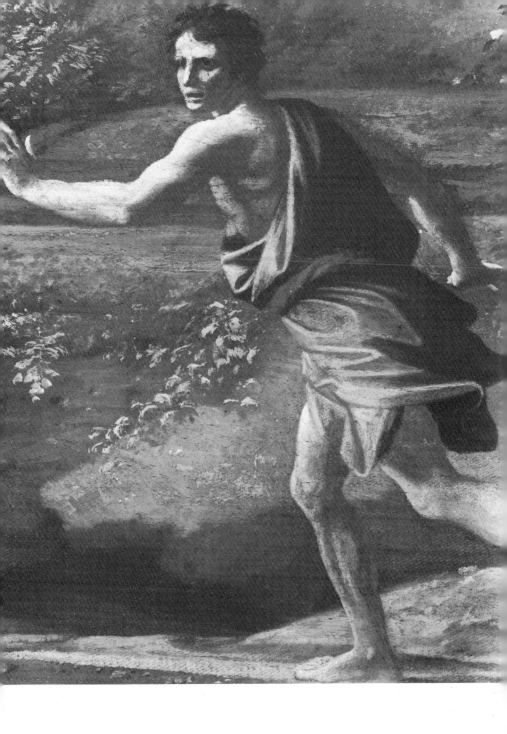

indicate in the picture's space. When we look at the Ingres head our 11 attention is drawn to its profile mirror reflection; in the El Greco the 109 turning head of Christ directs us to the angel in the top-left corner; in the Rubens and the Uccello the swinging action and thrust of the 130 attacking swords and lances lead us on to the defeated warriors, whom we then pursue into the picture distance.

In medieval illumination (for example, the two details from the Gothic Psalter) and in Indian miniatures (for example, the episodes 162 depicting *Krishna's Revealing his Nature as Vishnu*) we read such 'direc- 239 tional pointers' both by literary association and by the optical effects produced by the arrangements of their lines and shapes. The continuous narrative action is described in sequences of small pictures in the manner of a modern strip-cartoon. A method of depicting the action of a story in Persian painting, and one which survived in Europe into Early Renaissance painting, was to combine all the narrative incidents in one composition, each 'adventure' taking place in a different section of the design, the main character, dressed usually in an easily identifiable costume, acting also as 'link-man', story-teller or chorus whom we are made to follow in order that the tale may be understood. Therefore in the Giovanni St John in bright pink makes his 24 entrance through a grey arch in the bottom-left corner and sets out for the blue-green Wilderness like a jaunty Dick Whittington. We cannot resist accompanying him up the stony path, rather than along the smooth roads in the valley below, because our eye is drawn to his next appearance in the drama, higher up, and in the centre-distance. 19

OPTICAL The expression of movement in good painting is, of course, never
MOVEMENT dependent merely upon the viewer's ability to find subject or anecdotal relationships between the parts of a composition. More intense kinetic sensations are experienced when we allow our eyes to be guided by the *optical* signals the painter has placed across his picture surface. If at first we look consciously for some of the ways in which painters analyse the rhythms of action and organize sequences of repeated shapes, lines, tones, colours, textures, and spatial intervals to set a whole composition in motion, we should find later that our eyes will follow these visual signals instinctively.

For we have seen that arrangements of echoed shapes, lines, and textures, and notations of tones and colours, rising and falling like a musical scale, will lead the eye from one part of a picture to another. That it is essential to our full experience of movement in painting that we should be able to see it expressed in even the most deceptively

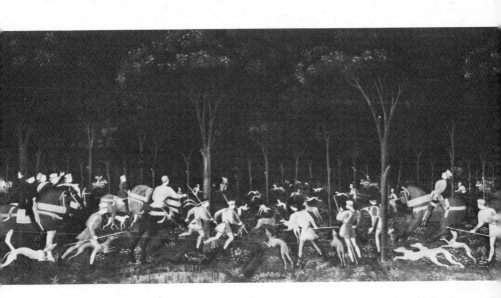

UCCELLO: Detail from *A Hunt in the Forest* (1465). Ashmolean Museum, Oxford

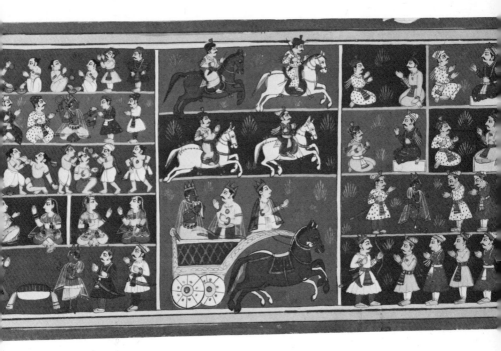

INDIAN MINIATURE (MALWA): *Krishna Revealing his Nature as Vishnu* (c. 1730).
Victoria and Albert Museum, London: Crown Copyright

GIOVANNI DI PAOLO (active 1420, d. 1482): *St. John in the Wilderness*. National Gallery, London

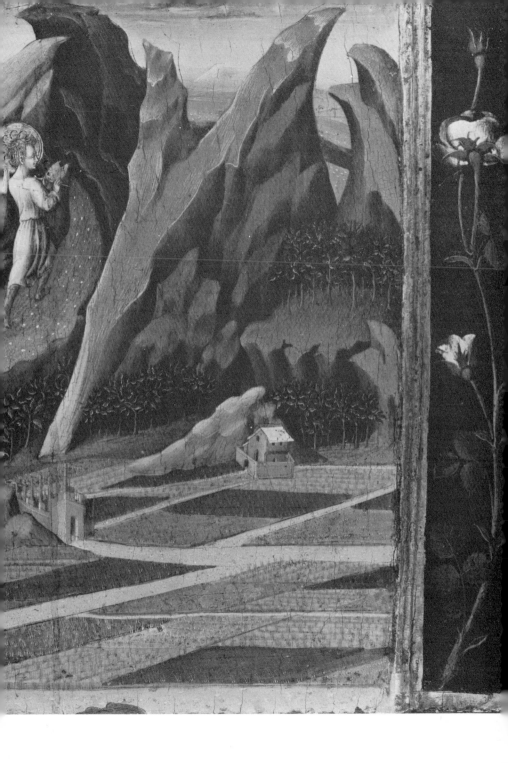

realistic painting in the same optical terms as those used by abstract painters may be appreciated if the diagram analysing the movement structure of the Rubens is compared to the one based on the Kandinsky 198c and if Turner's *Snowstorm* is compared to Pollock's *Painting (1952)*. 217

The repetition of shapes, lines and axial directions is most easily perceived in paintings designed in patterns of flattened shapes, the effect of agitated bustle in Dubuffet's *Vive Volte*, for example, is 156 produced principally by the arrangement of naïve spot and line figure symbols drawn in undulating rows between irregular horizontal bands like a fiercely scribbled musical notation. And although drawn without Dubuffet's *graffiti* savagery, the pattern of skating contours and dancing shapes of Miró's *Women, Bird by Moonlight* also invites 243 musical analogies, for if we allow our attention to be directed from shape to shape we find that the paths we have taken around the picture have been determined by a planned sequence of repeated hook and dot motifs. The anti-clockwise motion in the Klee is created by a procession of 'family shapes' which rotate literally *Around the Fish*. 16 These related shapes are arranged in repeated sequences of segments —from those of the fish and the near edge of their dish to the crescent-moon, the exclamation mark, and the mistletoe leaves—and of circles —the fish-eyes, the rim and base of both glasses, the cucumber slice, and so on. The effect of levitation in Chagall's *The Birthday* is produced 123 by the pair of arabesque silhouettes which float, propelled by the arrow-thrust of the negative space between them, against two counter- 49c movements created by textural sequences: one embracing in a sweep- 247 ing arc the patterned fabrics and textured windows, the other a revolving sequence of repeated discs of plate, loaf, stool-seat, table-leg spheres, and flowers; whilst in his study for *The Blue Circus* the 245 pendulum rhythm of a swinging trapeze is captured in a play of circle and segment shapes against a rectilinear patterned field.

Even when we look at a great picture painted in a style of striking three-dimensional illusionism the real sensation of movement we experience is never dependent upon our knowledge that the things shown on the canvas would anyway have moved energetically in such circumstances in the outside world. In such naturalistic works it is, instead, as much an optical sensation created by the organization of kinetic sequences in abstract patterns as it is in a Kandinsky, a Chagall, or a Klee. That these sequences are only partly concealed by a decep-tive naturalism becomes apparent immediately we turn a reproduc-tion of such a work upside down; for then, less likely to be distracted by passages of literary interest, we find that our eyes are directed irresistibly across the picture surface from one repeated curve or

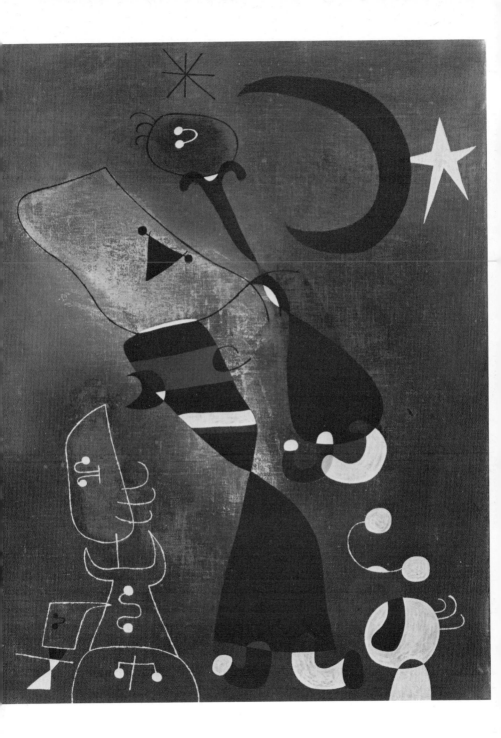

diagonal to another, from one silhouette to another and from one area of tone, colour, or texture to its echo in the next.

Where a great abstract painter like Kandinsky produces an effect of movement by repeating a circle in different parts of his picture and by echoing a rhombus with a similar geometrical figure, a great realist like Rubens, in his *Battle of the Amazons*, repeats the curve of a cloak in the guise of a twisting horse's mane, and the curling outline of a shield in his *Horrors of War* will induce the viewer to look from a sweeping line, tying armour to drapery, to its echo in the linear rhythm made by the edge of a sword carried through to the contour of a flying Fury. In El Greco's *Agony in the Garden* harsher, jerkier shape sequences produce a physical interpretation of ecstatic aspiration as husk-like and crinkled arrow-forms chase one another around the silhouette of Christ, poised as the pyramidal spindle in the centre of a crystalline composition. Such repeated accents and visual analogies create underlying rhythmic actions similar in effect to the stresses and concealed inner rhythms of a poem.

The 'rhyming shapes' of an abstract painter are more obvious and because only optical means of conveying movement are available to him we see the movement in his work more readily. At times these may remind us of stress and metre in music and poetry. Thus the optical movement in the Mondrian is irresistible, even though it is a painting composed entirely of squares and rectangles upon a grid-design that might have imprisoned these shapes, preventing any action between them. And how difficult it is to resist being drawn along this illuminated network of flashing signals! The vertical and horizontal lanes carry the eye through the complex system of routes from rectangle to square as these drive with the insistent beat and pattern of a teleprinter. As our eye rests upon a shape it is carried up and along the bands as if we had landed on the step of an escalator-belt gliding in perpetual motion.

SEQUENTIAL
MOVEMENT

The expressive portrayal of swift movement observed in nature has been one of the remarkable achievements of artists since the periods of early cave-painting. Of course the perception of certain actions is beyond the capabilities of the human eye. In a Géricault, for instance, we find the use of a symbolic movement-pattern to represent the full gallop of horses which remained a convention until the middle of the nineteenth century. However, despite the scientific inaccuracies of their neat symmetry an impression of the speed of Géricault's horses is convincingly produced by a system of rhythmically interwoven lines and inner arrow shapes.

CHAGALL: *The Blue Circus*
(1950). Tate Gallery,
London; © ADAGP, Paris

244

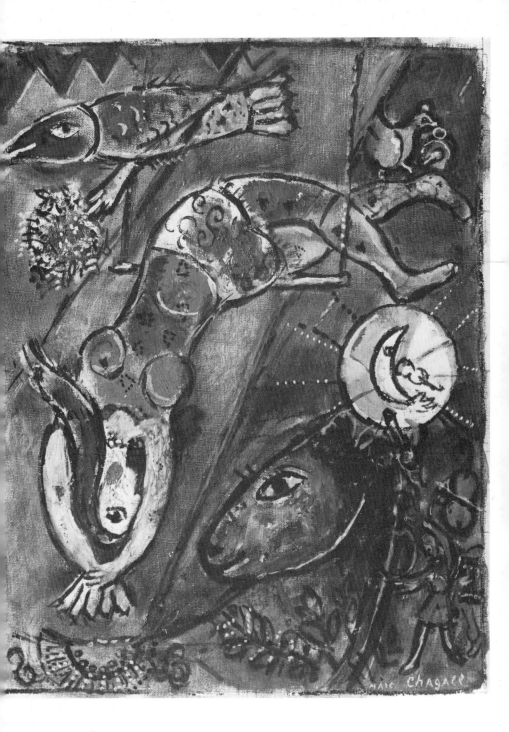

Some painters have described the stages in an evolving movement by using a sequence of similar forms, each one contributing in turn to the rhythmic completion of the action. One of the best known examples of this technique is Bruegel's *Blind Leading the Blind*, in which the figures are painted in a step-by-step articulated journey to stumbling disaster as if the artist had recorded the successive shuffle 247 and stagger of the same man in a continuous film-strip. The leg-positions in the Chagall and the Poussin complete movements in much the same way: the feet of Chagall's *Birthday* lovers perform the 247 back-kick continuity of a leap into space; and in the Poussin a pound- 247 ing folk-dance beat is described in a pendulum-arc. These rhythmic-ally progressive stages are so precisely charted that they might have been taken from a dance-instruction manual. This systematic develop-ment of consecutive actions in space creates the evolving pattern of an equestrian musical-gallop in the successive turns made by Rubens's 130 horses, of a courtly *galliard* in the *Rape of Helen*, of an unfolding fan 253 of can-can kicks in the Seurat and, if we consider the action of the 100 *whole* figure group, of an 'all-fall-down' pagan frolic's arching collapse in a wreath of spatially interwoven limbs in the Poussin. 53b

Today every artist is familiar with and may frequently make use of the visual evidence of physical action recorded by the cine-camera in consecutive 'frames' or single shot sequences on a length of film. He will also have seen time-lapse photographs of natural growth-rhythms which by movement progressions show, for example, an orchid open with the dramatic splendour of a bursting firework and a fern unfold with the eloquence of an Indian dancer's hand gesture. These discoveries provided painters like Duchamp and Balla with techniques with which to analyse and chart the dynamic *structure* of rhythmic actions. Their method of superimposing or fusing kinetic and articulated sequences to create a single complex image had been in part anticipated by the anatomical studies of Leonardo and Dürer and was, thanks to Muybridge's photographic research, already established in commercial illustration (like the diagram here, based 249 upon a German health-manual drawing, *circa* 1900). Whilst the multiple leg positions of Balla's famous walking dog, whizzing like the spokes of a spinning wheel, may now seem an obvious optical device, Duchamp's 'blueprint for movement', his *Nude Descending* 233 *a Staircase, No. 2* (derisively labelled at the time *Staircase Descending a Nude*) remains a remarkable planar mechanism. Duchamp's language was really an organic Cubism, his paper-thin oblique planes flickering together like playing-cards flipped in descending trajectory through space to capture the arching rhythm of a figure walking down stairs.

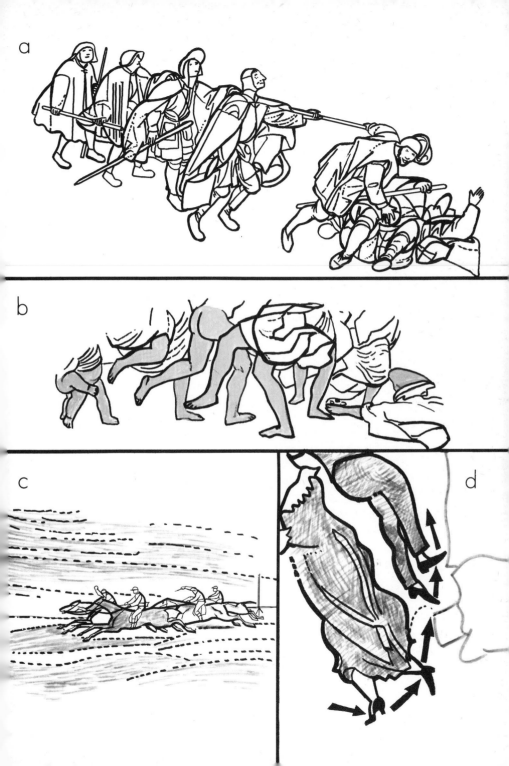

The Futurists and Orphists were also concerned with the expression of the mechanization, tempo and dynamism of modern life. Whilst the Duchamp is almost a monochrome drawing in paint, the works of his contemporaries like Marc, Delaunay, and Kupka achieved remarkable optical effects of flashing, darting and rotating forms through the use of simultaneous colour contrasts.

Duchamp's tilting planes entice the eye to follow the completion of a movement of delicately balanced forms. Earlier painters had also expressed subtle spatial movements by planar relationships. In the Poussin planes turn at alternating angles; in Cézanne's *Les Grandes Baigneuses* they move like revolving swing-doors around an implied axis, and in the Rubens they flow and spiral with the complex profusion of twisting leaves contained within the whole form of a bush.

QUALITIES OF IMPETUS

(The action-techniques described below may be better understood if we invert the plates of the paintings referred to, in order that we are not distracted by narrative interest or literary associations.)

We must all have known the odd sensation of illusionary movement that may be experienced by looking through the window of a stationary train at another which begins to draw away in the direction opposite to that which our own is about to take. Such directional contrast of motion is so strong that we are, for a moment, convinced that it is our own train that has started. By the same optical contradiction we have sometimes the impression from a night sky, that it is not the cloud but the moon it crosses that is moving. And because a circle is felt as a static, self-contained figure and an arrow as an aggressive, thrusting shape, a strip-sequence using them—or images based upon them—will be immediately understood as a play between active and passive bodies.

This principle of optical illusion is used by painters to give dynamic impetus to forms in a painting by contrasting the angle of their lines and axes with those that point in an opposite direction. As a racehorse seems to 'flash past' the vertical winning-post with greater speed than it appeared to have when it was seen bunched with other horses seconds before, so impetus is given to any action if its angle of force is related to one that is static or moves in another direction. So, in the El Greco, lines radiating behind the angel and the curving clouds pushing against the centre rock seem to set the vortex of the composition spinning as dramatically as in the Turner *Snowstorm*. The play between the curvilinear figures in the Persian painting and the angularity of their architectural background brings to them the same jumping vitality such contrasts achieve when the Chagall lovers fly

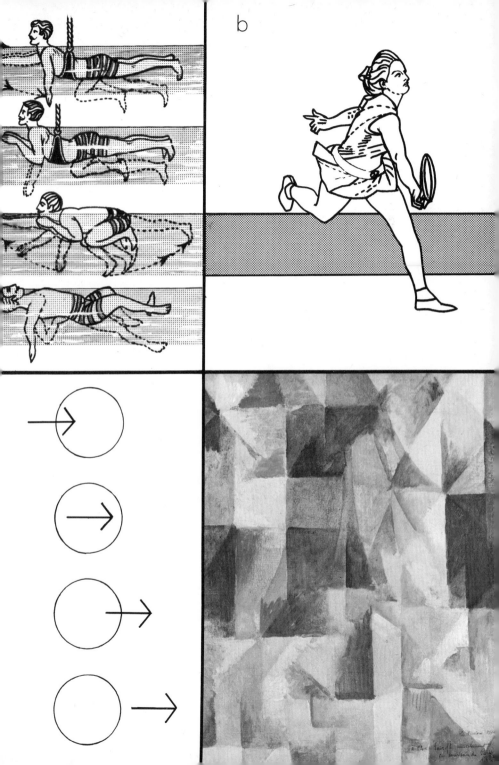

b

within their cubic room and Giovanni's St John leaves the square
foreground building for the curling embrace of the distant rocks. 240-1
We have noted the manner in which the eye is drawn, by optical
perspective, to the point on the horizon to which lines appear to
converge. Therefore, not only may the viewer's attention be drawn
in this way to those parts of a painting that lie on, or close to, the
horizon-line (for example, the 'distances' expressed in the Rubens, 198c
and in the background of the Uccello) but any line directed at an 151, 250
acute angle towards another, or any form that seems to push or
'knock' another, will appear to propel it forward. Thus the lines of
Uccello's lances meet the long horizontal direction of the harnesses;
the parallel axes of arms and thigh in the Cézanne push the standing
figure and tree-trunks forward, where they intersect at right-angles; 41a
and the expressive shadow shapes of Rubens's tonal counterpoint 93d
pattern thrust his forms in an endless spin around the bridge. Evi-
dence of the force of movement expressed when lines and forms
collide, converge or glance may be witnessed along the tracks of any
railway-junction, in action-photographs of swimmers breaking the
surface of a pool and in the upward arrow-thrust of spires and pointed
arches.

With the thought and speech 'balloons' they adapted from an
earlier tradition of painting and illustration (e.g. the Latin conversa-
tion-scrolls 'spoken' by biblical characters in thirteenth-century
illuminations), the artists of the comic-strip and the humorous cartoon
exploit the possibilities of line to express the action of the 'double-
take' spin of a turning head and the speed of whizzing forms. These
velocity-lines are also found in earlier periods of painting, though not
in so obvious a form. The comic convention of a meteor-trail of lines,
that streak behind a passing figure or burst and radiate to express
explosive action, has been 'fed back' into fine art as visual metaphors
by Pop Art painters and is illustrated in Lichtenstein's *Whaam!*. 153b, 259
When these linear accents are used to emphasize forceful action in
other styles of painting they may be found concealed as drapery-folds,
cast-shadows, patterns of local colour, or in some other pictorial
disguise. We see them, for instance, in the nervous, double contours
vibrating along the forms in the Cézanne and in the streaks imposing 41a
a flashing water-skid rhythm across the lower right corner which
keeps the viewer's eye moving within the Rubens composition. 153d

The calligraphic vitality of a Chinese brush-drawing may be
appreciated in the thick-thin contour variations that enhance the bony
grace of a Degas dancer and the organic thrust of a Van Gogh tree.
This driving force of line is demonstrated in Chagall's two heads, 123

FOLLOWER OF FRA
ANGELICO: Detail from
The Rape of Helen by Paris
(15th century). National
Gallery, London

where thinly drawn contours and tonal edges alternate to emphasize the urgency of movement in the forms. Lines, in a Chagall or a 245; 2⋮ Duchamp, that are used to encourage the action of a form will often be trailed off into blurs and dots like the gasp and short sputtering of a dying engine or in a Kokoschka or a Pollock will run through a picture 181 like burning fuses.

Gradations in tone or colour, released like exhaust-smoke, rocket-trails or bursts of fire from behind or alongside the painter's forms, will also push them forward. This may be studied in the marks of a skilfully lifted or smudged brush movement over a tinted ground or 175 to by the swirling impasto of thickly-loaded lights on the twisting fins of tone that curl in space like a catherine-wheel in the Turner; or by 217 be 218d the less impetuous application of separated degrees of retreating tone which we may observe in the Cézanne. 221

INTERVALS Movement-progressions may be marked out like morse-code signals in the form of spatial intervals or negative shapes. If we examine the negative-spaces between the main forms of the Rubens, the Chagall, 278-9⋮ and the Poussin, we find that these also contribute to the impetus of 96 movement where they push against the 'positive' forms. If we made tracings only of these negative-shapes, from any of our plates, we would produce maps describing sequences of converging, active images (for example, the Poussin diagram). The importance of these 263a moving spaces may not be consciously appreciated though they may be seen everywhere in our surroundings. They may accompany the thrust of moving forms, like the wedge between the Chagall figures, 49e or they may intensify an action by moving in the opposite direction— as will the dagger-shape seen above an opening door that points against its general direction; or the lean shaft pushing upwards, between half-drawn curtains, that emphasizes the downward fall of the material.

These spatial intervals act rather like the rest periods in modern music-form or the emotive significance of silences in oratory and the calculated pauses in poetry readings. The planned progression of 250 l these intervals brings movements and tensions to a painting in running, walking, drumming, bouncing, and 'one-one-two' dance rhythms, prompting the eye to pursue shapes and colours not only across but into the picture-plane.

CHARACTER OF Just as the tones, colours, lines, and shapes of a painting are suited to
MOVEMENT its mood and idea, so the character, or type, of movement expressed

is part of the spirit of the composition. For example, Uccello's 198 chivalrous knights advance in controlled order and in braking slow-motion to meet the enemy in gentle collision on the same spatial tracks, carry the viewer on an undulating musical switchback, a visual 'whee-eee-oops'. Rubens's uncouth warriors, however, charge 198 and crash their adversaries, splitting them into a tumbling helter-skelter spiral of retreat and the viewer's attention is bounced like a pin-table ball from form to form. El Greco's weightless, twist- 109 leaping ecstasy contrasts with the joyful levitation of Chagall's 247 floating lovers, the firefly jerky dance in the play of movement in the Persian figures, and the slow spin of the ground around the tree-trunk 205 'spindle', in the Bruegel, that suits the tempo of a drowsy afternoon. 17 Less emotional is the purpose of the movement expressed in a landscape by Cézanne, or in a Cubist still life, where the rhythms work 22 like torch-beams or boundary-markings to describe and emphasize the anatomy of the space that has been created, or in the classical 'music' of Poussin's statuesque dancers, where tightly-bound cross- 53 currents of intertwining rhythms embrace all the picture's draperies, garlands, torsos, tree-trunks, foliage, and 'negative' shapes. The 26 tensions and balances created by such running threads of movement will be examined in the next chapter.

'Just as sounds and rhythms combine in music, so must forms and colours be united in painting by the play of their manifold relationships.' (Kandinsky)

The design of a painting is its overall visual structure. The organization of all the elements in a picture (its shapes, lines, tones, colours, and textures), with the forces of space and movement, produces a final statement in which all the parts are as necessary to the whole as the components of a machine or the stages of a mathematical theory. This pictorial architecture creates the sense of permanence, completeness, and inevitability emanating from a great painting and endows it with the reality, presence, and authority of a mountain or a mature tree.

But the art of designing a painting is more than the organization of its parts into a coherent whole. For unlike the large sculpture or the mural decoration, which can borrow from and react against the optical energy of surrounding forms, the easel painting is traditionally a self-contained arena. Within and in relation to the boundaries of the frame, its elements must therefore be juxtaposed and interrelated to create a pictorial mechanism. Therefore the painting, however tranquil its mood or apparently static the arrangement of its lines and shapes, will seem to change and move as if activated by an inner dynamism as we look at it. This action is generated by the behaviour of its parts in relationship with one another and the frame in conditions of tension and harmony, of balance and contrast, and of flat pattern and spatial integration.

The manner in which these dynamic qualities are expressed is determined by the kind of pictorial syntax used in a particular style. When the vocabulary of a style is exhausted and its syntax found inadequate for the expression of new ideas and visions, other methods of pictorial presentation are developed. The discarded form often survives, however, in a dead language of pictorial clichés employed in academic painting as if they were canons from a standard grammar of correct compositional practice. There is therefore a popular notion that there are certain rules in the design of a painting which should never be broken.

We should be able to appreciate the design of any good painting both for its qualities as a flat pattern of lines and of shapes, of tone, colour and textures and as a composition of forms arranged within an imaginary three-dimensional space. One style of painting may, of course, be enjoyed primarily for its qualities of two-dimensional pattern—such as the Lichtenstein. And another kind of picture will be appreciated rather *more* for its sculptural design of forms in an illusion of depth—the Botticelli, for example. But a comparison between them demonstrates that each has been designed on both levels. Whilst the Botticelli is essentially a pictorial construction built on a scaffolding of interlocking pyramids and balanced in depth on a receding horizontal ground plane, it is also a sensuous pattern of lines and tones, colour and textural masses. And the simple shapes in primary colours Lichtenstein has borrowed from the mass-printed comic-strip not only create a dynamically decorative flat pattern but because of their perspective foreshortening and overlapping order these may also be seen as forms which move and are balanced in space in an almost classical three-dimensional design.

The arrangement of shapes in the Gothic and Persian manuscript paintings, in the Matisse and in the Kandinsky reveals the acceptance by these artists of the two-dimensional nature of their picture ground. Paintings such as these, designed primarily as flat patterns, are often characterized by rich textural embellishment and broad masses of intense colour. Their frame edges also play an essential part in the design. For example, the painter will contrive to draw the viewer's attention to them when they provide the outer contours to some of his shapes—as they do in the Lichtenstein. Or when they are incorporated as vertical and horizontal directions in a play between curved and straight lines—as they are in the Matisse.

We have seen that in early traditional design-forms of studio-painting such as the Gothic Psalter and the Indian miniature the overall pattern often included an inner frame or margin and that in order to illustrate episodes in a continuous pictorial narrative the pattern would be divided into 'comic-strip' sequential sections by lines running vertically or horizontally from edge to edge of the picture surface like boundary-marks on a tennis court. These bold divisions or compartments usually provided the background fields on which figure and landscape images were placed like emblems on the striped and banded grounds of flags. The reassertion of the two-dimensional nature of the painting surface in the twentieth century prompted representational painters such as Matisse, Nolde, Rouault, and Dufy to return to this kind of pictorial format. As we have seen,

259
258
258a
258
258
259
259
162
2; 5
162

INDIAN MINIATURE (MEWAR): *Krishna Waits outside Radha's House* (*c*. 1650). Victoria and Albert Museum, London: Crown Copyright

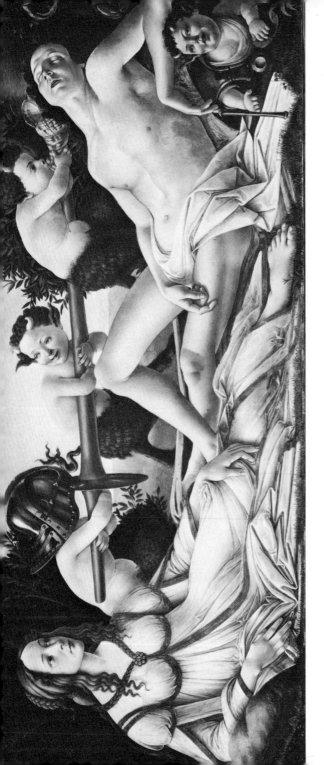

a

b

BOTTICELLI (c. 1445–
1510): *Mars and Venus.*

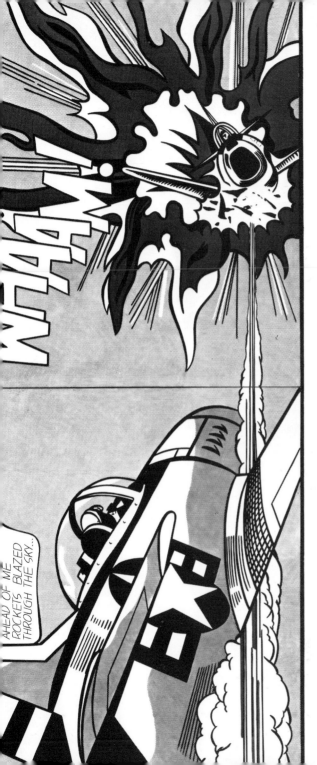

d

c

LICHTENSTEIN: *Whaam!*
(1963). Tate Gallery,
London

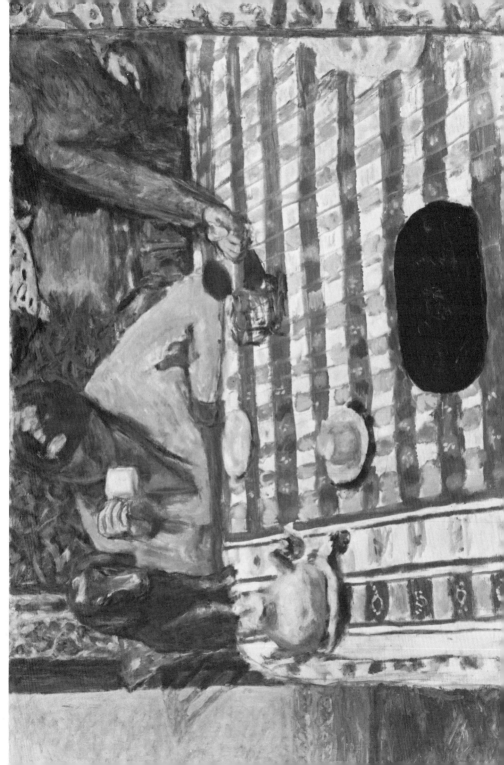

the acceptance of the two-dimensional reality of the canvas later enabled Hard Edge abstract painters such as Ellsworth Kelly and Barnett Newman to hypnotize the spectator with an immense flat image which extends across the picture area as if to push against, or even beyond, the canvas boundaries. And when Vasarely, Mondrian, 126; 271 and Albers have painted smaller squares within their square canvases 106 they have reminded us of the physical nature of the square and of the possibilities it affords for varying the changes and for the permutations in sub-division.

13a

When the picture area is broken down into geometrical parts these pattern units belong to and emphasize the physical shape of the canvas very much as woven and ceramic motifs are evolved from and enhance the form of a carpet and a tile. A comparison between a seventeenth-century Indian painting and a twentieth-century Bonnard 257; 260 clearly demonstrates this method of dividing the picture area into geometrical sections. The contribution made by each of these rectilinear compartments to the vitality and harmony of the whole design would be appreciated if, for a moment, we masked any of them. If, for example, we obscure the script-textured panel at the top of the Indian painting and the white silhouette of the goose at the bottom and mask the vertical strip of patterned curtain on the extreme right of the Bonnard and the black oval tray in the foreground, we find that the essential tension of the overall pattern immediately slackens and that the dynamics of balance and contrast are destroyed.

The influence of the asymmetrical placing of images in Chinese and 268a Japanese prints and paintings, with the compositional possibilities suggested by the accidental cut-offs and decentralizations of photographs, stimulated genre painters such as Toulouse-Lautrec, Degas, and Vuillard to divide the picture area into broad flag-unit masses of tone, colour, and texture, to represent their subjects from unconventional viewpoints, and to use only parts of things as units of the whole pattern. The frame would often bisect, decapitate, or truncate their figures and the foreground area might be wholly occupied by a close-up view of an outstretched arm or the top of a hat.

High level viewpoints generally emphasize the two-dimensional qualities of things and reveal the frequent geometrical patterns in nature. It is interesting, therefore, to compare an aerial photograph 185 with Bonnard's plan view of a check tablecloth or with one of 260 Riopelle's abstract 'landscapes'.

184

In previous chapters I have referred to the tonal maps of paintings by Rembrandt, Manet, and Velazquez and to the colour layouts of the 263c; 93c; 8e El Greco, the Poussin, and the Rubens. These schemes of tones and 110b, c, a

colours enable us to enjoy the original paintings both as spatial compositions and as flat patterns of broad shapes. Furthermore all that should, owing to the multiplicity of incident and anecdote, result in pictorial chaos and narrative fuss in Surrealist moralities by Bosch, and in playground parables by Bruegel has been instead superbly ordered into caverns and windows of flat tonal areas in the one and into carefully grouped and spaced decorative motifs in the other. Both artists also produced minutely detailed compositions in depth of grotesque, nightmare subjects, which are, however, bound together in a freehand geometry of flat pattern which creates honeycombs of horror to hold their prancing bogymen and beasties.

When we study the three-dimensional structure of a spatial composition we find that a characteristic feature since the Renaissance has been the use of a geometrical scaffolding which contains and integrates diverse images into a unified design.

The pictorial form most frequently employed in predominantly spatial designs is the system of interlocked pyramids. These pyramids are formed by the manner in which the picture's images are grouped together.

This kind of solid pictorial architecture brings a monumental breadth and grandeur to the complex planar relationships of both the Poussin and the Cézanne. The reproduction together of these works 96 reveals the similarity of their design-structures. The likeness between them demonstrates the realization of Cézanne's declared aims: '. . . to do Poussin all over again from nature' and '. . . to make of Impressionism something solid and enduring like the art of the museums'. In two diagrams I have illustrated some of the pictorial devices both 26 painters have employed: the restriction of their linear and axial directions to scarcely more than a few horizontals and verticals contrasted with four repeated diagonals, the use of three foreground accents (A, B, and C) to secure the platform of the three-dimensional design on which the two main 'pyramids' are erected, and the echoed contours in the figure-groups (indicated here in heavy outline) are a few of the more obvious similarities between the two designs.

El Greco encloses the pyramidal central form of his painting within 26 the larger pyramid of a rock and both of these combine with others in the pyramid-versus-ovoid theme of his design. This theme is expressed in a scheme of clearly defined compartmented units like those in the patterns of Byzantine paintings in his native Crete. And 26 a compositional analysis of Rubens's complex maelstrom of twisting, 26 tumbling forms reveals a firmly disciplined underlying order of interlocked pyramids whose planar edges are defined by tonal

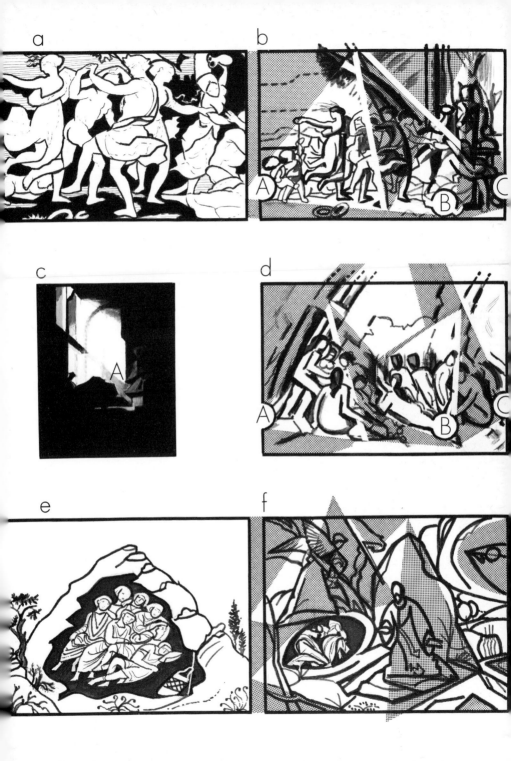

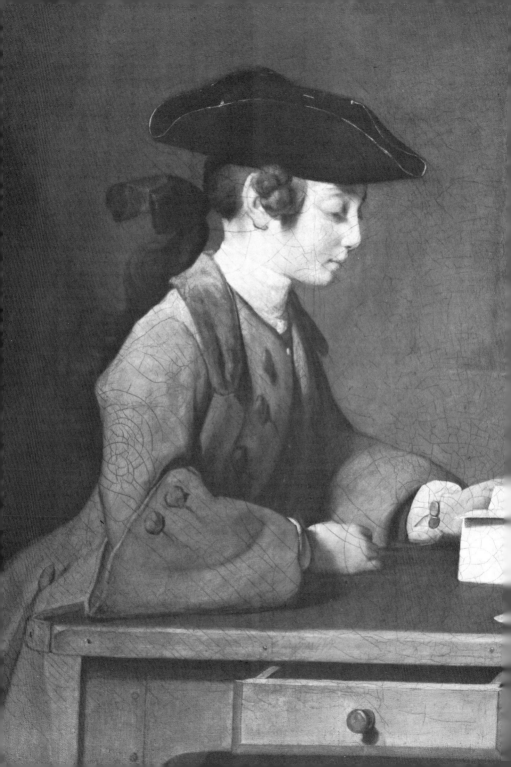

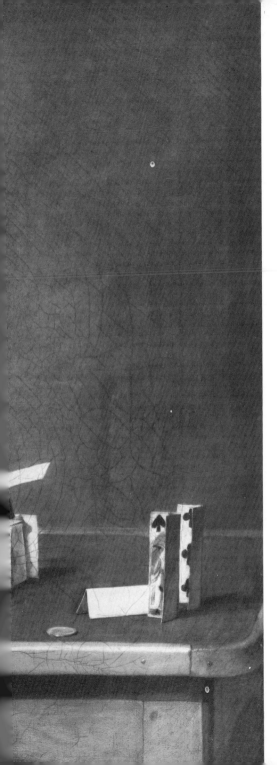

a

b

c

CHARDIN (1699–1779):
The House of Cards.
National Gallery, London

accents. Nor is this pyramidal design form used only in visionary and allegorical figure compositions, but is also the basis of many great still-life, landscape, and genre subjects. It is, for instance, the structural design of the domestic Chardin painting, where pyramids are tightly dovetailed into the platform of the table-top with majestic carpentry, the 'house of cards' by its horizontal, vertical, and sloping sides being 50a a planar replica of the three-dimensional form of the boy.

Spatial compositions have also been constructed on scaffoldings based on other geometrical forms. In the Bruegel, for instance, this is a 'cone structure' which not only ties the sleeping figures to the 265b centre table with lines radiating like the guy-ropes of a bell tent but, by its likeness also to a tilted maypole, also creates the optical effect that all the forms it encloses are turning in slumbering slow motion. And in the Turner the overall design is a giant couch-structure formed by the planes of spiralling clouds and curling breakers.

Of course we do not look at a painting with the primary intention of dismembering the mechanism of its design by theoretical analysis. We allow it to work *on* us before investigating *why* it works. But we shall be more sensitive to the energy generated by the optical effects created by its design if we have first made ourselves aware of the principles which govern these effects, whether the painting is enjoyed primarily as a pattern of flat shapes or as a spatial construction of forms. To be able to recognize and appreciate these principles in all types of painting, as qualities of tension and balance, of certainty and uncertainty, of attack and response in the play between the parts of the design, is to be able to experience the *live performance* given by the forces within a painting.

BALANCE AND CONTRAST By placing two coins one above the other in the positions shown in (a) we make a symmetrical balance. If we replace one coin by an object different in character (a matchbox, for instance), the balance is kept but a quality of contrast or opposition in shape, tone, colour, and texture is introduced (b). More interesting relationships in balance and contrast are set up if by adding more objects we establish diagonal axes across the surface of the paper (c). We now observe that not only are links or relationships established between objects of similar characteristics and qualities but that the individuality of each object is enhanced when it is paired with one of different characteristics (for example, the roundness of the coins is emphasized when related to the angularity of the box, the textured surfaces seem richer when close to plain shapes, warm colours warmer against cold ones, and dark tones deeper against light values).

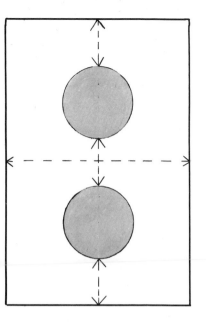 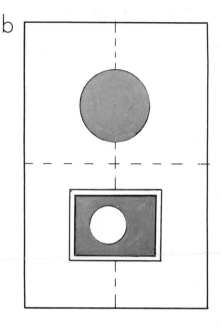

b

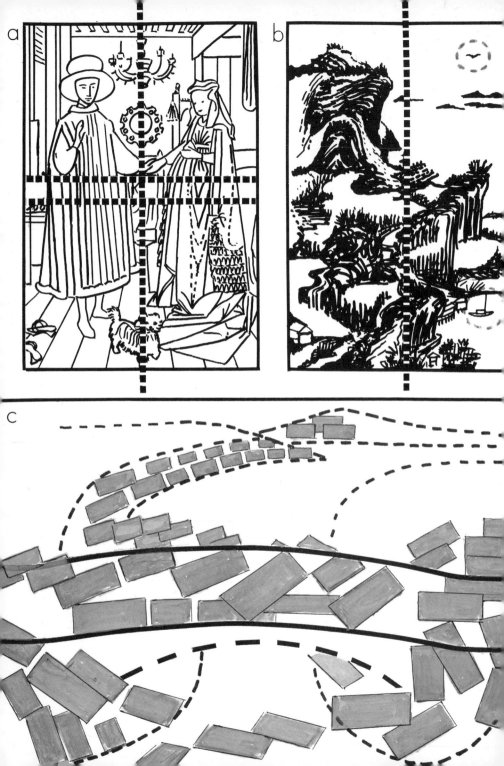

Relationships such as these can be found in all the paintings reproduced in this book. A play in balance and contrast is engineered between plain and textured areas in the Uccello, the Matisse, and the 151; 2 Braque, for instance, between amoebic and crystalline shapes in the 104 Kandinsky, and between angular and 'plumped-pillow' forms in the 54 Bruegel.
17

By the sharing of equal weights of shape, tone and colour, symmetrical balance is used to express the permanence of a marriage union in van Eyck's *Arnolfini Couple*, the conviction of religious 268a belief in Raphael's *Sistine Madonna*, Leonardo's *Virgin of the Rocks*, and El Greco's *Agony in the Garden*. The sense of authority and 109 stability created in these tripartite balanced compositions is sometimes reinforced by a triangular division of the three colour primaries or by exactly counterbalanced tonal values. Sometimes the viewer may be teased by the demands for optical dominance made by equally weighted double images—the pair of striped neckties painted in each centre of two white canvases in a Jim Dine diptych, for example, or the enigmatic double portrait of twin mothers holding twin babies painted by an unknown Elizabethan artist, whose frontal symmetry 40 has the hypnotic assertiveness and monumental simplicity of an icon- 135 painting.

Balance is not necessarily achieved only by giving equal weight to the colours, tones, or shapes in different sections of the design so that they compensate one another. Just as a very large mass of paper will be required to balance a very small amount of metal, so a small patch of intense red will balance a very large area of blue-grey; and the human interest of a flying bird or even a line of calligraphic characters will, in an otherwise empty space, balance a forest or a mountain to maintain the stability of a Chinese painting. Conversely, as in the 268b Chardin picture, a concentration of tonal contrast and texture (the 264-5 house-of-cards) may be weighted successfully against any overloading of human interest (the head of the boy).

These are examples of balance in the flat patterns of paintings. To appreciate the dynamics of spatial balance the viewer has to use his visual faculty for judging distances. That is, by exercising a kind of tactile empathy he should be able to feel the compensation for the volume of a foreground form in a picture in its balance by the weight of another, painted as if situated some distance behind. We can develop the ability to see the balance of things in depth within the imaginary space of a painting by creating a mental picture of the plan view of its composition. The plan view of the Rubens, for instance, might be 268c, 130 represented by an arrangement of rectangular symbols (indicating the

spatial displacement of figures and horses) and dotted lines (representing the surrounding structure of bridge and river banks). This analysis reveals the balance of forms across the platform of the composition, the swinging movement of tumbling forms in the 'south-east' section of the plan (or bottom-right foreground corner in the real painting) being held by the troop of Amazons retreating along the middle distance river bank and arching to the 'north-east' area of the plan.

TENSION The excitement of expectancy afforded in real life by the sight of an approaching union, an unavoidable collision, or a recovery of balance by a toppling form can be recreated in paintings by the optical tensions expressed in certain relationships of shapes, tones, and colours. For example, I have referred to the uneasiness produced by some colour combinations; and in a tonal analysis of Rembrandt's *Interior* 26 I have indicated the point of tension (A) where a blade of intense light plunges into the dark pivotal centre of the design. And there is the tension of recovered balance in the Bihzād as the large figure in 20 the top right corner just prevents, by its disproportionate scale, the other figures from sliding to the bottom of the picture. And in the Kandinsky there is tactile tension between the jelly-soft and snaky 49 shapes and the hard comb-and-grille constructions that seem about to topple against each other in dangerous gymnastics; in this design we may also feel the excitement and urgency of uncompleted union as the main amoebic shapes appear about to be swallowed by the curling, open-mouthed serpent form or reunited with it like a breakaway cell.

THE FOCAL POINT The idea of a Chinese scroll-painting is unfolded before us in an irrevocable sequence of continuous pattern as it is unwound from one roll on to another. In the finest examples the images appear to move and dissolve in such carefully designed series of contrast and repetition that a sequential design close to the forms of music and of abstract experimental film is realized.

Only by walking the length of a long processional mural is it possible to experience this kinetic or cinematic sensation of successive images which in reality pass across the field of vision in an ordered sequence from a predetermined start to an inevitable finish (for example, by moving along the *Triumph of Caesar* by Mantegna, at Hampton Court, or along all three sections of Uccello's *Battle of San Romano*, were it possible to reassemble them from London, Paris, and Florence and place them side by side as they were originally intended

MONDRIAN: *Broadway Boogie-Woogie* (1942–3). Museum of Modern Art, New York

to be seen. But standing four-square before most easel-paintings the viewer is able to see the total design at a glance and is not forced by any imposed physical limitations to take in the painting piece by piece. But in either case, in order that we may experience the 'visual journey' by which the pictorial idea is unfolded, we must usually look first for the beginning of a design.

The focal point, or centre of interest, begins and also closes the movement of most designs; directed to it, we are in the end always drawn back to it. That the focal point of the El Greco design is the figure of Christ is made obvious by subject, the melodramatic spot-lighting and the central placing. But it is only occasionally that the picture's title, the symmetry of its design, or some psychological interest will direct us to the starting point. Generally the painter identifies and underlines his centre of interest by the use of those same factors of significant isolation that pick out for us a particular thing from amongst the mêlée of forms in our everyday surroundings. When, for example, we are not looking for anything especially, our attention will be attracted to any element in our immediate field of vision that is momentarily unique or unexpected—an 'odd man out' in relation to the other shapes and colours around it. For instance, at a large terminus we will notice one form standing out against its neighbours through some quality of difference: the solitary figure standing in an open space, the single raised umbrella, the one bright dress among drab clothes, the tallest among the short, the fattest among the lean, the patterned among the plain, and so on.

The quality of uniqueness that should focus our attention on the start of a design may be found in several of the plates in this book.

In the Matisse, the Poussin, and the El Greco, for instance, the dominance of the principal figure is emphasized by its distinctive colour isolation; the pink of Matisse's nude isolated on a blue field, the lonely shrill pink of Christ's robes in the El Greco that flickers against a background of gold and blue-grey; the single note of yellow on the drapery of Poussin's dancing Bacchus that casts him in the main role. By its dominant position at the peak of the movement on the crest of the bridge the centre group of warriors in Rubens's composition, above the keystone of the bridge, becomes the keystone also of the design, and its climax. By its isolation and solitary blackness Bonnard intends that our eye is first directed to the oval shape at the base of his picture rather than diverted by the human interest of the figures at the top. Because of its alien and almost amorphous character we seize upon the rubbery shape that flies across the top-right corner of the Kandinsky pattern; and Braque uses, because of

its pivotal position and special identification function, the slit sound-hole of a violin as the focal point of his design, around which the other shapes revolve like gondolas on a giant fairground wheel. In some designs the focal points are further emphasized by halos or frames: the doorway behind Laila in the Persian painting, the angular 205 screens behind the Matisse figure, the triangular rock behind the 2 silhouette of El Greco's Christ. 263f

Some twentieth-century paintings, however, have no fixed centre of interest and the viewer can therefore begin his visual journey across the picture wherever he wishes. We can enjoy the sensuous 'all over' patterns of a Monet *Water-Lilies*, for example, or the edge-to-edge 103 textural richness of a Tobey, a Dubuffet, a Riopelle, or a Pollock just 156; 184; 181 as well in whatever directions we scan the picture surface. And it is essential to our experience of the vibrating sensations of Op Art designs that we stand at such a distance from them that we are able to take in their whole pattern at once—we then become aware of the domination of first one sequence of images and then of another. 89

SIMULTANEOUS FUNCTIONS IN DESIGN

Most of the elements of design I have attempted to describe are clearly demonstrated in the William Blake painting. I have isolated 274-5 each of these elements in diagrams: (a) shows its flat tonal pattern, whilst (b) reconstructs its spatial composition; (c) defines its rhythms and counter-rhythms and (d) the interplay of contrasts between rounded and rectilinear contours; (e) illustrates the balance of textured areas against plain and (f) the pattern divisions of the picture area; (g) isolates its movements and (h) its tension points (A, B, C, D, E, F).

It will be seen that many of these lines, shapes, tones, and textures have several functions in the design. The edges of Abel's grave, for instance, perform a number of roles: by their rectilinear character they contrast with and balance the centralized circle of the sun and the convoluting curves of the clouds which, symbolically, appear to pursue Cain; by their perspective foreshortening they establish the horizontal plane of the ground. In addition to the sensuous contrast of the straight lines against Abel's relaxed curves and the springing contours of Cain's distraught silhouette, these provide a movement of impetus to Cain's flight, like a sprinter's starting-block, in the tension points they create with the implied continuation of the rock's outline, with Cain's raised foot, and with the foreground spade.

We can also discover more subtle devices: the contrast of Eve's rounded surfaces and limp, collapsing curves against the taut silhouette of Adam; the echoed shape of Adam's outstretched fingers

BLAKE: *The Body of Abel Found by Adam and Eve* (1826–7). Tate Gallery, London

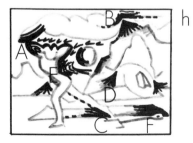

h

g

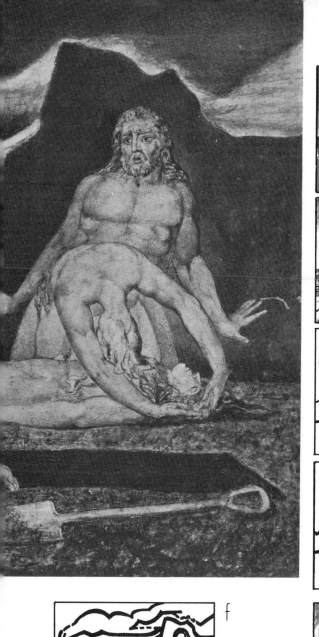

in the 'flames of retribution' flickering against the figure of Cain; the family likeness between the faces of Cain and Adam; the visual metaphor expressed in Eve's 'weeping' hair, which embraces her son's head; and the subtle repetitions of small silhouettes—the corner angle of the grave repeated in the shape of a mountain, for instance. When we have studied this painting for some time we find that not one of its statements is arbitrary and that every line, tone, and shape contributes to the expressive mechanism of the design.

Upon our awareness of the dynamic interplay of the elements of design depends our ability to enter wholly into the world created by the painter and so be able to enjoy the performance given by his shapes, lines, and colours. The significance of this performance for us and how profoundly it will touch us emotionally and stimulate us intellectually depends upon personal factors of temperament, background, and experience. But the ability to be both soothed and excited by a picture's abstract visual qualities is a faculty everyone can develop.

The full experience afforded by a painting is possible only through surrender to the visual impact of the original work. Unfortunately the mass of printed substitutes available in books and photographic reproductions and on films and slides tempts many people to be satisfied with less. This is not surprising since the originals can usually be seen only in public museums and private galleries and the chilling or claustrophobic atmosphere of some of these may not at first suggest surroundings sympathetic to that absorption in the interplay of shapes and colours with which true appreciation must begin.

The stadium spectator and the member of a theatre or concert audience can be immediately transported into a receptive mood by the pervading excitement of relaxed anticipation. But the visitor to a public or commercial art gallery must generally create this essential mood of expectancy and concentration for himself. It is not difficult to achieve this in the new museums and in the more imaginatively mounted retrospective exhibitions and one-man shows. But some of the more important collections are still housed in forbidding gilt and marble monuments to national and civic pride, their interiors often resembling the overheated lobby of a grand hotel or the draughty reception-hall of a grandiose railway terminus or hospital. Small wonder that their essential function for many visitors is that of shelter, waiting-room, or rendezvous.

As custodians of national treasures, museum directors must often sacrifice imaginative presentation and selection to the traditions of academic scholarship in the conventional chronological layout of their rooms. This system of hanging pictures in historical sequence denies us the visual stimulus and the often enlightening contrasts that an intermingling of works from different periods would create. Among the paintings reproduced together in this book we find intriguing similarities: in the design of the Bruegel and the Klee and 17; 16 of the Poussin and the Cézanne; in the linear qualities of the Indian 96;97 painting and the Stubbs; in the movement expressed in the detail 25 from the Poussin and a fifteenth-century Italian picture; and in the 237;253 versions of a pagan dance by Poussin in the seventeenth century and 96 Bauchant in the twentieth. In literature and music we are accustomed 160 to enjoying a variety of styles collected together in anthologies and juxtaposed in concert programmes. But at least the chronological sequence in which the rooms housing a comprehensive collection are

*s 278–9
ENS (1577–1640): The
rors of War. National
ery, London

277

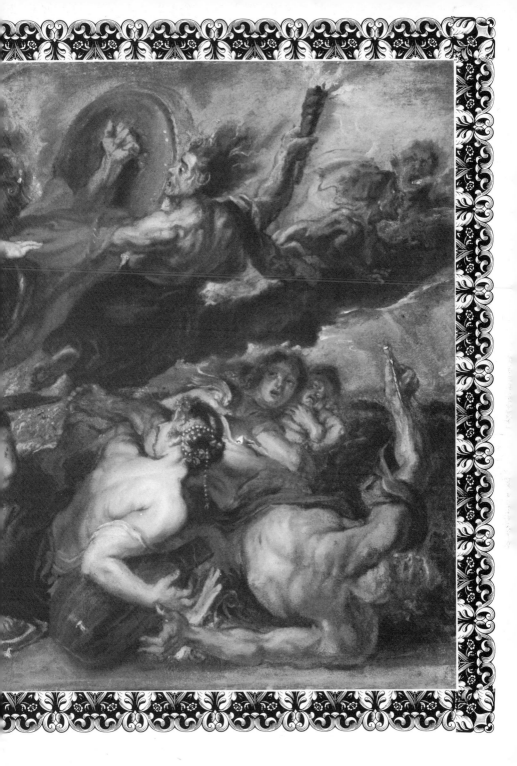

numbered enables a steady walker to familiarize himself with national characteristics and stylistic influences and developments in a very practical way.

However it is the museum director's responsibility for the security and preservation of the treasures under his care that may present the chief barrier to our immediate entry into the world of a great painting. He may rope off the exhibits as if visitors were expected to file past in dutiful homage to the dead. He may unintentionally obscure paintings beneath protective glass (in which we see ourselves more clearly than the picture) and enclose them in unsuitable and distracting frames. Above all, of course, he will lack the funds and space which would enable him to display all the works in a collection in the physical conditions and aesthetic surroundings he would wish. But if we are aware of the initial obstacles to our complete enjoyment of a painting, we can do something to circumvent them.

FRAMES When picture-glass reflections are obtrusive we can only wait until the painting is given another position in the gallery. But when a frame seems ostentatious or altogether unnecessary (and many pictures would be more easily read if displayed without them and placed instead within a shallow recess in a temporary false wall) we can always move forward until the frame scarcely impinges on our field of vision. A heavy 'window' frame around a Cézanne or a Cubist composition, or indeed around most twentieth-century paintings, will destroy the illusion of volume and of planes projected towards us. In order that such unintentional vandalism shall not demolish the spatial structure of these pictures for us, it is therefore essential that in these instances we focus our attention on the picture area alone and ignore the presence of the frame. Otherwise our efforts to see the expression of advancing planes in a picture whose frame is designed for pictorial illusions of spatial recession are as unrewarding as attempts to mount the bottom steps of a descending escalator.

But sometimes the frame, however richly gilded, garlanded, and scalloped, will so harmonize with the spirit and formal characteristics of its painting that the design of the picture is enhanced. A High Renaissance picture such as the Titian *Portrait of a Man* reproduced xvii here, a flamboyant Baroque Rubens, or a lush Rococo decoration 278– might claim an abundantly floriated frame as part of its pictorial territory. Indeed in some styles of painting the artist has intended us to see his frame as an essential unit in the overall pattern of his picture, and he may even paint a frame on the picture surface to provide an inner

REMBRANDT: Detail from *Christ Presented to the People* (1634). National Gallery, London

mount, as the manuscript painters did. Or he may create a neutral boundary area in order to protect the dynamics of his shape and colour relationships from outside visual distractions as Klee has often done; or enclose his subject within a painted border which harmonizes or contrasts with the images inside as Whistler and Pissarro did; or he may as Seurat did, create a vibrant inner frame from spots of all the colours he had used in the picture, so that it scintillated like a mosaic or a jewelled setting. Picasso and other artists have painted imitation frames in *trompe l'oeil* relief along the edges of their canvas or have created an isolated pictorial arena within the canvas area, as Braque has done in his *Oval Still Life*. In an early example of studio-painting such as the Giovanni di Paolo and the icon the frame was often carved from the plank which served as the painting surface, the picture area having been planed and chiselled to a lower level. A painter will also use old second-hand frames for their special period characteristics in order to heighten the intellectual, sensuous, and emotive qualities of his picture. Magritte, for example, was particularly fond of *fin-de-siècle* bourgeois frames both for their colour, texture, and proportions and for their aura of worn respectability, which underlined the bizarre relationships of ordinary things and the convincing ordinariness of disturbing or outrageous events recorded on his canvas.

100

104

240-1

THE EXPERIENCE
OF ORIGINAL
PAINTINGS

.

REMBRANDT: Detail from
*Saskia van Ulenborch in
Arcadian Costume* (*c.* 1635).
National Gallery, London

The deeper experiences afforded by a painting are reached only during a period of contemplating the original. Therefore to give oneself up to staring fixedly at one painting in a public or commercial gallery will seem a natural and more comfortable activity from a convenient seat. As a start towards a deeper experience of painting it does not matter what picture we are facing so long as our view of it is good and reasonably uninterrupted. If we then relax and lose ourselves in the painting's relationships of shape, line, and colour for ten or fifteen minutes, we shall feel, when we leave, that for a while we have possessed a picture and that it has possessed us.

The eternal fascination of a great painting is that whenever we return to it its effect upon us will certainly be very different from our previous dialogues with it. It will never seem exactly as we remember it and we will probably discover new relationships which change a colour, shift a tonal emphasis, and bring out unsuspected interactions between its lines and shapes. 'When it is finished it still goes on changing, according to the state of mind of whoever is looking at it. A picture lives a life like a living creature, undergoing the changes

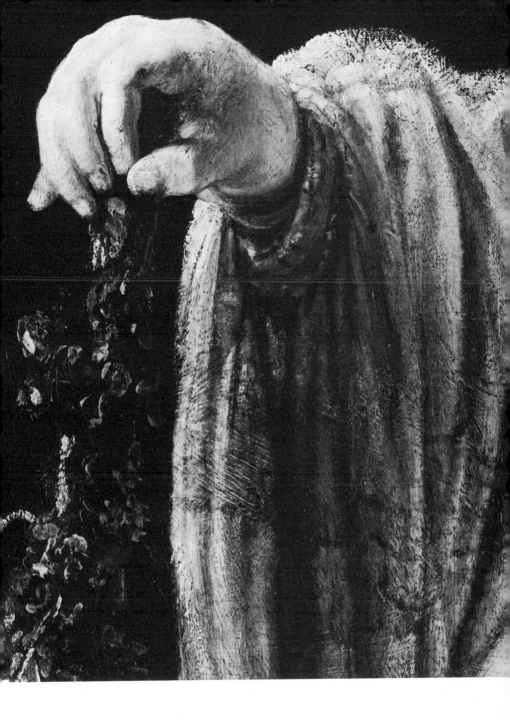

imposed on us by our life from day to day. That is natural enough, as the picture only lives through the man who is looking at it.'[1]

MASS-APPRECIATION Before the development of photographic reproduction paintings could only be known to most people by verbal description—which emphasized the subject and narrative and obscured the pictorial qualities—or by popular engravings—which, though remarkable for their technical dexterity, were flawed by inaccuracies and a propensity for sentimentality.

It was unfortunate that the nineteenth century's obsession with the literary content of pictures and their evaluation in terms of the high moral intentions of the artist should have become the standards by which painting was appreciated in the very period during which public museums were opening to introduce the original works of great painters to a potential audience of millions. Already even the Old Masters had been subjected to 'appreciation' in terms of story-telling—interpretations upheld by their engraved impersonations, which proudly decorated parlour walls like paper icons and successfully debased a Michelangelo or a Turner to the level of late Victorian popular taste. Popular painting in this hey-day of story-telling created an escapist dream-world of feeble anecdote and cautionary tale, of coy passion and tepid tragedy—a hypocritical ostrich morality that encouraged pornography to masquerade as acceptable pidgin-antique mythology and further reassured the already cosy conscience of the affluent middle classes with a sugared *genre* of Happy Family Poverty. A nineteenth-century art critic would therefore judge two contemporary companion-paintings by the standards of mission-hall mottoes:

In the year 1861 he sent to the Academy the two pictures engraved on this and the preceding page, respectively entitled *The Wanderer* and *Restored*. Both 285 relate to one incident. A little child has strayed away from home, or, as she would probably say, if old enough to talk, she 'has taken the kitten out for a walk', and has seated herself at the outskirts of a wood, tempted to enter it by the ripe blackberries on which she has been feasting. There she is discovered by a gentleman and his daughter, the latter of whom stoops down to ask the child some question: this is the subject of the first picture. In the second the wanderer is restored to its home, the mother welcoming her child, and the old cat her abducted kitten; the gentleman points to the spot where the truant was found. Nothing in the way of Art could be more unaffected and natural than these compositions, both are excellent, but if we have a preference it is for the former, in which the attitude and expression of the three figures, that of

[1] Christian Zervos, *Conversations with Picasso (Cahiers d'Art:* 'Picasso 1930–1935').

The Wanderer, engraved by Butterworth and Heath after the painting by Joseph Clark (*c.* 1861). *The Art Journal*, 1863

the child especially, are truth itself, while the 'tree-work' is quite as good in
its way. We hold this to be a perfect specimen of genuine Art—as perfect of its
kind as could be placed on canvas.[1]

Unfortunately the belief that people can be interested in painting
only if artists and their subjects are sweetened with sentiment and
spiced with sensationalism survives today in novels, movie bio-
graphies, and television travelogues. And that many people still prefer
the miniscule impersonation of a painting to the living challenge of
the original is encouraged by the tempting *tutti-frutti* format of art
gift-books. The bright, glossy, charming reproductions in these
attractive art history digests create serious barriers to the appreciation
and enjoyment of real paintings since it is on these convenient pixie-
postcard illustrations that many people are content to depend for an
aesthetic experience and on which their criteria are based.

When we see an important exhibition, however, its illustrated
catalogue is a worthwhile investment—both for its future historical
interest and for its power to recapture the visual experience and to
evoke the emotional atmosphere of the occasion. Large, individual
black and white photographs of paintings we have at any time
enjoyed—or have been puzzled yet intrigued by—should also be
collected, rather as we might make additions to a personal library of
recordings of music. Except when the photographs are of small
pictures—the two Teniers panels, for example, the Rembrandt 288
Interior or any of the manuscript-paintings here—it is generally more 81
helpful if these are of details from a painting, which may be bought
from most of the major museums. These are especially useful since
it is often difficult to concentrate our attention on particular sections
of a picture in a museum and these details may be of illuminating
interest: the form and vitality of the tiny Poussin figure, for instance; 237
the bizarre patterns and sensitive characterization found in the back-
ground landscape details which I have isolated here from four very 290
different kinds of painting; and the brush-stroke textures, such as
those illustrated from Rembrandt's canvases, which may not easily 281
be seen when displayed beneath their protective glass on a gallery wall.

Unexpected qualities will almost always be discovered from the
study of details from very large paintings, especially when these are
all too familiar as popular prints much reduced in size. Sections
photographed from Renoir's very big and well-known *Les Parapluies*, 294
for example, are revealed as self-contained units of an integrated
pattern whose abstract qualities might not have been fully appreciated

[1] *The Art Journal*, 1863.

pages 288 *and* 289
TENIERS THE YOUNGER
(1610–90): Panels from
*The Four Seasons (Spring
and Summer)*. National
Gallery, London
page 290 *above*
FOLLOWER OF FRA
ANGELICO: Detail from
The Rape of Helen by Paris
(15th century). National
Gallery, London
below
TITIAN: Detail from *Noli
Me Tangere (c.* 1510).
National Gallery, London
page 291 *above*
FILIPPINO LIPPI (*c.* 1457–
1504): Detail from *The
Worship of the Egyptian
Bull-God, Apis*. National
Gallery, London
below
GIOVANNI BELLINI:
Detail from *The Agony in
the Garden (c.* 1470).
National Gallery, London

Restored, engraved by Butterworth and Heath after the painting by Joseph Clark
(*c.* 1861). *The Art Journal*, 1963

beneath the apparent artless charm and snapshot naturalism of the whole composition. The shapes, lines, tones, colours, and textures in these Renoir details, as also in the section isolated here from Veronese's 294 vast painting, not only contribute to the dynamic unity of the over-all 293 pattern but have been given a unity of their own as miniature pictures within the picture, like movements in a symphony.

Cinema and television are very occasionally used as media for new techniques of pictorial analysis. Imaginative sequences have been made in which the artist's initial sketch for a picture is dissolved into the working study which then fades into the completed painting. Or a painter's several versions of a subject are recorded from various scattered sources and edited so that each is seen slowly superimposed upon another. The movie camera can follow and expressively unfold a composition's rhythmic sequences. It can reveal the organic harmony of parts to the whole by isolating one small motif and gradually blurring and then sharpening the definition of images in the surrounding field. And, with a freedom denied to the museum visitor, it can glide closely across the picture surface, exploring the landscape of its paint textures and sometimes exposing the evidence of the artist's afterthoughts and adjustments.

In supplementing our experience of original works with photographs and films we must, however, remain alert to the inevitable distortions in even the best of reproductions. For example, the balance of a tonal pattern can be seriously disturbed merely by the harsh contrast made by the white border which surrounds most printed reproductions and which emphasizes the very picture boundaries away from which the artist had taken pains to direct our attention. And loss of sensuous qualities and expressive functions is rarely avoided in the most carefully matched photographic prints. Among the travesties frequently committed by photographic colour projections is that since the scale of the pattern shown is rarely that of the original painting the expressive dominance exerted by one area of colour over another, in the balance of the whole picture, is destroyed—and that all the colours of the paintings shown by the coloured light-beams projected by films and slides seem closer to the translucent intensities of stained glass than to the very different qualities of artists' pigments on opaque grounds. Nor can printer's ink on paper accurately show the different qualities of colour obtained by palette-mixing, by glazing and scumbling, by broken hues, by the influences of tinted grounds, and so on. Again, in reproductions of works in which the primary hues dominate, colour relationships will be inevitably disturbed since in most processes a red in printer's ink

produces a higher degree of saturation than yellow or blue. Finally the subtle differences often expressed in degrees of intensity when a painting is virtually a monochrome are very rarely successfully recreated in a colour print. The sensuous glow and spatial movements of the Albers, for example, are dependent upon a most subtle 106 relationship of area and hue saturation between three variables of yellow—qualities that printing inks could not accurately recreate.

In this book I have been concerned primarily with the visual elements of painting. This is because I believe that by heightening our sensitivity to these forces and by developing an awareness of their expressive relationships within the picture frame we allow both the painting of today and that of a thousand years ago to communicate with us. What it is that a painting will say or mean to us and how it may affect us intellectually, emotionally, or sensuously must be our own affair. At that stage each is his own interpreter.

'Everyone wants to *understand* art. Why not try to understand the song of a bird?' (Picasso)

Index

*There is today a widespread, and
growing, interest in the visual arts—in
spite of, or perhaps because of, the
increasing domination of our life and
thought by technology and science. Yet
the appreciation of these arts comes
spontaneously to few people and no
one can appreciate the whole range
without help and training. This series
aims at providing a practical,
illustrated guide to appreciation, which
is here regarded as a skill which can be
developed from a natural aptitude,
rather than as something which can be
reduced to a set of rules or taught, far
less culled from picture-books and
histories of art. The emphasis is on what
to look for in the various kinds of art,
on the development of an intelligent
and critical approach, and above all on
the necessity of exercising our
perceptive powers: it is only through
constant training and use of these
powers that we can arrive at a true
understanding and enjoyment of
works of art.*

The full appreciation of paintings comes
only through the experience of their
physical reality. The mass media of
printing and television enable us to
identify and classify the world's great
pictures from the armchair. But painting
is a living visual language. If we cannot
read this language the artist will be able
to communicate very little to us. Unless
we can respond to the interaction of
its visual elements of shape and colour
on the canvas, we are denied the
experience of a painting's unique optical
sensations.

The purpose of this book is therefore to
suggest, with the use of photographs,
drawings, and diagrams, ways in which
the inherent capacity to perceive and
to react to a painting's visual qualities
may be developed. That is, by exercising